Francisco Asensio Cerver

# OIL PAINTING
## for Beginners

Vicenç Badalona Ballestar (illustrations)

Enric Berenguer (photography)

**KÖNEMANN**

Managing editor, text, layout, and typesetting: Arco Editorial, S.A.

Original title: *Pintura al óleo para principiantes,* Francisco Asensio Cerver
ISBN 3-8331-1717-6

© 2005 for the English edition: Tandem Verlag GmbH
KÖNEMANN is a trademark and an imprint of Tandem Verlag GmbH

Translation from Spanish: Mark Lodge
English language editor: Maia Costas
Project coordinator: Kristin Zeier
Cover design: Peter Feierabend, Claudio Martinez

Printed in Slovenia

ISBN 3-8331-1715-X

10 9 8 7 6 5 4 3 2 1
X IX VIII VII VI V IV III II I

# CONTENTS

# Materials

## OIL PAINTS: NEW POSSIBILITIES

If there is one thing that distinguishes oil from all other painting media, it is the intense luminosity and high quality of its colors. Furthermore, oil paints retain their original color despite the effects of sunlight and time, and their texture remains creamy after it has dried.

Oil is a pictorial medium that offers a wide range of possibilities. This is probably why oil painting has become what it is today. The origins of the oil medium date back to the beginning of the Renaissance. Since then, it has become the most widely-used medium and established itself as the king of all paint media. Even though the essence of the medium has remained virtually unchanged over the last six hundred years, innovations in the fine arts industry have provided artists with a large number of products and implements that make this art form easier and more accessible.

▼ Oil paints have an oily, pasty consistency that makes them easy to apply and extend with a brush. However, the intensity of their color depends largely on the quality of the paints you are using. High-quality paints are recommended to insure proper drying.

Oil paints are mainly made of linseed oil (which is the medium) and pigment colors. Once combined, these ingredients have a creamy texture that allows color mixtures like the ones shown here to be obtained with ease.

▲

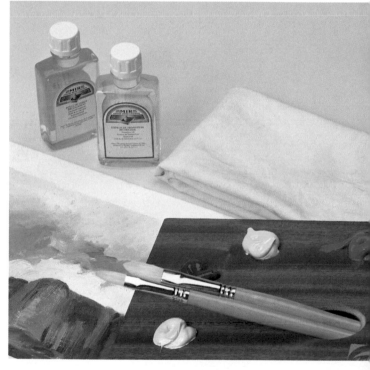

▼ The basic materials needed to begin painting (you do not need many) are some tubes of oil paint of the following colors: white, medium yellow, red, green, and black; two hog's hair brushes, a palette for mixing your colors on, linseed oil, turpentine, canvas-covered cardboard and rags. All these items can be purchased in art supply stores.

# THE COMPOSITION OF OIL AND THE PALETTE

Oil paints are made of pigment and oil, which is why only turpentine can be used to dilute the colors. Unlike other pictorial media, oil colors do not dry by means of evaporation, since there is no water in their composition; instead, they harden through the oxidization of the oil. The most signifi-cant characteristics of oil paint are its slow drying process and the way in which it can be superimposed in opaque or transparent layers. There is an extensive range of techniques for painting in oil, many of which will be explained later in this volume.

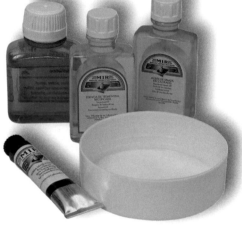

*Oil paints permit highly luminous transparent colors obtained by linseed oil, turpentine, and Dutch varnish, or even an oil medium or one of the many products sold for this purpose. In order to obtain transparent layers, normally coiled glazes, you will need a container in which the color can be diluted.*

▼ *Oil paint is made up of linseed oil, pigment and may contain a little turpentine. With these three components it is possible to paint any subject. The following pages in this chapter explain in detail how oil paint is made. The brushes used to apply oil paint must be cleaned with turpentine, and then rinsed with running water.*

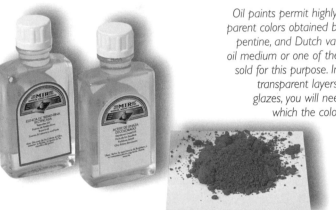

## SOUND ADVICE

Dippers are indispensable accessories for painting in oils. These metal recipients are used to hold linseed oil and turpentine.

▶ *The colors are placed on the palette according to shade, as shown in this example. They should be placed around the edge of the palette, leaving enough space between each one to avoid smearing. The paints on this palette have been arranged in a correct order.*

## MAKING OIL PAINT

One important technical aspect of this medium is knowing how to make oil paints, a process that requires more effort than skill. This page explains the basic procedure for making your own paint. Even though all colors of oil paints can be purchased ready made, it is useful to know how to make them yourself. Once you have mastered the basics of making paint you will be able to try out some of the techniques explained later on.

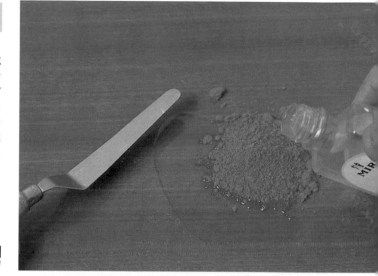

*1. Only a few basic materials are required to make oil paints. All you need is linseed oil - the refined type if possible good quality pigment, a steel palette knife and a clean and varnished brush. Place a small amount of pigment in the center of your palette; then pour a tiny amount of oil next to it.*

If the paint is too shiny and thin, you have used too much oil. If such a mixture is applied to a canvas, it will crease and bubble. If the paint appears dull or cracked you have used too little oil.

*2. Drag part of the pigment with the edge of the palette knife over to the oil and mix the two together. The two components must be combined gradually until the pigment has been completely blended.*

*3. If the mixture appears too thin, add more pigment and continue mixing. Once you have acquired the appropriate consistency, repeat the process until the paint has an oily, elastic texture with no lumps or particles of pigment. You may then add several drops of Dutch varnish.*

## PAINTBOXES

▶ *Small paintbox containing two side drawers. This is primarily a studio box, as it is somewhat clumsy to carry around.*

Oil paints are mostly sold in tubes, which can be bought separately. This is the best option if you have a paintbox to carry them in. There are paintboxes containing sets of colors of various qualities. These are indispensable because they allow you to keep your colors arranged in the right order, and store various painting accessories in them.

◀ *This model contains two rows of paints and two palettes that separate the compartments and fit perfectly into the slots.*

▶ *This paintbox has guide strips inserted along the sides of the lid for transporting canvas-covered cardboard. Placed in this position, a recently painted picture can be transported without any damage to its surfaces.*

*Box-easel set: an inexpensive option recommended only for those who paint very rarely.*
▲

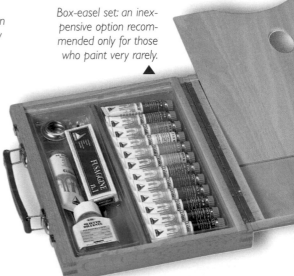

# ADDITIVES FOR OIL PAINTING

Oil paints can be applied in a wide variety of ways: they can be applied in transparent layers, glazes, and opaque layers, blending them with underlying colors applied earlier in the process, or they can be applied with additives that give them a grainy texture. With the exception of linseed oil and turpentine, the following products are not indispensable, but they are important for obtaining certain effects that will be discussed later.

*Ground marble and hematite. These two additives can be used to create textures. They should be added to the paint while it is still on the palette so that its tiny particles are completely coated. Applied to canvas, these additives can create spectacular visual effects.*

▲

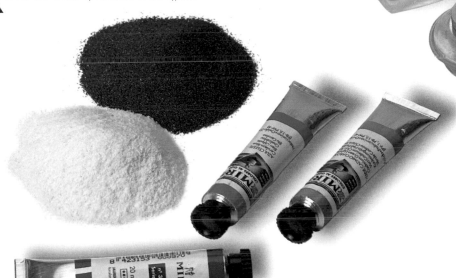

*▼ Linseed oil and turpentine. Two components that are never absent from the artist's paint-box. In addition to being painting materials, they are also used as paint thinners. Given that they form the foundation of paint, they should be of a high quality.*

*Acrylic textured gels. These products are very easy to apply to the canvas before painting. They dry quickly and can be used to create a wide variety of textured surfaces.*

▲

Varnish is applied when the painting is completely dry; this liquid unifies shiny and matt areas and protects the surface.

# Materials

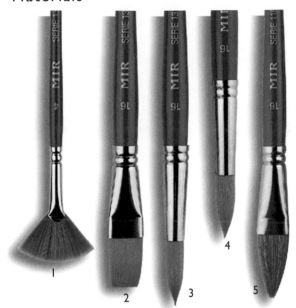

## BRUSHES AND PALETTE KNIVES

Brushes are indispensable tools for painting in oils. Virtually an extension of our hands, brushes are used to apply paint to the canvas, to obtain color mixtures, and to execute all manner of brushstrokes. Unlike brushes, the palette knife is used to apply the paint in the form of dense impastos; painters also use this implement to drag paint across the canvas. These two tools help the artist execute highly individual and effective brushstrokes.

▶ *There is a wide range of oil paint brushes to choose from. Here is a selection of the various types of brushes available on the market: fan brush (1), flat brush (2), round-tipped brushes (3-4), and filbert brush (5).*

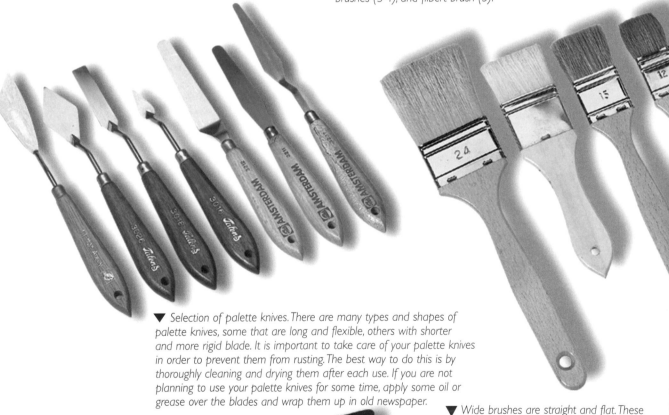

▼ *Selection of palette knives. There are many types and shapes of palette knives, some that are long and flexible, others with shorter and more rigid blade. It is important to take care of your palette knives in order to prevent them from rusting. The best way to do this is by thoroughly cleaning and drying them after each use. If you are not planning to use your palette knives for some time, apply some oil or grease over the blades and wrap them up in old newspaper.*

▶ *This brush, whose tip is made of rubber, falls somewhere between the palette knife and the brush.*

▼ *Wide brushes are straight and flat. These are considered the most useful of all paintbrushes. Despite their somewhat rough appearance, they can be employed in a variety of ways. The brushstroke made with a wide brush facilitates color blending and roughing out, the technique of filling in the canvas.*

# CANVAS AND UNIVERSAL SIZES

The type and the size of a surface to paint on are just a few of the many questions posed by the painter. There is a wide variety of surfaces to choose from, some of which come ready to paint on, others that require a certain amount of preparation, and those that can be purchased completely "raw." All the materials needed to paint on canvas can be found in your local arts supply store.

*Canvas is the most commonly-used support for oil painting. The two examples of canvas shown here are completely unprimed. Canvas can be bought by the meter in rolls or mounted on a stretcher.*
*A primed canvas is ready for immediate use. If it is not primed, you will have to prime it so that the fiber surface is protected from direct contact with the oil paint.*

Both the canvas and the cardboard available on the market can be bought in three main formats: landscape, seascape, and figure. As the names of these formats indicate, they are basically designed for these three motifs, although this does not imply that they cannot be used for other subjects.

*Canvas-covered cardboard is a cheaper and very suitable support for painting in oils. It is made of rigid cardboard about 5 mm thick, and comes covered with a primed layer of quality canvas. Therefore it is ideal for painting most of the exercises included in this book. However, this type of support is not sold according to the universal size measurements; it can be purchased only in small formats.*

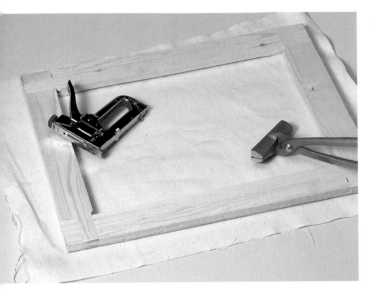

## MOUNTING A CANVAS

A good art supply store offers a variety of products for painters to prepare their own materials. It is, of course, very handy to buy canvases already mounted on stretchers, but the amateur painter should learn how to mount an unprimed canvas. Starting with an unprimed canvas allows artists to add their own personal touches, such as choosing the type of canvas and the most suitable stretcher for it.

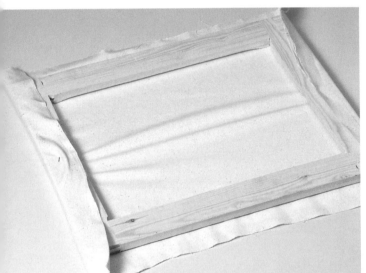

▶ *There are many types of canvases to choose from; the most popular ones among oil painters are made of linen, cotton, or a combination of cotton and polyester. The linen canvas is a high quality support; highly recommendable, although also expensive. Supports made of cotton bring good results, although they are not as stable as the linen ones. However, many artists paint on cotton canvases without encountering problems. The intermediate option is to use a canvas made of linen and cotton. In order to stretch a canvas, you will need material large enough to overlap the stretcher by five centimeters on either side, a pistol-type stapler for fabric and a pair of pliers for pulling the canvas taut.*

▶ *1. Lay the canvas on a flat surface. After centering the stretcher on the canvas, punch the first staple into the center of the crossbeam. Then stretch and fold the canvas over the opposite crossbeam. This procedure should be done with your hands to ensure that the first staple is not pulled out. Without allowing the canvas to loosen, punch in a second staple. A ripple will form across the surface. This is a result of the tautness.*

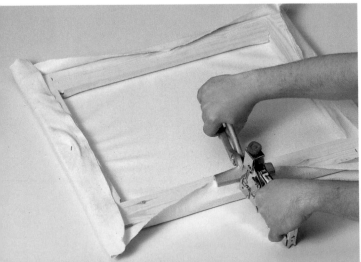

▶ *2. Once again, stretch the canvas to one of the two free sides. Once you have stretched and fastened the canvas to three sides of the stretcher, use a pair of pliers for the final side. Be sure to distribute the tension evenly since excessive force could pull some of the staples out. Staple the fourth side without releasing your grip on the pliers. The canvas should now be attached to the stretcher at midpoint of all four sides.*

# STRETCHING A CANVAS

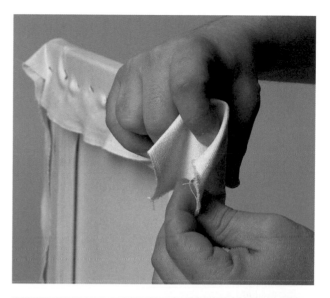

This process is very important, regardless of whether the canvas you are stretching is primed or not. By distributing the tension evenly among all four sides, the ripples will disappear from the surface. It is essential to ensure that the corners are folded over correctly; this will complete the tightening of the canvas.

*From the center of any of the four sides, at about ten centimeters from the central staple, stretch the canvas a little and fasten another staple. Do the same on the opposite side, ensuring that the canvas remains as taut as possible to prevent rippling. Stretch the canvas again on one of the adjacent sides, to compensate for the transversal crease, and staple. Do the same on the opposite side. The canvas should now be almost completely fastened. All that remains is the corners. Pay close attention to this phase, since this is the most critical moment of the tightening procedure. Take the corner of the canvas and fold it inward toward the corner of the stretcher. Tuck the corner of the canvas in forming a 45° angle with respect to the stretcher.*

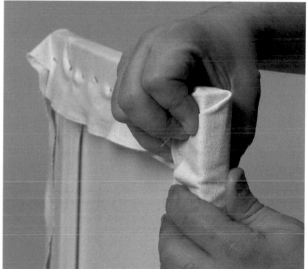

Not all canvases are easy to stretch. Primed canvas is far more difficult to stretch than the unprimed variety and can even tear on one side. If, at the end of the process, there is still a wrinkle or two, it can be smoothed by dampening the back of the canvas.

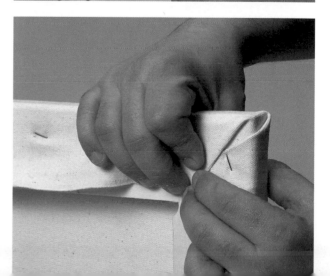

*Without letting go of the folded corner, fasten it to the stretcher with a staple. Then fold the surplus piece inward and staple it as well. Now follow exactly the same procedure for the three remaining corners, always working on the side opposite to the one you have just finished. This allows you to correct the tension on the surface of the canvas.*

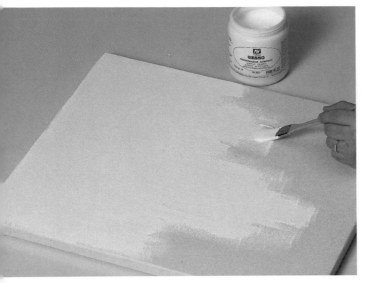

## PRIMING THE CANVAS

If the canvas you have stretched is already primed, it is ready to paint on. If it is not, you will have to apply a primer to prevent the oil paint from coming into direct contact with the surface of the canvas. You can make your own primer using animal based glues, but this task is somewhat complicated and messy. The best option is to buy an acrylic plaster primer, which guarantees highly satisfactory results. In addition to canvas, this product can be used to prime wood, cardboard, or paper, which, if unprimed, cannot be used for oil paints. To sum it up, a correctly primed surface is indispensable for painting a good oil picture.

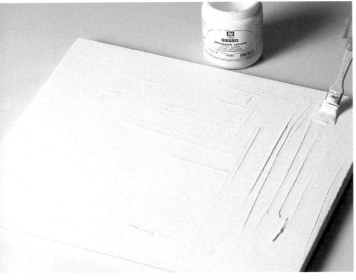

▶ 1. *To prime any type of surface, you will need a pot of primer and a good wide brush. Apply the primer lengthwise in thick strokes in one direction to ensure that the liquid penetrates the canvas and seals the pores. Continue until the entire surface of the canvas is covered.*

▶ 2. *Once the lengthwise surface of the canvas has been covered, repeat the procedure going from side to side. Greater care must be taken along the edges as the brush may not reach certain areas. Once the canvas is completely covered, it is ready to be painted on.* •

▶ 3. *The canvas must now be left to dry. It may take several hours, although leaving it in direct sunlight or near a source of heat may accelerate the process. Once the canvas is dry, you may find certain irregularities in its texture. This can be remedied easily by rubbing a piece of sandpaper wrapped around a block of wood over the surface. This procedure must be done very lightly.*

## OTHER TYPES OF OIL PRODUCTS

Despite the fact that oil is a very traditional medium, new possibilities and applications have been added to conventional oil paints. All good art supply stores stock a variety of products for use in oil painting. These modern implements can be used alongside the more traditional painting techniques.

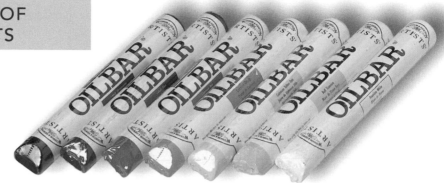

▼ Oil paint con also be applied in the form of sticks without losing any of its unique characteristics. This set allows the artist to work with oil paint without the use of brushes as if it were a completely different medium. The range of colors is luminous and stable. They can be used to touch up a picture painted with traditional oil paints or for creating special effects. Oil sticks can be used to draw, paint, or apply thick impastos.

Oil pastels are bound with oil and gum Arabic, which makes them completely compatible with this painting medium. ◀

▶ The painter Edward Munch spent much of his time investigating the oil medium. He attempted to obtain a formula that would convert the greasy paint into a resin, making oil paint soluble in water. The great painter was on the verge of achieving this goal, but he lacked the necessary means and his endeavor ended in failure. Nonetheless, over the last few years, several oil paint manufacturers have achieved Munch's dream. The result is a paint with the characteristics of oil, which dissolves in water and dries rapidly. This type of oil paint allows the artist to rough out the canvas knowing that the preliminary layers will dry very quickly.

# PALETTES, PAINTBOXES, AND EASELS

If painters do not like the type of cases and paintboxes available on the market, they might prefer to make their own painting equipment. Likewise, they may prefer to make their own palette. Another tool necessary for panting is the easel, of which there is a wide variety to choose from.

▼ *Cases for transporting an artist's paints and equipment. You will find easels ranging from the smallest and most simple boxes without compartments to the most sophisticated double-box type. They contain metal trays to hold paints and other accessories, and are much better than the box sets with plastic compartments.*

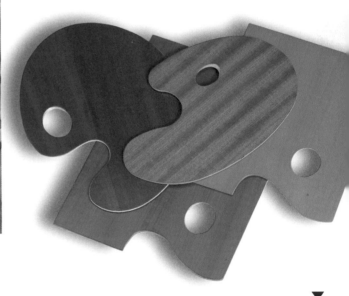

▼

*It is very likely that you will need a bigger palette than the one included in the case, or, on the other hand, an even smaller one. Palettes come in many shapes and sizes. The one important thing to remember is that its surface must always be covered with two coats of protective varnish. The color of the palette is not important, although some artists opt for one that is either very dark or very light. This range of palettes shows some of the most commonly-used shapes and sizes.*

▶ *It is extremely difficult to paint comfortably without a firm support to rest the canvas on. You can improvise but if your support is not good enough, all the time and energy invested in the picture will be for nothing. Therefore, the sturdiness and firmness provided by the easel makes it an indispensable item for all amateur painters.*

# Mixing color

## TESTING COLORS

The palette should not be filled with excess paint. You should place on it only the colors you are going to use, and in the necessary quantities. With only three colors it is possible to obtain all the colors of the rainbow, and by extension all the colors existing in nature. Once you have enough experience in color mixing, you will easily be able to obtain any color.

In this first chapter, we are going to outline the fundamentals of the medium. It is not difficult to start painting in oils, but the beginner does need some basic knowledge on how to mix colors. Before any artist begins to paint, he must arrange the colors correctly on the palette. Before going on to more complicated matters, it is essential to fully understand the rudimentary aspects of this art form. Here we will demonstrate how easy it is to blend oil colors.

▶ *To begin, you will need the three primary colors: blue, carmine, and yellow. It is important to place these colors far enough apart so that they can be mixed conveniently. Remember that the better the quality of the paints, the better the results obtained. The palette you use must also be of good quality and have a varnished surface so that the paint does not penetrate the pores of the wood.*

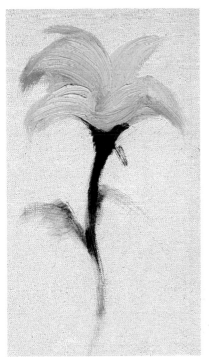

▶ *1. In order to learn about the possibilities of the oil medium, you should begin painting simple motifs such as a flower. Dip your brush in the yellow and paint several strokes in the shape of a fan. This is easy, isn't it? If you combine blue and yellow you get green. Now apply a new stroke of this color to paint the stem; if there is little paint on the brush, the marks of the hog's hair brushes will be left on the paper.*

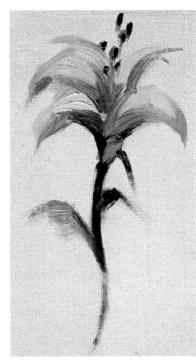

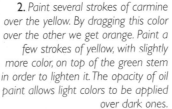

*2. Paint several strokes of carmine over the yellow. By dragging this color over the other we get orange. Paint a few strokes of yellow, with slightly more color, on top of the green stem in order to lighten it. The opacity of oil paint allows light colors to be applied over dark ones.*

# MORE COLORS ON THE PALETTE

Having tried our hand at the first exercise, we will now attempt to work with more colors, since many tones are difficult to obtain with only the three basic colors. When inexperienced amateurs take up oil painting, they often arrange their colors randomly. This is a mistake; the order in which artists arrange their colors will make the task of mixing and applying either easier or more difficult.

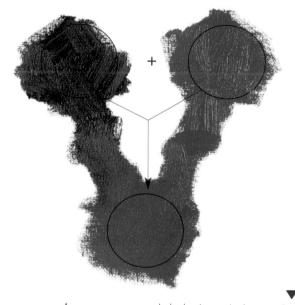

▼ This is a classic arrangement of colors on the palette; white should always be first and in abundance; the other colors in ascending tonal and chromatic order, yellow, red, and carmine; then the earth colors, such as ocher and burnt umber; last green, dark blue, and black.

A common error made by beginners is the way they make luminous color. White is used to gray tones and to obtain highlights. Try the following simple exercise: lighten carmine by adding red and then darken it with white. In the first case, the result is a lighter but intense tone; in the second, a pinkish pastel tone.

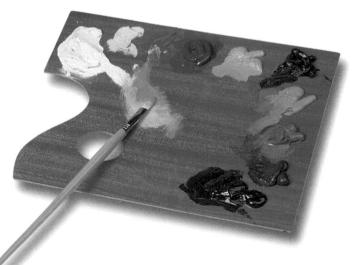

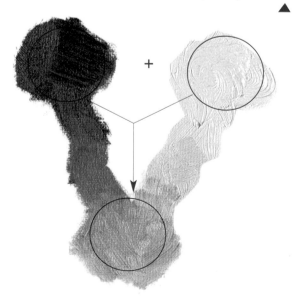

▼ The best procedure for obtaining correct color combinations is to drag a tiny amount of the first color to the center of the palette. Then drag the second color over it and mix the two until you obtain a homogenous color. Then you can add other colors to this mix to achieve the desired tones.

# OBTAINING COLORS

The primary colors are yellow, blue and carmine red. By mixing these colors together we obtain the so-called secondary colors, that is: by mixing yellow and carmine red together you obtain red; yellow mixed with blue produces green tones; blue combined with carmine red produces a range of violet tones.

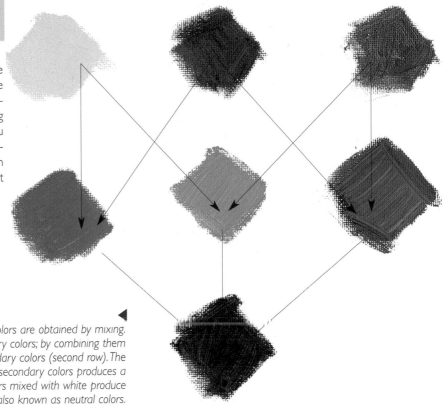

▶

*These examples show how colors are obtained by mixing. The top row shows the primary colors; by combining them we obtain the secondary colors (second row). The combination of two or more secondary colors produces a tertiary color. Tertiary colors mixed with white produce broken colors, also known as neutral colors.*

▶

*There is no precise color for painting an orange or a tree. Unintentionally, we tend to relate a color to a specific object. For instance, when we think of an orange, the first color that comes to mind is orange, but this is not altogether true. The color of any object is made up of many other colors; furthermore, the light that envelops an object makes a color tend toward one tone. The orange's skin may very well be orange, but only under certain conditions. For instance, placed next to a blue object its shaded area will no longer be orange but will take on bluish and even violet tones.*

19

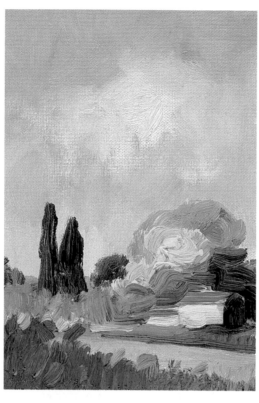

## HARMONIC RANGES

Colors can be organized according to their range and tone. They are divided into three basic ranges: cool, warm, and neutral. The colors belonging to the warm, range are those that appear to give off heat, in other words, red, pink, carmine, orange, and their mixtures. Other colors considered warm are earth colors, such as brown or ocher. The cool range of colors includes green, blue, and violet. The colors corresponding to the neutral range comprise gray or "dirty" tones that are the result of mixtures made on the palette.

▶ *Warm range colors are formed with carmine red and yellow, but by combining them with earth tones, an extremely wide range of tones can be produced. Therefore, the warm range of colors extends to yellow, orange, red carmine, and the so-called earth colors: ocher, sienna, and burnt umber. Cool colors like green have been combined with red to make them warm.*

Neutral colors, also known as broken colors, comprise dirty undefined colors. When a „dirty" color is added to clean or pure colors, the result is a dirty blend but, when this range is used exclusively with neutral colors, a pictorial range of stunning beauty is achieved. A neutral color is obtained by mixing two secondary colors together and then adding white.

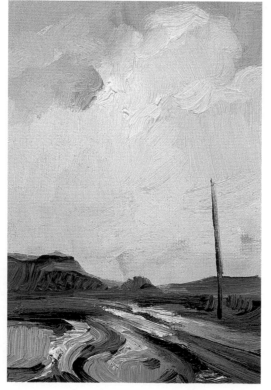

▶ *The basic colors comprising the cool range are greenish-yellow and blue; but if we combine them together, we can obtain a very wide chromatic scale. By combining different amounts of red, a range of violet tones is produced. Therefore, the cool range of colors comprises tones of green, greenish yellow, and violet.*

# *Step by step*
# Landscape with basic colors

With only three colors and white, we can obtain most of the colors existing in nature. To demonstrate this, we have chosen this cliff top as our model. It is important to pay close attention to each step and not become discouraged. In the initial roughing out, the brushstrokes may appear akward; but this is normal. If you carefully follow the instructions explained in each step, this exercise will be easy. Pay special attention to the color mixes produced on the palette.

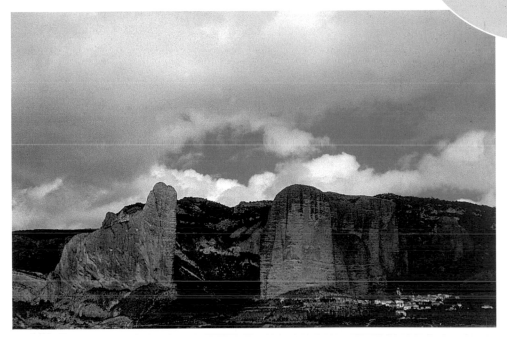

## MATERIALS

*Palette, oil paints: white, blue, carmine, and yellow (2), hog's hair brush, (3) canvas-covered cardboard (4), and dippers: one filled with turpentine and the other with linseed oil.*

**1.** *First, dip the brush in turpentine and wring out excess liquid to prevent dripping. Then, using a little blue, begin to draw the brush over the canvas-covered cardboard. Paint the outline of the cliffs first. If you make a mistake, the oil medium allows you to make as many corrections as necessary. Paint the hollows in the clouds last.*

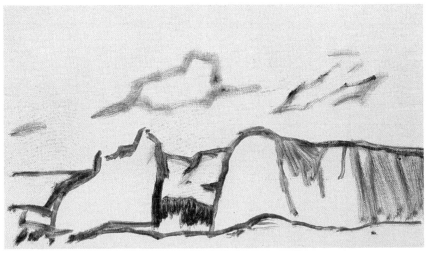

# STEP BY STEP: Landscape with basic colors

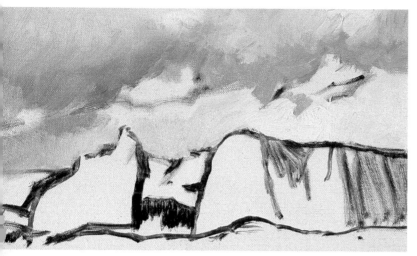

**2.** Blend a little blue and white together on the palette. The mix should contain more white than blue. A touch of blue is enough to give the white a cerulean tone. Always start in the uppermost part of the sky, where the white of the clouds is clearer. As the shapes of the clouds are defined, add a touch of carmine to the mix; the tone obtained is akin to violet. Paint the darkest areas of the clouds with this tone.

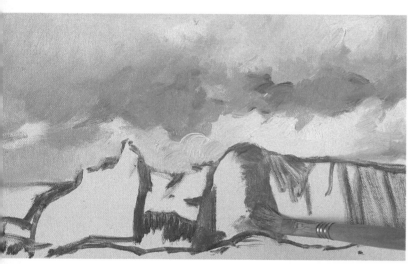

**3.** By combining blue with white, we obtain a cerulean tone that is much darker and more luminous than the color of the clouds. This new mix does not include carmine. Use this blend to paint the blue of the sky. Then, with an almost pure white, paint the tops of the lowest clouds. For the cliffs, start with a mixture of carmine and yellow to obtain an orange tone, and then add a hint of blue to "break" the mix.

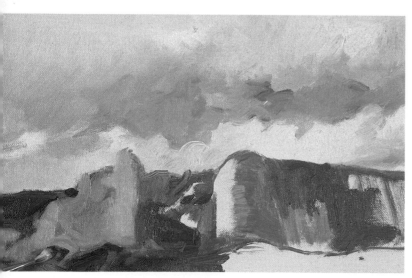

**4.** Paint the right-hand side of the cliff with various colors obtained from mixes made on the palette: blue mixed with yellow produces green; blue mixed with carmine produces a violet color with a tendency toward one or the other color, depending on the proportions used. By blending a touch of yellow and carmine you can obtain red, but if the amount of yellow is increased, it turns orange. A touch of violet added to the green produces the broken color on the right-hand side of the cliff. To apply lighter tones to the left-hand side, we first created a yellowish green tone, to which we added orange. Finally, white was added to lighten the tone slightly.

**5.** *In the previous step, we mixed broken colors together. The contrasts of the craggy cliff face should be painted with darker broken tones than the ones previously applied to each area. The brightest area of the cliff is painted with a pinkish tone obtained with carmine and white to which a touch of yellow has been added.*

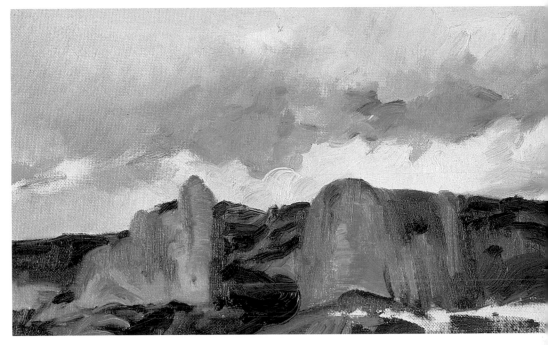

As the canvas advances, the layers are applied more densely without adding any turpentine to the mix.

**6.** *The range of greens of the lower area is slightly broken. The first green has been obtained from green and yellow and blue, the result of a homogenous mix made on the palette; with carmine and some white the color has been turned into an earth color. The tone varies in some areas, and is even mixed with blue. The houses situated below the cliff are painted with several small patches of white, dragging some of the underlying color with it so as to obtain slightly dirtier colors.*

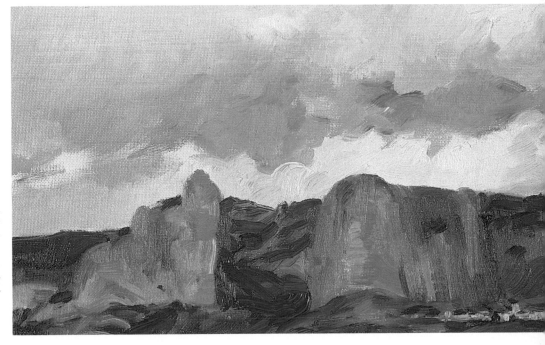

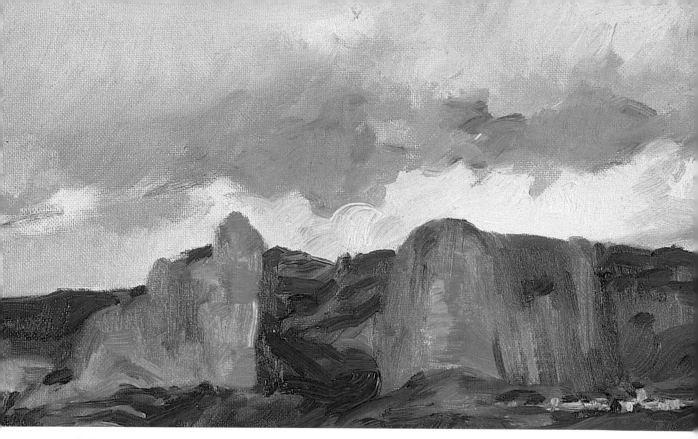

**7.** *All that remains now is to increase slightly the contrasts of the cliff with the darker tones. These same dark tones are used around the little houses, so as to make* *them stand out even further. This simple landscape shows you how easy it is to paint a picture based on mixes obtained from primary colors.*

## SUMMARY

**The whitest aspect of the clouds** is comprised mainly of a large proportion of white and a small touch of blue.

**The lightest tones on the right** were grayed with white.

**The greenish tones in the lower part** were painted with bluc, yellow and a touch of carmine.

**The orange tone of the cliff** was painted with carmine, yellow, and a dash of blue.

**The preliminary outline** was painted in blue.

**The village** was painted with tiny touches of white.

# 2

# The brushstroke

## BRUSHES AND THEIR IMPRESSION

The impression or mark that paint leaves on a surface depends on the instrument used to apply it. In this chapter we will first deal with the effects of different kinds of brushstrokes and then move on to their practical use. As we have seen in the first section of this book, there are many kinds of brushes, each with its own characteristics and uses.

> Oil paint is sticky to the touch, but it is also soft enough to be able to mold it with a brush. The paint saturates the brush and permits the tip to interact with the canvas in a variety of ways. A brushstroke can create lines, smudges, and a number of effects that, when viewed together, allow for numerous types of textures.

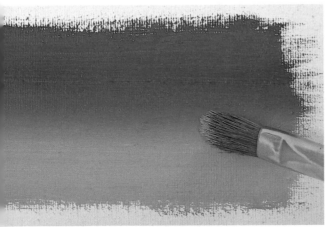

▶ 1. *After dipping the brush in oil paint, we place the tip on the canvas and spread the color over it. The length of the line depends on how much paint the tip can hold. For this reason, there are different kinds of brushes for different types of effects. This picture shows a line painted with a small, flat brush. Flat brushes leave a line with an even, regular edge.*

*2. In order to produce a smooth gradation between two colors, the two original colors must be kept perfectly clean and free of any other color before their edges make contact. This permits us to add several tones on top of these colors.*

▶ 3. *The two colors are blended by passing the brush several times over the two freshly painted colors. Use long strokes that merge a part of one color with the other. After several horizontal strokes without adding more paint, the two colors will blend together in soft, progressive gradation.*

## THE USE OF BRUSHES

Some areas of a painting may require brushstrokes that allow the colors to blend, whereas others need brushstrokes that are superimposed on one another, leaving small, clearly distinguished lines. These different types of lines can be painted easily if the correct type of brush is used. Some brushes allow you to rough out the surface with patches of color, and others with small dabs. Still other kinds of brushes are ideal for creating large, uniform surfaces. As we will see in this section, there are brushes for every type of line, and after all, lines are the main technique in painting.

▼ 1. *This is a simple exercise that consists of practicing brushstrokes and changing from one color to another by adding a second color to the first on the palette. Paint a yellow line with a flat brush. Then add a bit of red to the yellow paint on the palette and mix them. With the resulting orange paint, apply another stroke on top of the first. Avoid using repeated strokes, which would start to pick up the color underneath. In this exercise, the brushstrokes should end straight. The procedure creates on accumulation of small strokes with decreasing amounts of yellow until they finally are completely red.*

The brushstroke can vary according to the thickness of the paint, the drag of the brush, and the condition of the underlying layers of paint. By taking these various factors into account, we can blend the different colors or apply them one on top of the other.

**3.** *Brushstrokes can produce an infinite variety of appearances depending on how the brush is applied over the colors. The line can be soft and barely show the grooves from the bristles, or the brush can be used to daub on blotches of color, as in this illustration. Here the strokes are small and pasty, and they are superimposed on top of one another.* ▲

▼ **2.** *These brushstrokes, painted with a filbert brush, end differently than the previous ones. This technique uses cool tones. First, paint strokes with blue paint that has been lightened by adding white on the palette. Paint dark blue over this without mixing the colors. From this point on, add new tones without mixing them with the previous ones. Compare the results of this exercise and the previous one.*

# STROKES AND PATCHES

Each brush has its own characteristics, which are expressed when it is applied to the canvas or on top of other colors. In this exercise we will use different techniques for blending colors, as well as different types of strokes, to create different parts of a painting. This simple exercise will highlight the uses of each type of brush in terms of its impression and how it is used to blend.

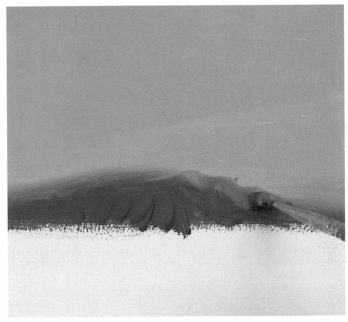

*1. The largest areas should be painted first. Before painting them, consider what the next color will be, so that the two tones can be blended or superimposed. When painting the larger area, keep in mind where the next color will begin.*

▲

▼

*2. Just as we blended the patches in the first part of the chapter to form a gradation, this exercise calls for a blend at the boundary between the two areas. To do this, use a medium-sized brush instead of a large one. This will allow a discrete blended area where one color mixes with the other.*

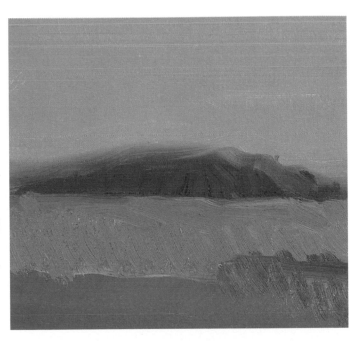

◄

*3. The foreground also has two colors, but there is no gradation between them. Not all parts of a painting require the same treatment: some require gradations, while others require the colors to be superimposed.*

▶ **1.** *Since the preliminary sketch reveals that the sky occupies a large part of the landscape in this composition, it should be painted with a large brush. With just a few brushstrokes we can cover this area of the canvas, including the contour of the sky above the mountains. Use long, uniform brushstrokes, and avoid leaving lumps of paint on the canvas.*

# APPLYING IMPASTOS AND BLENDING

A brushstroke can produce many different effects, depending on how it is applied across the surface and the amount of paint used. If we use thick brushstrokes on a freshly painted surface, the stroke will move some of the underlying color along the new line. If, on the other hand, the brushstrokes are precise and do not drag on the wet paint, there will only be a minimum of blending between the two tones.

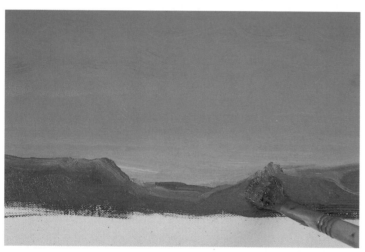

▶ **2.** *Any medium-sized brush is suited to this part of the painting. A flat brush or a filbert brush will work equally well. First, dip the clean brush into a bit of white paint and use long horizontal strokes on the blue background. Paint the mountains in the background with burnt sienna. Blend part of the blue paint from the sky into your stroke when painting the top edge of the mountains: this will add texture to the painting.*

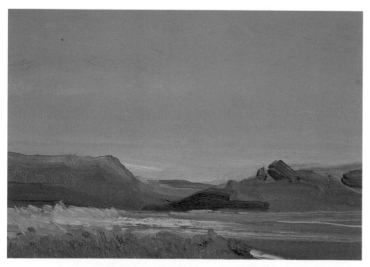

▶ **3.** *Use a small brush to paint the distant parts of the landscape. Combine green, yellow, and brown, and paint with long brushstrokes. By superimposing and dragging the brushstrokes, the tones and colors will blend. Paint the foreground in bright green, applying the paint with a medium-sized brush and using long strokes. This area shouldn't be covered with a thick coat of paint, but rather covered with color as quickly as possible. Add texture to the grass by using short, vertical brushstrokes.*

# Step by step
# Fruit

Here is a simple exercise in terms of both drawing and composition. The shapes in this still life are all extremely simple and based on circles. The exercise allows you to practice with several types of brushstrokes and color. In contrast with the previous exercise, we will deal with the shapes and take a close look at the brushstrokes involved in a step-by-step analysis. In order to simplify this exercise, we will use a very limited palette of colors.

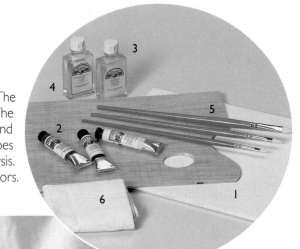

## MATERIALS

*Canvas-covered cardboard (1), oil paints (2), linseed oil (3), turpentine (4), paintbrushes (5), and a rag (6).*

1. *Since the preliminary sketch of this still life is extremely simple, it can be drawn directly with oil paint instead of pencil. A more complex composition would require a preliminary sketch of the main contours using any type of drawing medium. Sketch the outlines with heavily diluted paint. Add the three pieces of fruit using quick, approximate strokes. There is no need to erase any mistakes: the lines can simply be covered over again.*

**2.** *Once the fruit has been sketched, we can start with the first colors. The first step is to color in the background. A neutral color is a mixture of the dirty colors on the palette. If the palette is still clean, it can be made by mixing green, umber, and white. Paint the area corresponding to the shadow of the pomegranate and upper part of the plum. The most illuminated part of the pomegranate should be shaded with violet carmine, leaving the area of the reflection white.*

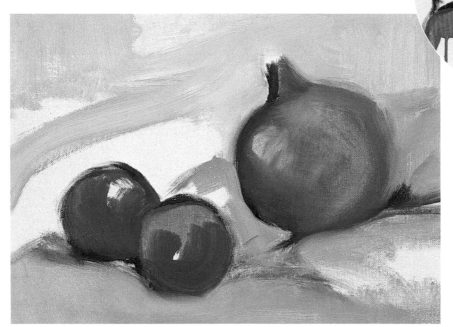

**3.** *The plums are painted with the same violet carmine that we used for the pomegranate. The gray area of the right plum separates the two pieces of fruit. Run the brush over the pomegranate several times so that the colors blend. This will also give the fruit its spherical shape. Start painting the tablecloth with more white and violet carmine, green, and blue, without letting the colors mix completely on the palette.*

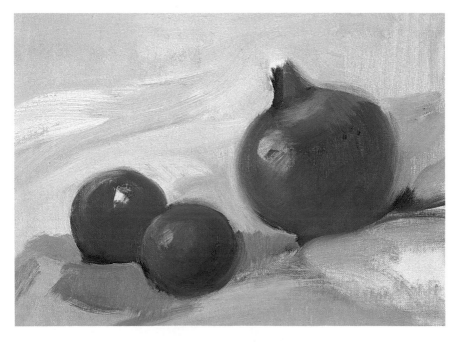

**4.** *Use curved strokes to bring out the spherical shape of the pomegranate. When the brush passes over the gray area the color will lighten slightly, as it removes some of the underlying colors. Now is the time to start separating the illuminated areas with touches of dark violet mixed with cobalt blue. Use this same color mixed with a bit of ultramarine blue to paint the foreground. These brushstrokes will also pick up some of the underlying color.*

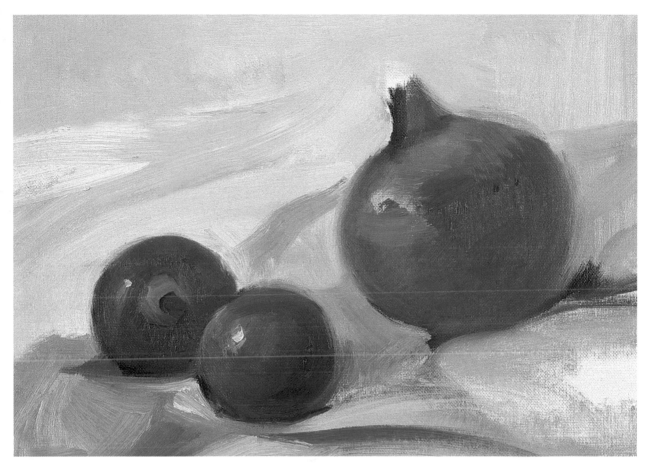

**5.** *Resolute brushstrokes of carmine should be applied to the plum on the left. The colors on the right side of the painting tend to be cooler and bluish, whereas on the right they are much warmer. The highlight should be the main reference for positioning the darker tones. The bluish tones on the brighter side should be slightly lightened with white. Paint the more illuminated parts of the pomegranate with violet carmine lightened with white. Bluish lines mark the folds on the tablecloth.*

**6.** *In this detail we can see the lighter tones, which define the shaded area. The brighter colors on the pomegranate range from white, at the brightest reflection, to a complete gradation of carmine. There are a few touches of blue near the main highlight.*

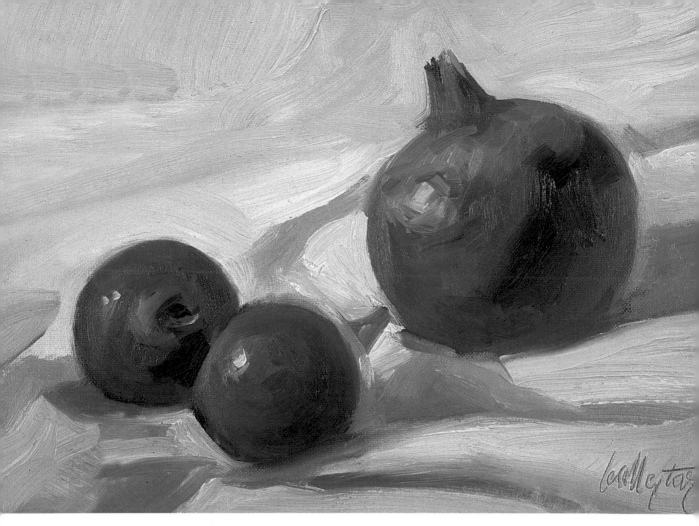

**7.** *On the pomegranate, the highlights can be enriched with tones of orange that contrast with the red and pure carmine. In order to do this without changing the color to pink, we use Naples yellow instead of* *white. The dark parts of the plums completely define their spherical shape. This puts the finishing touch on this exercise, which involves a great variety of both direct and blending brushwork.*

## SUMMARY

**The preliminary sketch** was painted directly with a paintbrush and oils. The brushstrokes should be free and very diluted.

**A very diluted grayish color** was used to paint the plum on the left and the pomegranate. Some tones blend in this area.

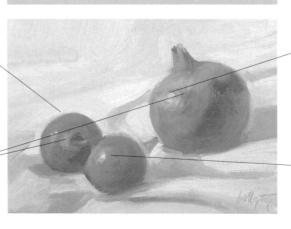

**The areas of reflection on the plums and the pomegranate** were left unpainted so that they could serve as a reference point. The reflections are later painted with bright dabs of color.

**The dark area of the plum** was painted with dark violet and cobalt blue. Repeated brushstrokes were used to make the tones blend with each other.

# Blocking in
# and planes of objects

## BLOCKING IN AND COMPOSITION: OILPAINTS AND CHARCOAL

The blocking-in technique consists of simplifying the complex forms of a model. The first step is to look carefully at the shape of a model and try to find the simplest lines that could define it. In these exercises we will see how different motifs can be developed by blocking in their essential lines, and how objects can be understood through simpler elements.

> A painting should be understood as a succession of objects located on different planes, even though only a couple of them need to be shown. When composing a painting, it is essential to observe the location of each element from the beginning. Representing a model in a painting can be a very complicated task if you start painting directly without previously blocking in the objects. The blocking-in technique allows the artist to synthesize the shapes of reality, transforming them into simple objects that can be easily drawn.

▼ 1. *This sketch shows the logical location of the objects in the painting. The still life will evolve from these simple drawings. Each block will contain a fully developed element in the final painting.*

*3. Once the main forms have been blocked in, you can start applying colors. This application is gradual and must conform to the way in which it was blocked in from the start. The nearer planes should be given more detail than the most distant ones.*

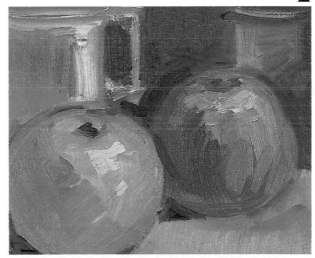

▲

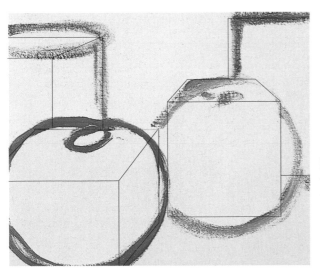

▶ 2. *The still life will be based on the previous sketch. Start by painting the foreground, using a reddish color. The drawing technique should be fast and direct. Use a brush with turpentine to paint the first element: a circular shape that will eventually be a piece of fruit. The turpentine will help the color to spread quickly over the cardboard-covered canvas. Use an orange tone to draw another sphere in the next plane, slightly higher than the first. In the background, sketch in the containers in brown, using very basic lines.*

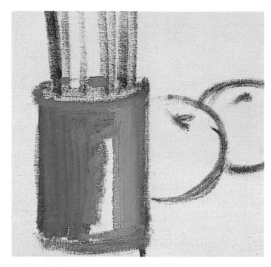

▶ 1. *The first thing to do is to establish the shapes that make up the simple elements, such as a rectangle and two spheres. The foreground is always what determines the rest of the composition. The rest of the objects should be arranged in reference to this. Once the still life has been sketched, paint in the foreground. Different tones should be used for the other planes so that there is a contrast between the closer and farther objects.*

## BLOCKING IN SHAPES AS GEOMETRICAL FIGURES

When painting with oils, an artist generally starts with the general and works towards the specific. In other words, the first strokes constitute a rough sketch of the basic shape, which will later be filled in with detail. The first colors applied are also general: the details are left for later. Blocking in and applying patches of color are two closely linked concepts in the evolution of a painting.

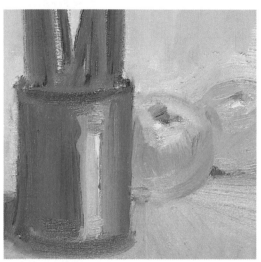

▶ 2. *Thanks to the preliminary blocking in and the first applications of color, the object painted with oils can be outlined or suggested with loose strokes that mix with the background colors. Planes surrounding the foreground should be painted in clearly differentiated tones. The main subject should stand out against the background.*

The thickness of oils allows brushstrokes to create blends with only the color applied to the canvas. Having passed the brush several times over an area, it is possible to break the form of the background and make the planes of the shapes look as if they were out of focus.

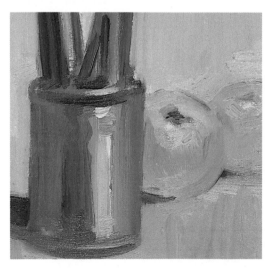

▶ 3. *This exercise illustrates the importance of blocking in the first stage of the painting process. A sketch can sometimes be so essential that it would be impossible to develop the painting without one. Once you have applied color to the perfectly defined shapes, blur the profiles of the pieces of fruit in the background. This will increase the difference between the two planes.*

## TAKING ADVANTAGE OF BLOCKING IN

Blocking in is one of the most important aspects of painting. In fact, a correct blocking-in procedure is the first step in any kind of painting, no matter what technique is being used. This quick exercise deals with how to apply brushstrokes in the foreground after the main sketch. This will show how to take advantage of the sketch and develop it into a complete picture.

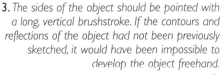

*1. After the main shape has been blocked in, fill in the interior with the colors that will make up the color base. This will establish a clear difference between the areas of light and shadow. In this simple sketch, the areas of light remain unpainted.*

*2. On top of the first patches of color, apply short, horizontal brushstrokes to the front part of the object, which is also the brightest. It is essential to respect the shape of the sketch in spite of any modifications that may be made to the interior of the objects, since this is a detail of what might be a more complex still life. The preliminary sketch allows us to define each of the shapes and planes of the object.*

*3. The sides of the object should be pointed with a long, vertical brushstroke. If the contours and reflections of the object had not been previously sketched, it would have been impossible to develop the object freehand.*

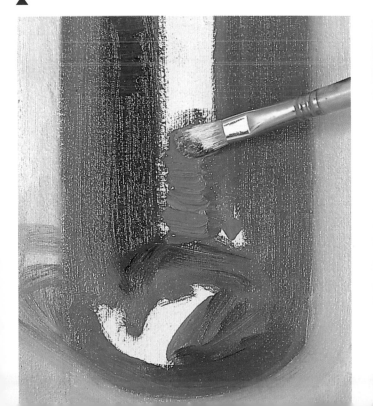

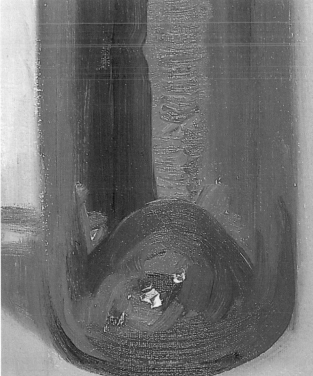

## A SKETCH FOR EVERY METHOD OF WORK

The position of various objects in the painting allows the artist to assess the different possibilities in terms of the composition of the elements that make up the whole. How detailed the sketch needs to be depends on the precision each element requires.

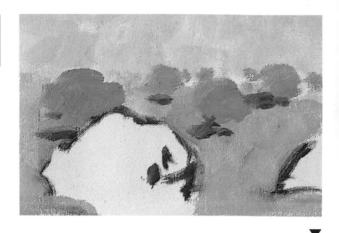

▼

*1. The first sketch of this simple landscape allows us to put each element in its place and establish the various highlights.*

*2. With oils, a light sketch is enough to sum up the shapes. The shapes in the background can be suggested with vague patches, whereas the contours of the objects in the foreground should be given more detail. The shapes in the background should also be smaller than those in the foreground. Shapes should be suggested with fresh, direct brushstrokes.*

▲

▼ *1. The most important highlights are treated with direct dabs of color or pure white. This characteristic will determine how the model is sketched. After sketching out the main shapes with free strokes, darken the background to isolate the main highlights, which in this case are focused on the objects.*

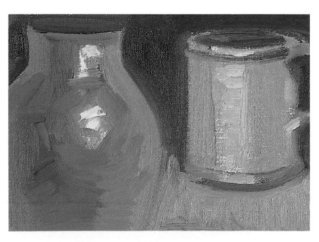

▶ *2. The dark background painted in the first step of the sketch has isolated the main elements, perfectly defining their shape. The highlights are painted with free brushwork that does not mix with the underlying colors. Now the color and reflections can be established in the foreground. Sharp contrasts are created by alternating dark and light tones. This juxtaposition highlights both the light and dark tones.*

# *Step by step*
# Bottles with tablecloth

The sketch of the model is the first step toward the painting. Even the simplest subject should be prepared using this process, which consists of correctly positioning the main structural lines of the objects or shapes to be painted. Once the forms have been sketched, the closer planes will receive a more clearly defined treatment than the more distant ones. Each plane should be dealt with differently, in terms of both brushstrokes and color.

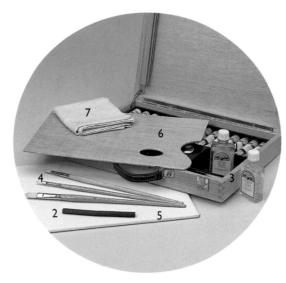

## MATERIALS
*Oil paints (1), charcoal (2), linseed oil and turpentine (3), paintbrushes for oils (4), canvas-covered cardboard, (5), a palette (6), and a rag for cleaning (7).*

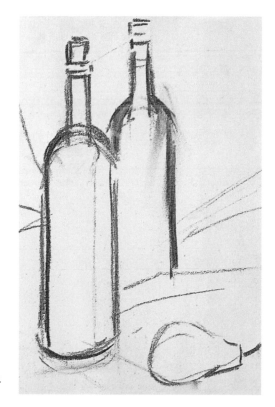

**1.** *The first sketch distributes and positions the various elements in the painting. The main elements of this painting are the brown bottle and the pear. The green bottle is located in a more distant plane. The sketch should be concise, with only the essential lines. The shapes should be sufficiently defined with the strokes, since symmetrical objects like the bottle are always more difficult to draw.*

# STEP BY STEP: Bottles with tablecloth

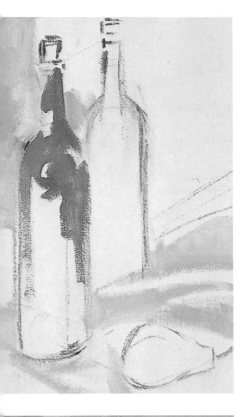

**1.** *Start painting the background area with blue mixed with a lot of white. The cloth in the foreground should be painted with a very dry brush, only suggesting the areas of shadow. Fill in the bottle in the foreground with a mixture of sienna and English red. This mixture should not be carried out on the palette, but rather on the painting itself, by dragging the latter over the former. When painting the bottle, leave the areas corresponding to the highlights blank. These areas will be painted later.*

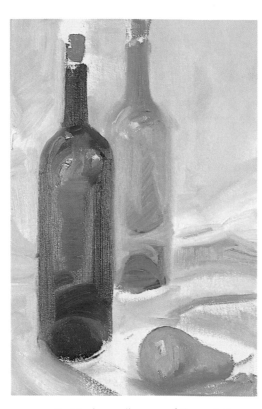

**2.** *Fill in the background with a bright mixture of cobalt blue, white, and Naples yellow. The neck of the bottle in the foreground should be painted with long, tightly-grouped brushstrokes. Use natural sienna for the central area of the bottle. Paint over the sienna with burnt umber, as well as English red mixed on the palette with some sienna. Then paint the pear in the foreground with bright yellow, Naples yellow, and green, using a purer green for the lower area. The bottle in the background should be less clearly defined than the objects in the foreground.*

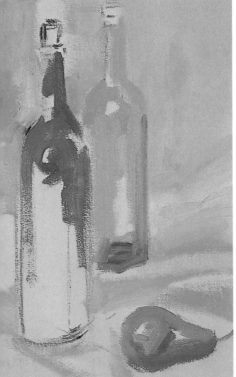

**3.** *Work on all areas of the painting at the same time. Paint the center of the bottle using downward horizontal strokes which mix with the umber color from the previous step. The lower part of the bottle should be painted with curved brushstrokes that blend together with the previous colors. The bottle in the background should be painted in a similar way, but limit the tones to greens that have been mixed with a great deal of white and Naples yellow.*

When defining the planes, choose the colors according to the placement of each object in the still life. If the foreground is painted in dull colors, it would be illogical to use bright colors for the background.

4. *This step illustrates the different ways that the objects have been dealt with up to now. In the first bottle, the color is contrasted: the neck is painted in dark brown, with long, vertical brushstrokes, whereas the center has short, horizontal brushstrokes, which make up a different plane. New planes are created in the body of the bottle: the center has short, red, horizontal brushstrokes, and the curved area has orange strokes that follow the shape. The reflection is painted in yellow.*

To make a distant plane merge with the background, run the brush over the contour several times until the outline becomes fuzzy.

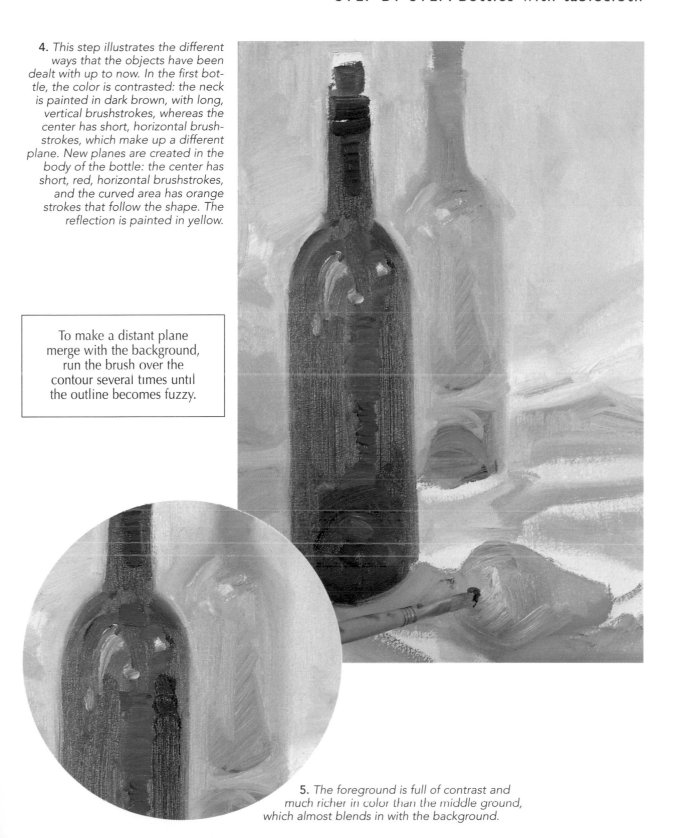

5. *The foreground is full of contrast and much richer in color than the middle ground, which almost blends in with the background.*

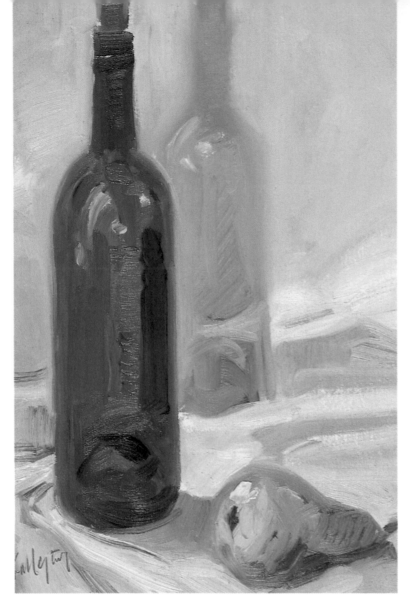

**6.** *Painting the tablecloth is simple, although the foreground requires more attention than the background. The preliminary sketch should have established the main lines, which will provide a clear path for the brushstrokes to follow. The light tones are much brighter and more pure in the foreground than in the background. Run the brush very lightly over the contours of the bottle in the background to give it an almost blurred appearance. This concludes this exercise in sketching and painting planes with oils.*

## SUMMARY

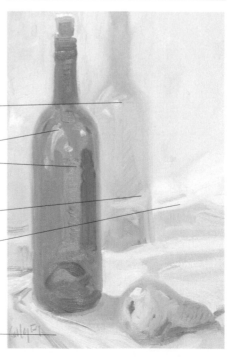

**The shadows and colors in the foreground** are strong and contrasted, whereas those in the background are soft and tend to blend in with one another.

The highlights on the **main bottle** were painted with strong, bright colors.

**Following the preliminary sketch,** the contours of the bottle in the background are blurred, without a clearly defined shape.

**In the background** the colors tend to blend.

**The tablecloth** is more clearly defined in the foreground. The lines are more precise in this part of the painting.

# Beginning a painting with diluted paint

## THE ORDER OF COLOR: FAT OVER LEAN

This section deals with a process which is essential when painting with oils. After the preliminary sketch come the initial applications of color. Although it might seem complicated at first, it will quickly become second nature. These should provide a base that is stable enough for the other colors to dry on naturally, and consist of very diluted colors in discrete tones.

One of the basic principles dealt with from the beginning of this book is that oil paints can be diluted with turpentine. This section will deal with a preliminary process using oil paint that has been heavily diluted with turpentine.

1. *After drawing the preliminary outline, divide up the areas of light and shadow. This is done with a brush dipped in turpentine and then in paint diluted on the palette. Use this color to paint the entire dark side of the subject. Don't worry if the brush strays into the light areas: corrections can be made by running a brush dipped in clean turpentine over the error while it is still wet. This is a simple and effective way to remove unwanted paint.*

▲

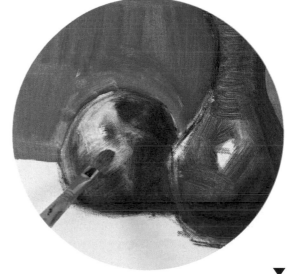

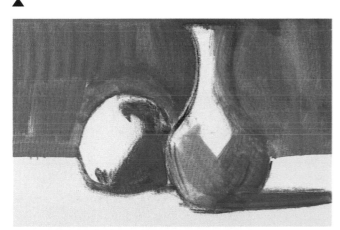

3. *Once all the areas of light and shadow have been situated on the canvas, continue roughing out with the brush soaked in turpentine. In order to open up a white, all you have to do is run the brush over the area in question to remove the previously applied color and thus obtain the white color of the underlying canvas.*

▼

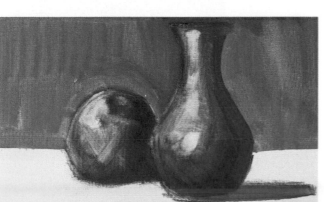

▶ 2. *Colors diluted in turpentine allow forms to be defined according to dark and light areas, which are virtually drawn by the deepest tones. The first applications made with very diluted paint, a technique also known as roughing out, define the main areas of light and shadow. These gray strokes are all that is needed to obtain the framework.*

## DILUTING THE COLOR ON THE PALETTE

Following the previous exercise, in which we painted a still life using heavily diluted tones, we will now deal with the next step in the application of color. In the first steps of an oil painting, the oils should be diluted in order to provide a base for subsequent layers of paint. This procedure also allows us to make any necessary corrections without wasting paint. The process of filling in the picture with color is part of the first application of diluted paint. Now we can dilute the colors on the palette to obtain sharper lines. If this procedure is carried out correctly, the painting will dry properly.

▶ 1. *Once the main elements of the model, the light and shaded areas, have been sketched using diluted paint, the next step is to apply slightly darker colors. This process should be repeated at each stage of the oil painting, and should be done progressively: first, fill in the lighter tones and then the darker ones, using fairly dry strokes with heavily diluted color.*

*3. The darkest contrast should be left for last. In this exercise, the darkest colors should be applied directly, without being diluted with turpentine. The brushwork is denser, and the colors should be mixed on the palette to maintain the purity of the colors.* ▲

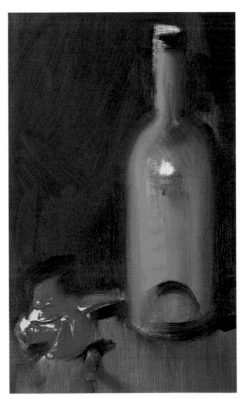

▶ 2. *When applying a brushstroke of dark color on top of a lighter tone, the stroke will pick up the underlying color, especially if it contains turpentine. With several repeated brushstrokes, the new color will blend in with the underlying tones. Apply darker brushstrokes, slightly diluted with turpentine on the palette, on top of the previously painted green color. Paint the flower with very bright pink, diluted with turpentine before applying the brush to the canvas. Use a very dark color for the shadow of the flower.*

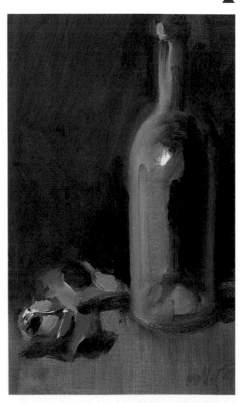

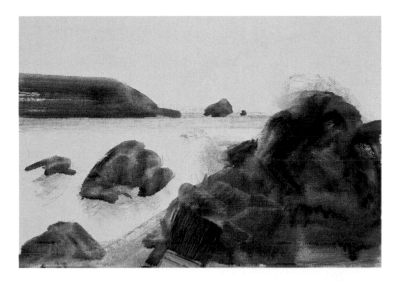

1. *The strokes of the wide brush are broad and sweeping, making it ideal for filling in large surfaces. Surprisingly enough, the wide brush permits a great variety of techniques, since its outline can be fairly precise. Dragging the wide brush also quickly blends the diluted tones of the painting.*

## APPLYING PATCHES OF COLOR AND USING THE WIDE BRUSH

The wide brush is one of the most practical tools for any painting procedure. Despite its clumsy appearance, it facilitates the roughing out of the picture with diluted oils by providing a quick method especially suited to the first stages of painting. This simple exercise consists of practice with the wide brush, working on techniques that can be applied to any subject, especially during the preliminary stages of roughing out the picture with color.

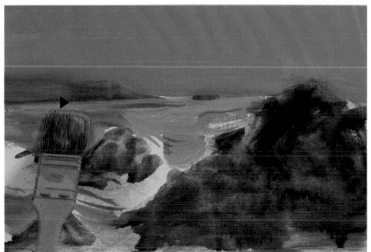

2. *Once the main areas of the picture have been colored in with heavily diluted paint, we can start on more detailed brushwork, such as defining the outlines which are now more clearly visible. The wide brush permits a wide variety of brushstrokes, although it is obviously not wellsuited to detail work.*

> Old wide brushes should never be thrown away, since they can produce brushstrokes that are impossible to perform with new brushes.

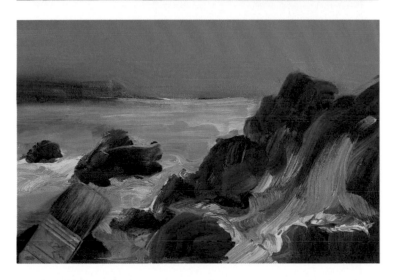

3. *After roughing out the painting color, the shapes can be defined using darker tones, employing different part of the brush to create a variety of strokes.*

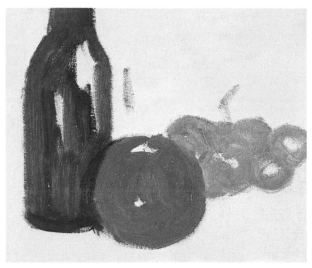

▶ 1. *Using paint which has been slightly diluted on the palette, sketch out the bottle and the grapes and fill them in with color. Two easily distinguishable tones of green are used in this preliminary sketch, which includes no details of the shapes, although the highlights should be left blank. A brightly colored orange serves as a point of contrast.*

## PAINTING THE CANVAS WITH PATCHES OF DILUTED COLORS

When painting a picture, the colors should always be applied progressively, using the fat-over-lean principle, even when the tones are highly contrasted. The sketch and the roughing out of the subject should be painted quickly and freely, painting both the shapes and the colors at the same time. This is the greatest advantage of oil painting over other media: it allows us to build up the painting progressively, using patches of diluted color.

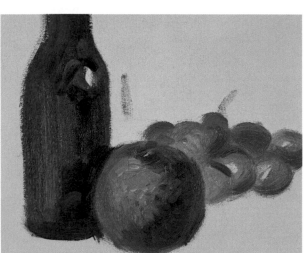

▶ 2. *The tones can be corrected during the preliminary stage of filling in with color. Since both the colors and shapes have been painted in unison, the colors can be corrected as you work. At first, the bottle was a dark green color. However, repeated applications of increasingly thick paint changed the tone progressively to a blue tone. A reddish brushstroke should be applied to the bottle. Use a combination of blue and orange, mixed on the palette, to give the orange its shape. The grapes in the background should be painted in a much brighter tone than the other colors.*

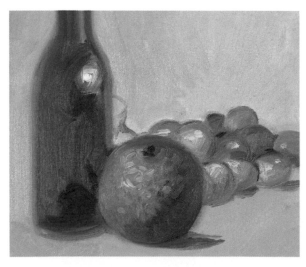

▶ 3. *The colors and shapes should be corrected progressively. Apply increasingly precise brushstrokes on top of the preliminary patches of color to gradually create the shape. The last stages of the painting process should be completely free of turpentine. With undiluted oil paint the brushwork can render a wide range of blends and dabs of color.*

# Step by step
## Still life sketch

Oils are one of the most noble kinds of paint. When dry, they maintain their bright color and freshly-painted appearance for years. This is only true, however, if the painting has been properly created using the techniques described in this section. The first step should always be to fill in the painting with patches of diluted color, and each successive application of paint should be less diluted than the previous one.

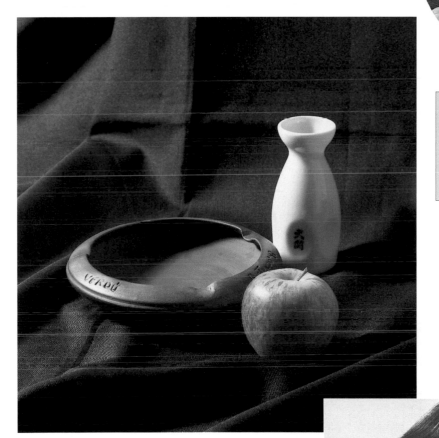

**1.** *The first layers of oil paint should always be more diluted than the later ones. Dip the brush in turpentine and dilute the paint on the palette. After removing the excess paint from the brush to keep it from dripping on the canvas, start to sketch out the shapes of each of the objects in the painting. Since this subject is fairly simple, it is not necessary to sketch the objects with charcoal first. As you can see, the dark background defines the shape of the vase.*

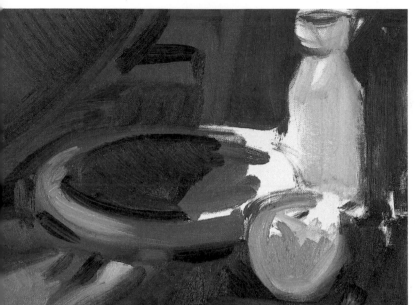

2. *The entire background is painted in a dark, still very diluted color, which is essential during the preliminary stages of roughing in the painting. In this way it can be easily corrected by dipping the brush in pure turpentine and passing it over the area that needs to be retouched. This is especially useful for opening up the main highlights on the painting. Accent the darker parts of the painting with a slightly thicker shade of violet. The white vase, on the other hand, should be filled in with an almost transparent tone. Next, apply the first thick and dense brushstrokes to the apple.*

3. *Now move on to the ashtray. Paint the interior with darker, less diluted colors so that the edge looks brighter by contrast. Colors mixed with a great deal of white and diluted with less turpentine can be used to paint the outside of the ashtray. Drag in part of the underlying colors when highlighting the curve.*

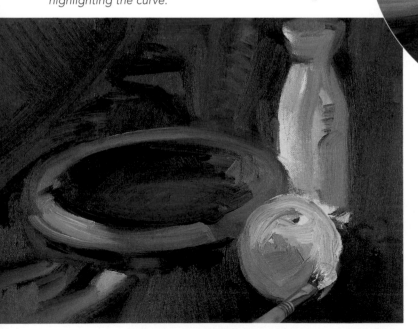

4. *The strokes should now contain increasingly smaller amounts of turpentine. In fact, once the painting has been entirely filled in, the paint can be applied pure, without any turpentine. The previous brushwork on the apple was already done without turpentine, so none should be used for further work on this object. If necessary, use linseed oil to make the paint more fluid. Apply reddish brushstrokes to the apple, mixing them with the yellowish colors directly on the canvas. The small white vase should be painted with bright, free strokes. Then add a highlight to the mouth of the vase to suggest its shiny surface.*

**5.** *Complete the painting by applying a very bright shade of white to the vase. Since the surrounding background is dark, the contrast makes the vase appear even more brilliant and luminous. Model the apple with repeated brushstrokes until its spherical shape is clearly represented. The successive strokes make the colors blend and turn orange in some places.*

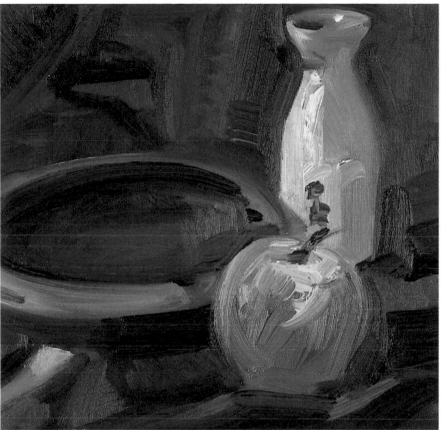

Never use regular paint thinner to dilute oil paint. The only acceptable product for this purpose is turpentine. When buying turpentine in a drugstore or hardware store, make sure that the label guarantees that it is pure turpentine, and not some other kind of solution or mixture.

**6.** *One of the advantages of oil painting is that you can constantly retouch the objects that are being painted. Nevertheless, make sure the layers are not too thick, since the resulting pasty mass will be difficult to work with. The oval of the ashtray can be corrected with repeated brushstrokes that put the finishing touches on its shape and volume. Similarly, paint the darker areas with successively superimposed strokes, each one thicker than the last, but not so thick as to create lumps.*

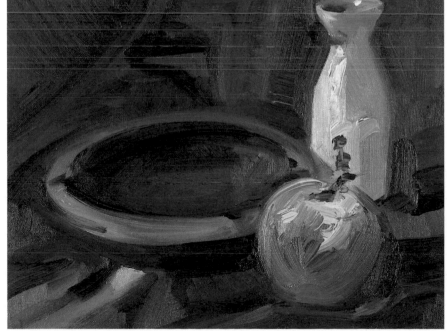

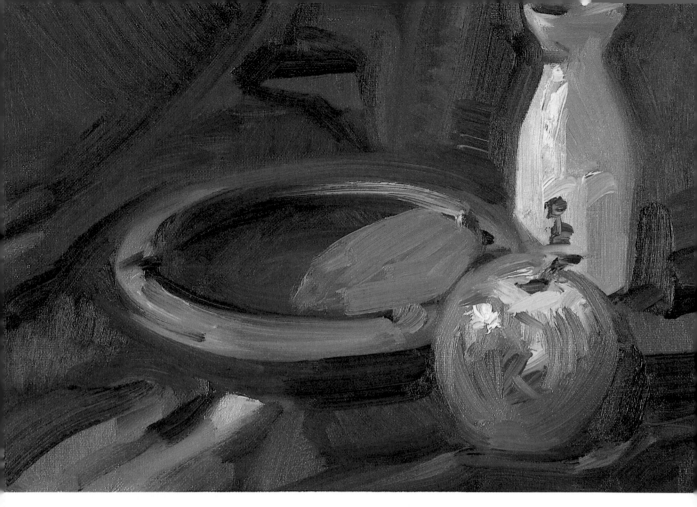

**7.** *Since the tones on the inside of the ashtray have too much contrast, they need to be corrected with a lighter shade of gray. This should be applied only to the high-lighted section of the ashtray. The contour of this object should be completed with long soft brushstrokes that drag in some of the underlying colors.*

## SUMMARY

**The preliminary sketch** was painted with highly diluted paint and very little variety of color. The color at this stage is, in fact, treated as if this were a drawing.

**The highlight on the ashtray** was done using free brushstrokes that drag in part of the underlying colors.

**Pure white paint** was used for the brighter

**The apple** was painted much more directly than the other elements. The mixture of the colors it is filled in with should be applied directly on the canvas.

**The layers of color** should be gradual. When roughing out the painting with color, remember the principle of fat over lean.

# The palette knife

## APPLYING IMPASTOS

This topic provides several exercises to practice working with a palette knife. Even though the palette knife is nothing more than a steel blade attached to a handle, this tool can perform various tasks, such as laying on paint, modeling, or applying impastos.

> **The palette knife is a tool used almost exclusively in the oil medium. Its variety of uses makes it an invaluable tool for the artist, and, though not as widespread as the brush, it can produce results that are just as interesting.**

▶ *The palette knife can be used to execute large impastos. The amount of paint needed must first be prepared before it is loaded onto the knife. Since oil paint does not shrink after drying, the form in which the impasto is applied to the canvas will remain intact after the paint has hardened.*

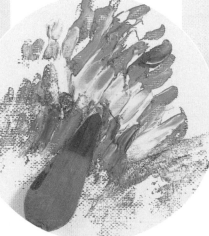

◀ *A color can be applied over another one in order to obtain unusual effects of mixed color. By drawing the palette knife flat over the paint with an even amount of pressure, you can create a smooth surface. Another layer of color can then be added. Thus, the texture created is smooth even though the colors will appear mottled and streaky.*

▼ *Textures like the ones reproduced here can be achieved with small quantities of paint. The most important aspect of working with the palette knife is the way in which the color is applied. Oil paint is very soft; even more so when it is manipulated with a metal instrument like the palette knife. The small amounts of paint can be applied consecutively, with soft touches that do not squash the color over the surface of the picture.*

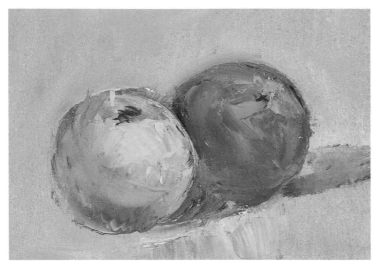

▶ 1. *As a beginning painter, you may experience the following more than once: at a certain stage in the development of your painting you are no longer pleased with the results. You cannot remove the paint with a brush cleanly anymore because it will cause the color to expand and dirty the areas that you do not wish to alter.*

## RECTIFYING

With oil paints, a color texture that is too complicated to correct with a brush is common. The palette knife comes in very handy for this purpose. The corner of the blade can be used to remove unwanted paint, provided it has not had time to dry. The following exercise demonstrates just one of the various ways in which this tool can be used to correct an error.

▶ 2. *The palette knife is a perfect tool for removing paint cleanly from any surface. Just scrape away the unwanted color using the corner of the palette knife as often as necessary until there is no paint left in the zone. Once the layer of paint or the impasto has been removed, the surface is free to repaint without the danger of the previous color mixing with the new one.*

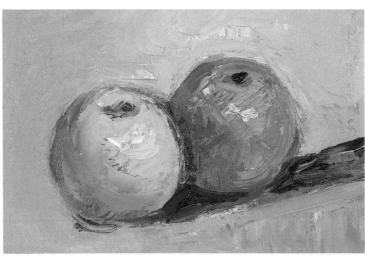

▶ 3. *The use of the palette knife enables you to open up the necessary space in the right area, without affecting adjacent areas that are considered correct. It is easy to repaint the form over the clean area in oils. As you can see, the new applications of color have successfully corrected the area in question.*

# THE USE OF THE PALETTE KNIFE

The palette knife is easy to use and highly versatile: it can be employed in as many ways as the brush, although the impression it leaves on the support is completely different. This simple exercise will highlight the basic uses of this tool. The way paint is applied and dragged across the surface of the canvas is important as well as the amount of preassure applied to the palette knife.

◄

*1. This example demonstrates a simple method to obtain special effects using the palette knife. After scooping up a regular amount of paint apply it to the canvas with the palette knife in long sweeping strokes. It is not necessary to create thick impastos with the palette knife; the normal procedure is to apply the tool softly over a freshly painted surface.*

◄

*2. The reflections on the water are painted by applying small touches of white with the palette knife. In this case, only the corner of the palette knife is used so as to leave just the right amount of paint on the surface. Compare this application of color with the one demonstrated in the last step; the texture of oil paint can be modeled very easily with the palette knife, often by dragging some of the underlying colors.*

> It is important to clean the palette knife thoroughly after each painting session. The best way to clean it, having removed any leftovers of paint, is by using a rag soaked in turpentine.

◄

*3. By holding the palette knife flat over the surface of the canvas, you can produce big impastos in the sky. As you can see, the application of one color over another always causes some blending This allows you to obtain a variety of effects, very different from those produced with a brush.*

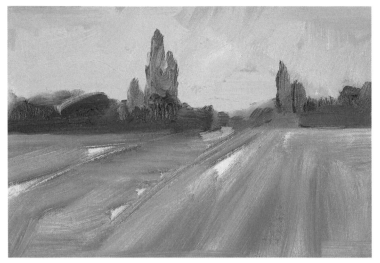

## THE TEXTURE OF OIL PAINT WITH THE PALETTE KNIFE

The palette knife is not only limited to a knife technique. It can be combined perfectly well with the brushstroke. In fact, the palette knife is used exclusively to lend a specific texture to the painting's finish. In this exercise you will learn how both techniques are combined, that is, by starting with the brush and then continuing on with the palette knife.

▶ 1. *The first step is to obtain the basic outline of the subject with a brush. As previously demonstrated, the first applications ore diluted with more turpentine than subsequent ones. The brush is much easier to control than the palette knife, and thus allows the painter to obtain a more detailed base in less time. If you do plan on using the palette knife in your work, it is best not to apply thick impastos with the brush, since this is precisely what the palette knife should be used for.*

▶ 2. *Having roughed out the canvas with the brush, begin applying impastos using the palette knife. The techniques demonstrated up to this point can be used, but care must be taken when dragging the color, because if the initial applications are too diluted, it may be difficult to lay the point correctly with the palette knife.*

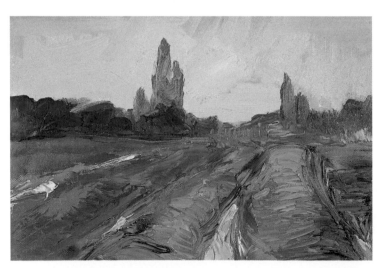

▶ 3. *The finishing touches on the painting, as well as the textures produced in this case on the field, were done exclusively with the palette knife. This exercise demonstrates the wide range of techniques possible using this tool.*

# *Step by step*
# Landscape

Landscapes are the best motifs for practicing with the palette knife. They provide a space to work freely with impastos and dragging techniques. Unlike other genres, landscapes can be adapted according to the tastes of the artist. For instance, the color of the model and even the proportions of some of its elements can be changed without detracting from the final result.

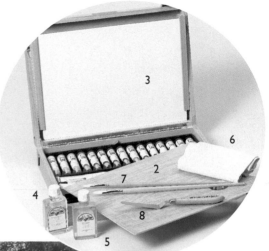

## MATERIALS

*Oil paints (I), palette (2), canvas-covered cardboard (3), linseed oil (4), turpentine (5), rag (6), brushes (7), and palette knife (8).*

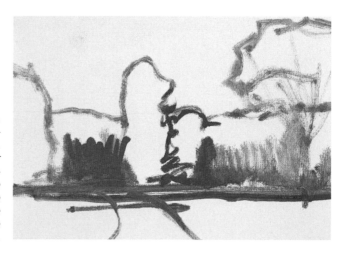

**1.** *Before you begin painting with the palette knife, you must first rough out the most important elements using a brush thinned with a little turpentine. It is important that the brush be merely damp rather than wet, so that the color does not run over the surface of the canvas. The first impression left on the canvas should indicate clearly the main areas of the landscape. Its structure is very simple: above the line marking the end of the field, several dark patches are applied to indicate the area below the trees.*

53

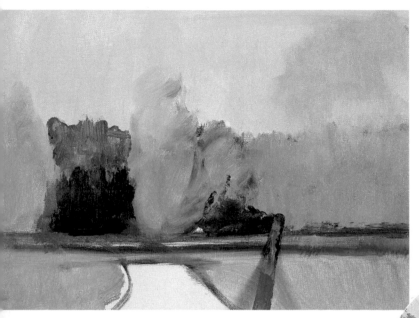

**2.** *Continue to use the brush, applying the colors with a little turpentine, but be sure to squeeze out excess paint with a rag before touching the tip on the canvas. The tones used in this stage include a wide variety of greens. After filling in the background, begin work with the palette knife. Load some cobalt blue onto the tip of your knife and apply it below the trees to represent shadows.*

**3.** *After adding the dark tones that define the first contrasts in the trees, paint the lightest areas with tiny impastos. These new applications will blend with the underlying colors. Enrich the greens on the palette with tones of yellow and ocher. The dabs of luminous green painted in the foliage on the right are pure color applications. The palette knife can also be used to paint the sky, using the same color as before, this time thinned with turpentine.*

**4.** *Continue painting the trees with tiny impastos of yellow, green, and blue. The various dabs of color create contrasts and differences in dimension. The darkest tones outline the lightest areas. Thanks to this contrast, the brightest areas can be clearly distinguished as points of light in the vegetation. Now we are ready to paint the path.*

**5.** *Paint the entire area with the palette knife; it should be applied much flatter in the field and path than to the texture of the trees. Using the same colors, shade the areas of foliage before defining the trunk.*

The most precise applications done with the palette knife are those that correct and form the details of the painting. For this reason, they are added toward the end of the session.

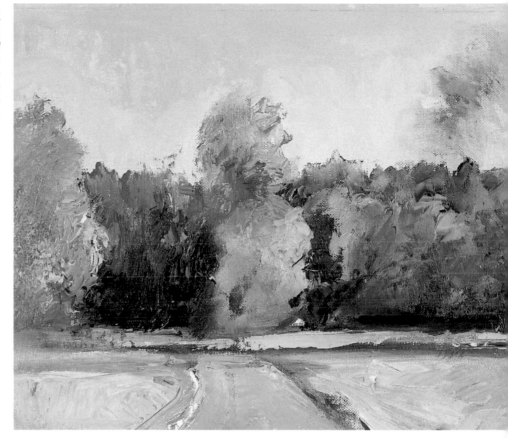

**6.** *Contrast the darkest areas of the trees with a very dark blue. Then use the tip of the palette knife to sketch the shadows on the field. The drag of the palette knife makes the blue mix slightly with the underlying tones. Once again, use the tip of the palette knife to scratch the surface of the still wet paint in order to draw the main branches of the tree on the right.*

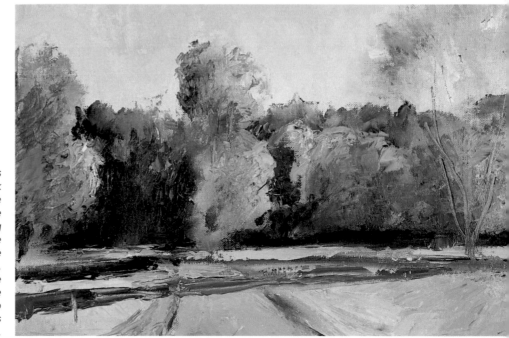

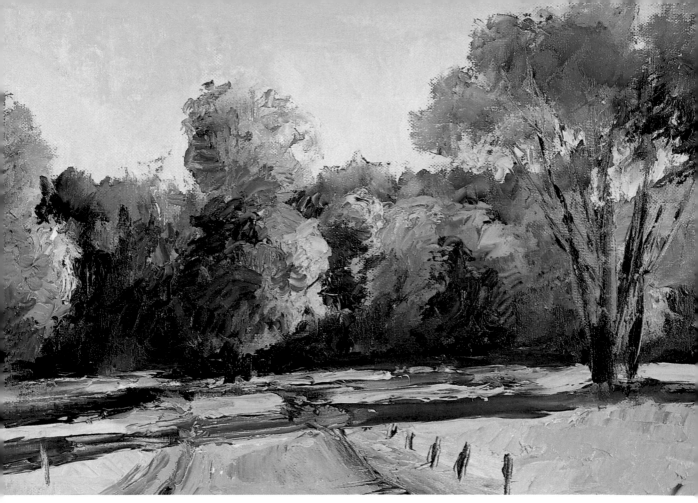

**7.** *Apply the final contrasting colors to the trees. These dark areas bring out the most luminous tones. Paint the posts of the fence leading down the path* *with the tip of the palette knife. All that remains is to paint the definitive contrasts with the tip of the palette knife using dark blue.*

## SUMMARY

**The preliminary outline** was sketched with a brush dipped in dark blue thinned with turpentine.

The first applications of the palette knife define **the dark areas between the trees.**

**The texture of the trees** was created with tiny dabs of pure color.

**The tree on the right** was drawn by sketching with the tip of the palette knife directly on the canvas.

**The path** was painted with very flat and sweeping applications of the palette knife.

# 6 Applying the color base

## COLORING THE BACKGROUND AND SUPERIMPOSING PLANES

Applying a color base is a simple way to obtain a background against which you can develop painting. It is always advisable to color the canvas with undefined brushstrokes prior to painting. It is essential, however, that these first layers, as well as the brushwork, be correctly applied. In this exercise we suggest a simple experiment: create a floral background and superimpose a flower in the foreground.

After the preliminary wash with highly diluted color, continue to define the forms and spaces. The opacity and texture of oil paint make this process a form of painting in itself, though still far removed from the perfection of the final product. There are as many ways to apply this color base as there are subjects; in this topic, we shall look at several of them.

1. *To suggest a plane of depth in a painting, an object in the foreground can be highlighted in perfect detail. This background of blue and crimson flowers toned down with white was created with free brushwork without detailing the form of the flowers; in this way, a background which appears slightly out of focus is obtained.*

▲

2. *Against this background, paint a flower with bright, pure colors that are not toned down with white. The brushwork suggests movement, as it has spread out some of the colors in the background. The preliminary application of the background provides a perfect chromatic base over which to paint the new lines that define the form of the petals.*

▲

▶ **1.** *After drawing in the forms, begin to cover the canvas with paint. These preliminary bands of color are intended to cover the different areas of the painting as quickly as possible. It does not matter if this process covers up the original drawing, as this can be restored later. In any case, this preparation of the background should be done with fairly thin paint, so that the underlying drawing remains visible.*

## DILUTED AREAS

Earlier we learned that oil paint should always be applied fat over lean; this allows artists to apply the first layers of paint very quickly. The preliminary coloring of the painting, lacking in detail, should cover the canvas as quickly as possible, establishing the main areas and overall color scheme. In such cases as this, the colors should be applied in large patches to unify the different areas of the painting.

*3. So far, no details have been added to this preparatory stage. Details should not be included until the background color has been fully established. First apply another layer of color to the mountains, including more detail in the foreground. The shaded areas between the flowers should then be superimposed on the evenly shaded field. Once this background is finished, the group of flowers can be painted, using short brushstrokes.*

▲

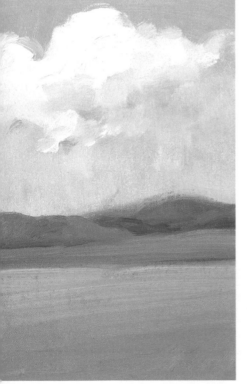

> The layers of color become more and more defined as the painting develops. The forms are constantly redrawn as the colors are applied to each of them.

▶ **2.** *Every area of the painting, however small it is, should be painted in a particular way, working from the general to the particular. First paint the clouds, superimposing the color over the background with precise brushstrokes. The mountains should be painted with a certain amount of detail, though this is not yet the definitive layer, but instead will act as a base to which you can later add more detail. As you might expect, the colors become more and more defined, using an increasingly smaller amount of turpentine.*

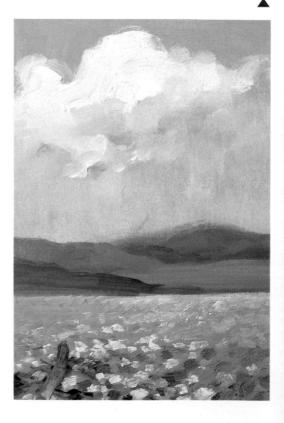

## BUILDING UP FORMS

Once artists know how colors interact, they can then apply them directly to the painting, so that these patches of color create the structure of the forms. This technique is applicable, above all, when the motif calls for a certain abstraction of form, such as a bunch of flowers, for example, in which the different patches of superimposed colors themselves create the form of the subject.

1. *The first applications of color should be performed quickly, without paying too much attention to detail. The main aim at this stage is to cover the background with colors to provide a base upon which subsequent layers of color can be added. This process should be carried out gradually. In this exercise, the dimension of the subject is suggested by the more luminous tones.*

2. *All the work carried out during the preliminary stages of the painting is aimed at creating the tones and different colors over which successive layers of paint can be added later. During this process, the main colors merge together to produce new ones. These color mixes, created directly on the canvas, produce tonal variations within the same chromatic range - the cool range in this particular case.*

3. *The contrasts painted over the luminous tones create the outline of the forms and intensify the details. These colors should be added gradually and should become more precise as the painting develops. They are then covered by new, denser brushstrokes. The same process should be used in any similar work. Detail should always be left to the final stage.*

## SUGGESTING FORMS WITH COLOR

A simple patch of color allows us to create forms which are not defined by the use of lines. A single brushstroke is often all it takes to suggest an object or simply to enrich the canvas. This exercises shows that it is not necessary to paint objects or forms using excess detail; it is the context that provides the information necessary to understand the detail, without actually defining the forms or objects.

▼ 1. *In this exercise, the background has been covered with the colors that will form the base for subsequent work. During this preliminary stage, different shades of green should be used; this difference in tone helps to situate the two different planes present in the painting.*

2. *The color base sets the course for subsequent tones and colors. For example, the texture is suggested by the tones of the chosen range; this allows us to suggest forms in the bushes which would otherwise not stand out. It is not until all the colors are seen as a whole that the objects take on a recognizable form.*

▲

▼
3. *The colors used as the base of the painting are primarily two tones of green. When red touches are added, they create a sharp chromatic contrast with the dark green. This red is too dark to be painted over the lighter green areas. To suggest the forms, the red used in these areas is much brighter. The contrasts in each of these areas should be balanced.*

# Step by step
# Landscape with garden

The application of the preliminary color base should always be the first step. Sometimes, the base will be very general, other times it will conform to a perfectly defined structure. In this exercise, you can practice using different shades of color until the painting is considered finished. This model uses very simple forms, beginning with its symmetrical and elliptical composition. The real difficulty in a painting is often painting forms that require a high level of precision. The color sketch of the large green areas surrounding the pond provides an excellent base on which to work.

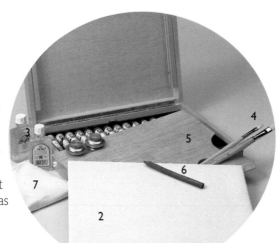

## MATERIALS

*Oil paints (1), canvas-covered cardboard (2), linseed oil and turpentine (3), brushes (4), palette (5), charcoal (6), and rag (7).*

**1.** *Start to block in the subject with a quick charcoal sketch. Then go over the lines with a brush dipped in black oil paint and a little turpentine to situate the forms within the frame. The pond is spherical in shape, though as a result of the perspective, it appears elliptical. Draw in the main shaded areas surrounding the columns, as well as the trees in the background. In this sketch, and in the following stages, all detail should be omitted. This stage can be completed very quickly, allowing us to situate the forms in accordance with the main contrasts in the painting.*

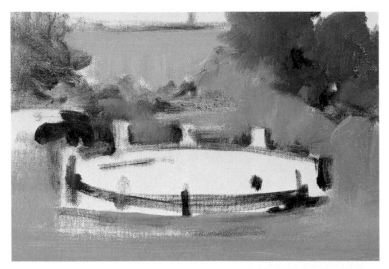

2. A large area of luminous green suggests the elements surrounding the pond. This process adds no texture or detail, as the only intention here is to cover each of the main areas of the painting. Painting quickly and freely, outline the forms of the trees to the right and shade the background with ocher.

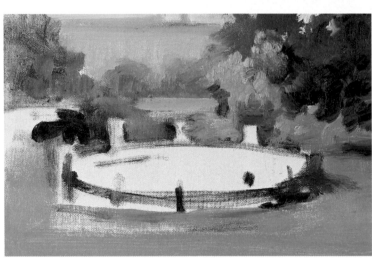

3. The trees in the background should be painted in the same tone mixed with white. Once the background has been covered, new tones can be added and superimposed over the previous layers. During this process it is inevitable that the brush picks up some of the underlying color. Add a more luminous tone over the ocher, mixing the new color with the previous ones. Many small brushstrokes can be applied around the pond to form the trees. These colors should be dark and opaque for the trees on the right, over which you may add several bright green notes.

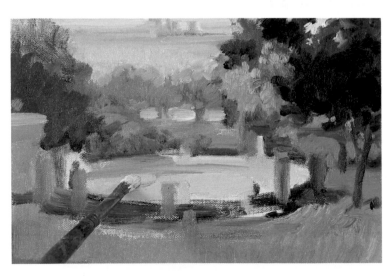

4. Details should not be painted until the main forms of color have completely covered the background. After painting the treetops on the right, paint the shafts of light filtering through the foliage and between the tree trunks, superimposed over the large green area. Then continue to paint the vegetation on the left. After painting the grass with tiny brushstrokes, begin to outline the pilasters around the pond.

**5.** *As the background is gradually filled in, new brushstrokes are super-imposed to add texture or to correct errors. Although it may mix with some of the previous color, paint a vivid yellow over the bright-est tree on the right; small, dark brushstrokes should also be applied to the area on the left.*

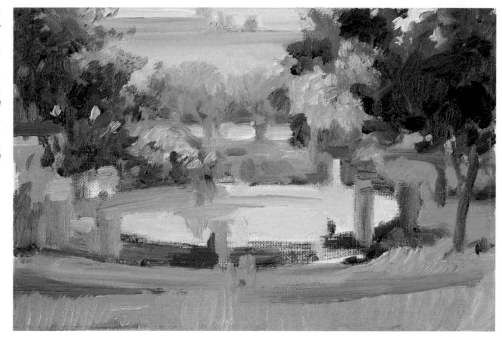

The paint and brushwork should have just the right thickness. Too much paint would spoil the finish in certain areas.

**6.** *The lines of color that form the pilasters should be retouched to give them the desired form; care should be taken not to color the inside of the pond, as its ocher tone should remain pure. Over the pilaster in the background, a few red brushstrokes suggest the wild flowers. The base color of the background has to be completely finished before the details can be added.*

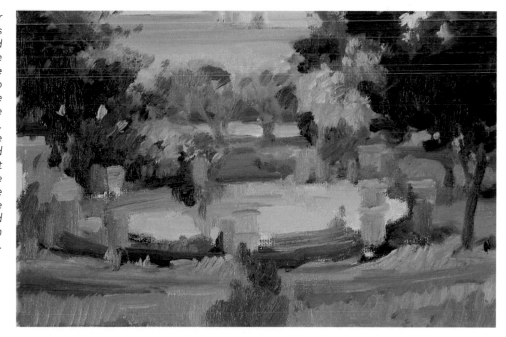

**7.** *Now paint in the definitive contrasts of the pond, first on the square columns, using blue and grayish colors for the shadows. No highlights should be added until all the details have been completed. The exterior of the pond should contrast sharply with the interior, which still possesses its original luminous tones. Make the final touches on the different contrasts on the ground and the vegetation in the foreground. Retouch the forms of the arches in the background and this will complete the exercise.*

## SUMMARY

**The colors should be perfectly distributed** so as not to mix more of the underlying layer than is strictly necessary. The tree trunks were superimposed over the ground.

**The red flowers** were painted once the background was finished.

**The first layers of paint** should never be too pasty. Preliminary forms are painted with highly diluted paint, making no attempt to include any detail.

**Several small contrasts** could be added after the color in the background had prepared a sufficiently broad, stable base. Before painting the details of the trees, the trees themselves were painted using large, flat patches of color.

**After the main colors have been applied to the background,** it is possible to situate the forms in accordance with the contrasts they produce. The ground surrounding the pond is painted as one large swath of green.

# 7 Development of the painting

## ROUGHING OUT WITH DILUTED COLORS

The roughing-out stage is one of the most critical parts of any oil painting. This constitutes the moment when the painting comes to life. A correct roughing out helps to break the "silence" of a blank canvas, and serves as a guide to develop the work.

Having learned the different approaches, artists can develop their paintings from many perspectives. Regardless of the technique they choose, they must always follow a number of rules that are applicable to any work process. The development of an oil painting must comply with these norms; otherwise the result will almost certainly be a disaster once the paint has dried.

▼ 1. This exercise will allow you to follow the development of a typical painting in oils. In this case, we will forgo the usual preliminary sketch of the subject that all paintings require. The aim of this topic is to understand the complete painting process. The first applications of color must be thinned with turpentine. At this stage, you should only be concerned with the basic forms in order to obtain an approximation of the background over which other layers of color can be applied to gradually bring out the details.

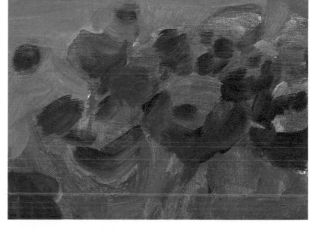

▼ 2. The background made with paint thinned in turpentine provides a perfect base on which to proceed. The next application of color should not be too pure, this is a rule that must always be respected. The amount of turpentine that is added to the paint should not be excessive, each subsequent application of paint should contain less turpentine, so that the paint becomes thicker as the picture develops.

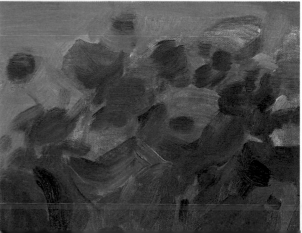

◄ 3. New mixes of colors and tones can be added with paint that is still not too thick. The background is fundamental for building up the main forms, especially in subsequent brushstrokes destined to bring out the forms more precisely. This is the stage in which the most important lines are painted to approximate the flowers that will eventually emerge on the canvas.

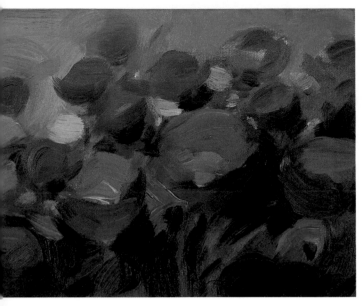

## SUPERIMPOSING LAYERS AND CORRECTIONS

The thickest applications of paint are applied over the background. This is a gradual process that consists of applying paint thinned with less and less turpentine, without applying excessively thick layers. If the background is too wet due to the effect of turpentine, the thicker layers may run. The paint must first be prepared on the palette. One important piece of advice to bear in mind: a tiny amount of turpentine can thin a large quantity of oil paint; therefore, consider carefully how much you really need.

▼ 1. *We can now begin to apply new layers of slightly thicker paint over the thinned color base. If a more fluid application is required, some more turpentine must be added, although it will have to be compensated for by also adding a little linseed oil. If you want to speed up the paint's drying time, several drops of Dutch varnish should also be added to the paint. This makes the paint "lean" thus conserving its liquid appearance.*

▼

2. *Over previous applications of much thicker paint, begin to add almost undiluted direct strokes that will define the flowers by means of contrast.*

▶ 3. *Paint the final strokes with the characteristic freshness of pure oil paint thick impastos with intense colors. The highlights, as well as the contrasts, should be painted definitively with very direct strokes; this technique can be varied according to the type of finish you want to achieve.*

**1.** *The first stage of a painting involves roughing out the canvas. In this stage, the colors must be applied with abundant turpentine and the white canvas should remain visible between the strokes and patches. No attempt should be made to add details or define forms. In addition to the initial colors, the planes of each strip of land are established.*

## THE DENSITY OF PAINT

In the next exercise we are going to summarize the last exercise clearly and concisely, although in this case the subject is a landscape. The layers of color applied during the first steps were thin enough to reveal the developmental process. In order to speed up the drying time of the most diluted layers, several drops of Dutch varnish can be added to the mix of paint and turpentine.

> A painting that requires a highly detailed finish must be executed with sufficient layers of paint, always working from the most general to the most specific.

**2.** *Roughing out provides a base for "leaner" layers, that is, paint containing less turpentine than was used in the first applications.*

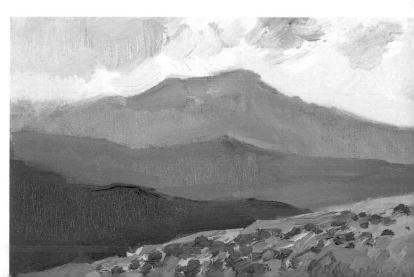

**3.** *The most decisive layers are left for last. Only after a correct roughing out can loose brushstrokes be applied to work on the details. As you can see in this landscape, the final details are strokes that could not have been elaborated during the first stages of the work.*

## COLOR APPLICATIONS AND BLENDS

The process of oil painting can produce fresh and sponta-neous results, or even results in which tones are blended together. In the exercises we have done so far, the finish obtained was very direct; this exercise examines a different fin-ish, even though the technique involves similar processes. All the examples demonstrated in this topic may undergo slight variations, but they always commence with a similar elabora-tion, and their procedure is identical.

▶ **1.** *Paint the outline with one of the colors that you will use later in the painting. The blocking in of the form is one of the fundamental aspects of the still life, portrait, and human figure genres. Since the sketch is painted with only one color, it will be easy to blend it with the other tones.*

▶ **2.** *The color base must first establish an outline before the first color can be applied that will be blended with others. This color should be applied very directly over the thinned background. The di-rection of the stroke is crucial, as it establishes the shape to be blended. The most luminous areas are still the light areas of the preliminary background.*

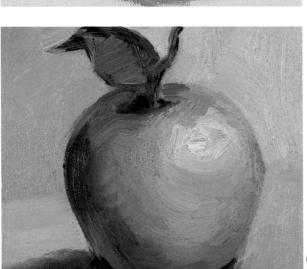

▶ **3.** *The colors should now be applied in the form of impastos, although the brushstroke should continue to blend the various tones. We can thus enjoy pure colors and direct applications as well as colors that have been completely blended into one another.*

# *Step by step*
# Figure in backlighting

In this exercise we will paint a male figure standing against a window in backlighting conditions. Due to the distinct contrasts between the areas of light and shadow, the tones of the model are reduced to a chiaroscuro. Since there is no great variety of colors and tones, this picture should be relatively simple, although great care must be taken with the separation line among the shadows. This is a perfect model for following a simple step-by-step exercise of a picture painted in oils.

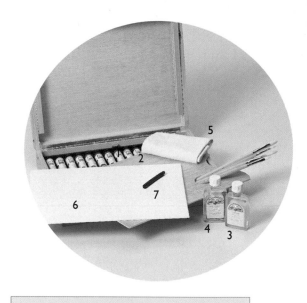

## MATERIALS

*Oil paints (l), palette (2), linseed oil (3), turpentine (4), rag, (5) canvas-covered cardboard (6), and charcoal (7).*

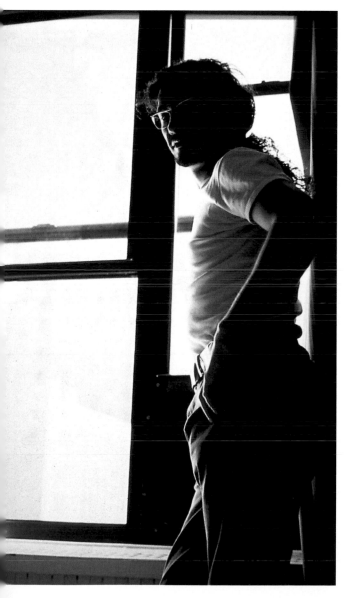

**1.** *The preliminary drawing is very important. Like many subjects that are done in oil, the drawing is a simple suggestion that will be built up as the painting advances. Although in subjects like this one, where there is a clear separation of areas, it is necessary to include much more of what is to be painted. First, sketch the general lines; then, having worked out the shape of the figure, draw in the shadows.*

# STEP BY STEP: Figure in backlighting

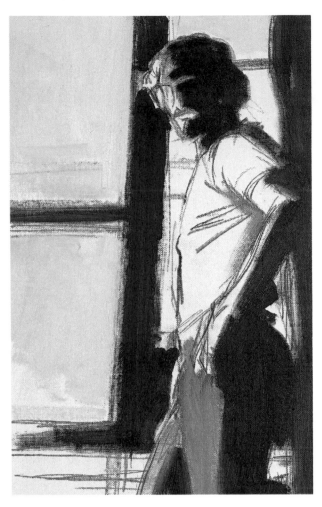

*2. Begin the picture with colors previously thinned with turpentine on the palette, ensuring that they are not too diluted. As in the earlier step, where we included the shadows, here we have used a very dark tone comprising umber, sienna, and a touch of cobalt blue. The areas in shadow should be painted as single blocks of color. Highlight the pants with cerulean blue mixed with electric blue and grayed with white.*

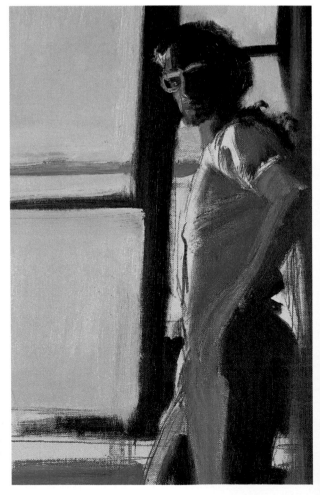

Don't use too much paint during the first stages of the work. The white color of the canvas must be left unpainted in the areas where the highlights will be placed.

*3. The colors for the highlights on the skin should be prepared on the palette: rough out the face with a mix of orange ochre and a hint of red. Apply the same color to the arm, toned slightly with a touch of blue. The shadow over the T-shirt is blue with a clear violet tendency. You will notice that in this area, the diluted brush is quite dry.*

**4.** Retouch the lighter area of the face until it merges with the shadow on the forehead. The nose, on the other hand, requires a direct stroke to create a sharp contrast with the shadow cast over the body, therefore start to superimpose thicker colors over the previous ones. Create the highlights on the T-shirt with direct touches of white, although this should only suggest the creases produced by the fabric that later on will be given more detail.

**6.** Paint the shirt with direct brushwork in white toned with blue. Contrast the illuminated area of the arm with the shadow. There is no need to gradate the tones, this sharp contrast between the planes is enough to suggest a very sketchy volume. Define the planes of the windowsill by outlining it with dark tones. Apply tones of blue and ocher to the window frame, in order to heighten the shadows.

**5.** Here we can see how the face has been painted under conditions of backlighting: several dabs of color create the main highlights. Next to the nose, a subtle tone of umber creates a contrast with the illuminated side of the profile. The highlight in the shoulder has been painted with intense strokes of white that superimpose the previous applications.

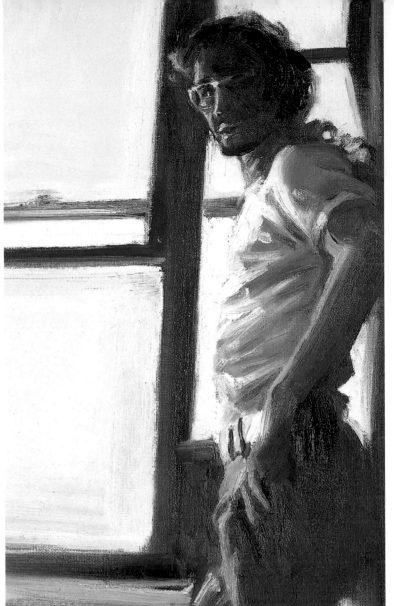

7. *Paint the creases of the T-shirt with touches of direct white, which bring part of the underlying tones to the surface. The face, which is almost in shadow, should be painted with luminous and dense touches. Go over the arm with delicate sweeping strokes, which merge with the tone of the light. All that remains is to finish the pants with a highly luminous blue and to suggest the hand, painting only the fingers that are visible.*

Never overdo the color white, especially in works where the areas of light are extreme. The lightest color mixes should be made with luminous colors like Naples yellow or cerulean blue.

## SUMMARY

**The preliminary sketch** was executed with a very direct drawing, on which corrections and the study of light and shadow can be carried out.

**The first application of color** consolidates the study of highlights and shadows. The first shadows are very flat, lacking detail, and were applied thinned with turpentine.

**The blue tone of the T-shirt** provides a base for strokes of gray and white that suggest the creases.

**The hand** was completed last with two strokes to represent the fingers.

# Obtaining tones and direct methods

## BLENDING COLORS ON THE CANVAS

The main method for blending colors is to mix them with the brush directly on the canvas. In this way, the tones are mixed until they are indistinguishable. This provides a base for later brushwork. This first exercise uses a blending technique which is almost inevitable in any form of oil painting.

In the previous topic, we studied the general process followed in all types of oil painting which can, however, lead to varying results depending on the techniques employed. Some artists prefer a highly blended, detailed finish while others prefer a more spontaneous effect with a marked impressionist finish. Blending is the preliminary stage to modeling, one of the most academic techniques.

1. *Draw the preliminary sketch in charcoal. Then go over this drawing with very thin paint, making sure it does not run. To keep this from happening and to produce a broken line, squeeze out the brush as much as possible before beginning. This type of line merges the tone of the paint with the background drawing.*

▲

2. *Apply the first patches of color over the drawing of the model. The preliminary colors, as with all oil techniques, should be lean. In the study of how to obtain the right tones, the direction of each line is important. The lines in the background should flow and the brushstrokes should be slanted. Use blue, toned down with white. The stems should be painted in an almost white tone, and the brightest petals with shinier, thicker brushstrokes than before.*

▲

3. *After painting the main forms, use a fine brush to increase the contrast in the darkest and lightest areas of the painting. These contrasts serve to create the definitive outline of the flowers. The different planes within the painting can be separated by the use of different tones for each area.*

▲

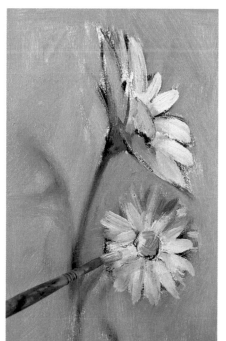

▶ **1.** *This dark color can be used for the drawing as well as to differentiate the tones. The preliminary drawing should be perfectly finished, with all the shadows well defined. Once you have obtained a base of uniform color, let it to dry to prevent further applications of color from smudging the preliminary work.*

## PRINCIPLES OF VALUE PAINTING

Value painting is the method in which shadows are created using different tones of the same color. In this exercise we are going to study some of the basic rules for interpreting tones. In the previous exercise we saw how lines can be completely blended on the canvas, but what happens when a line gradually merges into the background or over another color?

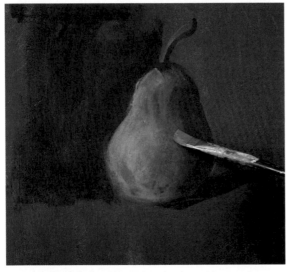

▶ **2.** *To prepare transparent colors for this type of work, mix oil paint, a little linseed oil, and Dutch varnish; this mixture produces an almost transparent color to paint the brightest tones with. To integrate the background color into this process, leave the dark areas unpainted. For this type of work in which the tones need to be completely blended together, it is important to use high-quality brushes.*

> In value painting, do not use black to darken the tones since this color easily dirties any adjacent colors and causes the paint to crack as the layers of paint dry out at different speeds.

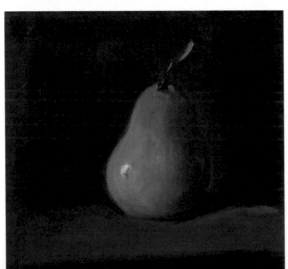

▶ **3.** *In this preliminary stage, areas of light and shadow are established. The shadows are of the same color as the background, and are thus less likely to merge with subsequent highlights. To adjust the tones of the lighter areas, use an even more transparent color.*

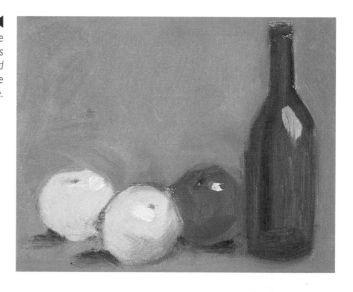

◄ The use of complementary colors can create intense contrasts. In this exercise, the green bottle contrasts sharply with the red apple next to it. The yellow is applied to offset the difference between the colors. This technique is used to complement the value painting procedure.

## THE IMPRESSIONIST TECHNIQUE

Impressionism represented a break with the entire academic tradition; this vision of painting interprets objects in terms of brightness of the color, meaning that no value work or modeling of shadows takes place. Colors are applied directly, complementing or contrasting with each other. This still life will help us to understand this technique.

◄ When colors are used in the impressionist fashion, the highlights of the objects must affect all the elements contained in the picture. Thus, add a yellow highlight to the bottle, as a reflection of the apples on the left. Painting the background with a mixture of the colors used helps to unify the range of colors present in the painting.

> The opacity of oil paint can affect transparent color in two ways: a light transparent color becomes opaque when successive layers are applied, but if the background is dark, it becomes more luminous.

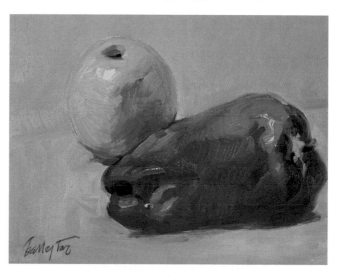

◄ In Impressionism, colors affect each other and make the luminosity of the elements in the painting interdependent. The reflections between objects should be painted using complementary colors. These striking colors do not have to mix; their reflection in the other elements in the painting is enough.

# Topic 8: Obtaining tones and direct methods

▶ **I.** *In this exercise, there is no need for charcoal or pencil; simply use a brush dipped in thin paint to draw the basic design directly on the canvas. Then squeeze out any excess turpentine from the brush and start to draw. In this preliminary stage, lines can be corrected and redrawn as often as necessary. If you need to erase any part of the drawing during this stage, simply rub the area with a cloth dampened in turpentine.*

## WORKING DIRECTLY ON THE CANVAS

One of the best methods for making quick sketches is one that allows artists to capture the model directly on the canvas, without having to deal with other aspects that could hinder the process, such as careful drawing, excessive use of different tones, highly modeled forms, etc. Direct work, also called *alla prima,* is the favorite technique of many artists who prefer spontaneous drawing and painting. This exercise provides a clear example of how this method is applied.

**2.** *You may now begin to paint over the sketch with thicker colors since the goal is to capture the scene as quickly as possible. When paint thinned with turpentine dries, it loses its shine and the color tends to fade. Dutch varnish can be mixed with the paint on the palette to prevent this from happening. Also, you need not use the best quality oils for roughing out the canvas, as they will be painted over later. It is therefore better to start with medium-quality paint followed by higher-quality paints.*

▲

**3.** *As you progress, use less diluted paint until you are working with pure colors. Also, remember to never add a drier layer of paint over the one on the canvas; this would violate the rule of fat over lean.*

▲

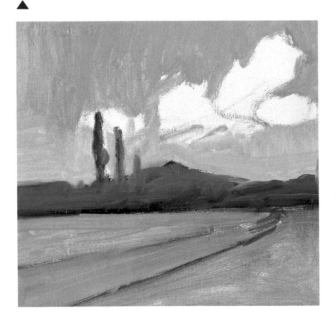

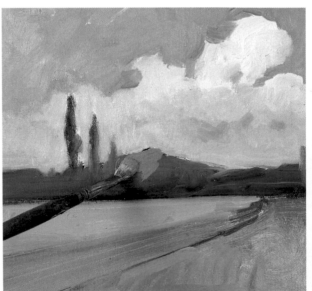

# Step by step
# Landscape and river

The model for this exercise is a landscape with a river. We have deliberately chosen a very simple model so that the reader can practice the *alla prima* techniques studied earlier. The process starts as should all paintings in oil from the general to the particular. The way the different brushstrokes influence tone will create the large, light colored area of the river in this beautiful landscape.

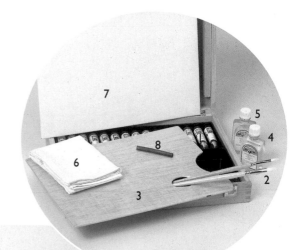

## MATERIALS

Oil paints (1), brushes (2), palette (3), turpentine (4), linseed oil (5), rag (6), canvas-covered cardboard (7), and charcoal (8).

1. *Painting directly is one possible technique when working in oils and could be applied here, given the simplicity of the model. We shall, however, start with a quick charcoal sketch to shape the model. Holding the charcoal flat, you will be able to draw a completely straight line. For the mountains in the background, draw slightly broken lines using the tip of the charcoal stick. After drawing the basic layout, sketch in the bridge and cluster of trees on the left.*

2. *The layout of this exercise is so simple that the roughing out can be done very quickly. Only the main contrasts in the landscape should be included at first. Use paint that is very thin but not too runny. The first patch of color will depict the mountains. Using darker, thicker paint, shade in the vegetation and the darker areas on the left. This entire layer of paint should be applied over the thin blue of the background. Paint the sky almost white, with a few drops of linseed oil to liquify it.*

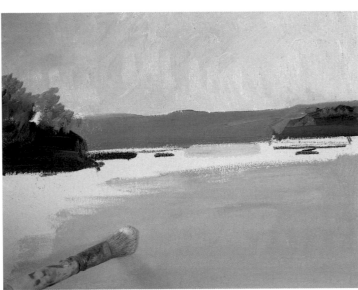

3. *Next apply ultramarine blue and cobalt blue directly to the vegetation. This layer will mix with some of the underlying color. Then start to paint the water in a dark gray blue. Since this area of the painting will undergo major modifications, this first layer should be very thin. Mix different tones of green and white, using sweeping, horizontal brushstrokes.*

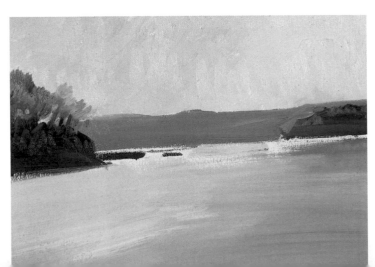

4. *Then move on to the trees along the river-bank, using more precise, detailed strokes than before. Apply this brushwork over the color mix obtained earlier. The color applied to the water should now be much thicker than before, and mixed with some white. Repeat this process on the upper part of the painting, using horizontal strokes and working downward. Then cover this bluish area with darker, thicker colors and definite brushstrokes that blend with the background.*

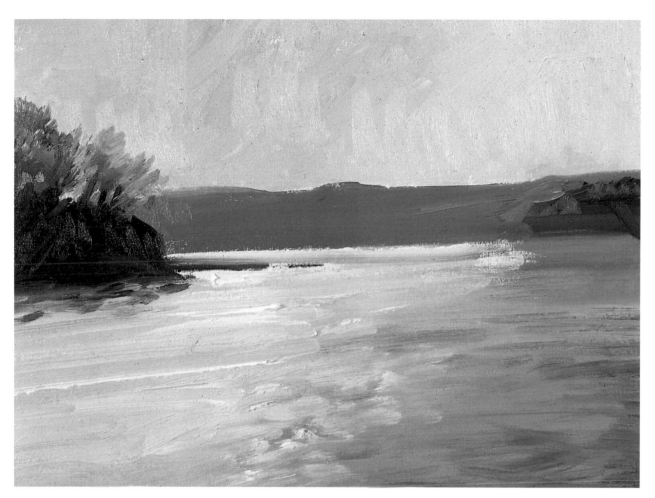

**5.** *Once you have applied the color base, do not add more turpentine to the color mixes. Paint the darkest patch of water directly in dark blue. Observe the brushstrokes: they are not identical, but a mixture of short and long strokes, some of which blend into the underlying tones. If the paint is too thick, you may add a little linseed oil but just enough to liquify it.*

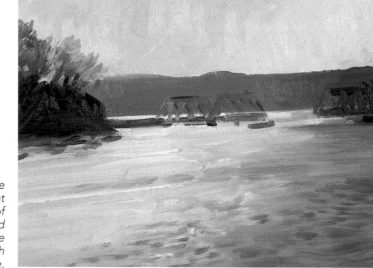

**6.** *The brushstrokes on the surface of the water mix dark and light tonalities of different intensity. Those next to the lightest patch of water should be short and delicately overlaid onto the luminous background tone. Paint the lines representing the bridge with a brush dipped in a grayish blue and a little white.*

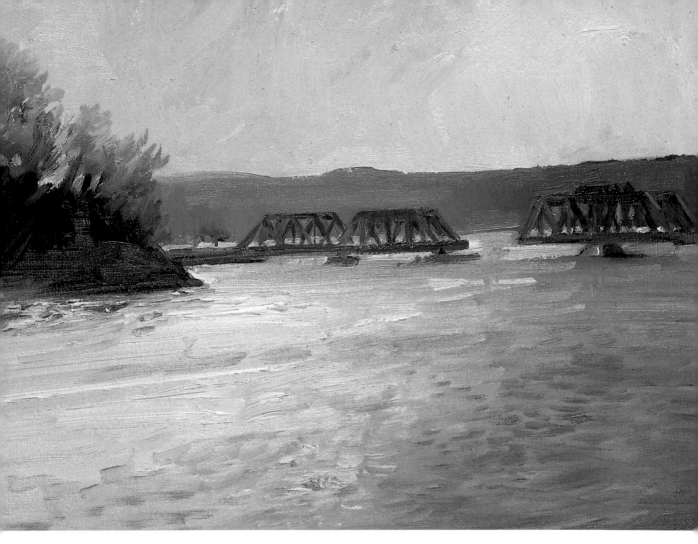

**7.** *Use shorter, more detailed brushstrokes on the surface of the water. Do not use too much paint, just enough to alter the tone of the underlying color. Redraw the bridge on the right with completely straight lines. More detailed brushwork should be used for the trees, with short brushstrokes that blend into the background, yet do not disappear entirely. Retouch the bridge last with several dark, straight brushstrokes, painted over the underlying colors. Finally, use a slightly broken white on the brightest patch of water for a few, well-placed highlights.*

## SUMMARY

The preliminary scheme was drawn in charcoal; the entire landscape is based on the horizon line.

The mountains in the background were painted with a thin blue. This layer forms the base for the darker tones later.

The group of trees on the left was painted in blue with very little turpentine. The brushstrokes are short and clear.

The sky is a luminous, almost white color.

The water requires several layers of paint; the first are very thin and form the base for denser, more contrasting brushwork at a later stage.

The brushstrokes that represent the reflections in the water are highly specific and well defined.

# 9 Palette knife and brush

## PALETTE KNIFE AND BRUSH: PAINTING WITH IMPASTO

The palette knife can perform a wide range of techniques; it has a sharp edge which can be used to separate and spread out paint. The texture of oil paint and the brush which modifies every line and smudge offer the painter an almost endless variety of creative possibilities. After reviewing the previous section in which this technique was used, we here present a new exercise in which the potential of brushwork is combined with that of the palette knife.

> The palette knife is much more useful than you might imagine. In a previous topic, we demonstrated some of the possibilities of this simple instrument. In this section devoted to the palette knife, we shall study several other techniques which cannot be performed with any other painting tool. Working with a palette knife is very different than any kind of brushwork. The combinations of the two that we are going to explain here will take you one step further in learning the techniques that combine palette knife and brush.

1. Use a brush in the first stage of this exercise since it is more suitable for painting lines. The application of a color base at this stage is very important as it situates the main colors. It is also important not to dilute the paint too much, unless you intend to let it dry first. Pasty brushwork allows you to represent the volume of the main forms very quickly.

▲

3. To mix two colors, draw the palette knife over the some area several times. Using a dark color and the edge of the knife, paint the tree trunks. Repeat this until the line acquires the right consistency. Use various palette knife techniques on the sky: some delicate, so as not to pick up the underlying color, and others more forceful to obtain the opposite effect.

▲

▶ 2. Once you have roughed out the canvas, scoop a little paint onto the edge of the knife; then apply it to the canvas and spread it out, pressing down slightly on the knife. At first, it is not necessary to apply a large amount of paint; the impasto can be created as the painting progresses. Using crimson mixed with a little white, draw the knife over the underlying colors. This will cause them to mix together slightly.

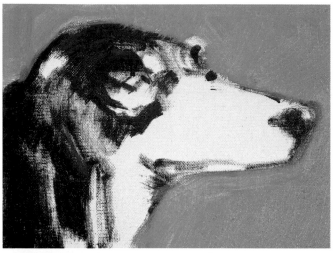

▶ **1.** *Block in the subject with a brush and a dark color. At this stage, you may make as many corrections as desired, since the work with the palette knife will completely conceal these underlying layers. After blocking in the subject and the main, dark areas, paint the entire background with a brush, retouching the outline of the animal with a quick stroke.*

## FIRST IMPASTOS

In the first exercise on this subject we created various impastos using both palette knife and brush. Palette knives are ideal for this purpose, and in this particular case we shall study one of most striking uses: their creating a variety of textures in the same area of the painting. To put this technique into practice we shall paint the head of a dog. Pay special attention to the superimposition of impastos after completing the preliminary brushwork.

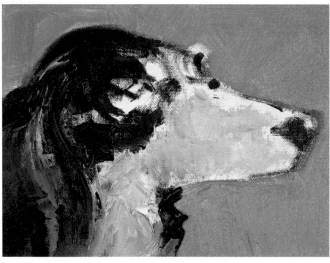

▶ **2.** *Paint the color base of the dog's head by applying an impasto with the palette knife; the lighter areas should be painted in grayish white mixed with other tonalities. Apply just the right pressure with the knife so that the surface remains smooth. Using an almost black color mixed with cobalt blue, add in the main dark areas of the fur. The marks made by the knife should be longer here than those used for the animal's face.*

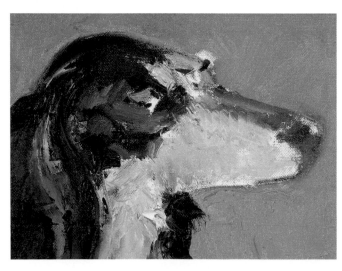

▶ **3.** *The definitive form of the head should now be superimposed over the most luminous areas. Do not add any details yet to the forms and features of the animal; the most important thing at this stage is to preserve the tone of the colors to prevent their merging together.*

# TECHNIQUES WITH THE PALETTE KNIFE

Despite its crude appearance, the palette knife is capable of performing highly detailed work. These details depend on the amount of paint applied and how the knife is placed on the canvas. However, this technique, like all others, requires regular practice before it can be mastered. If you look closely at the final stage of the last exercise, you will see a wide variety of impastos and lines, some of which would be very difficult to obtain with only a brush.

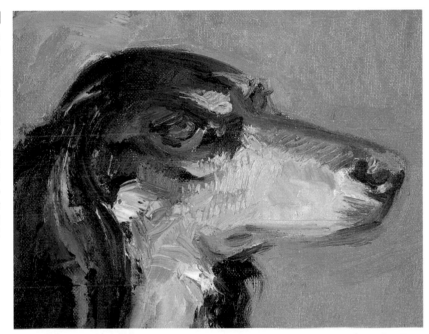

**4.** Depending on how it is applied to the canvas, a palette knife can be used to create many different types of lines, planes and patches of color. Be careful not to apply too much paint as this makes it impossible to obtain precise details. Apply several impastos, all in the same direction, to shape each of the areas of the dog's head. At the same time, add new bluish tonalities as you build up the planes. Notice the difference between the texture of the upper part of the muzzle and the rest of the face; the impastos on the upper part are slanted while on the rest of the face they are vertical.

**5.** Apply a dark color with the tip of the palette knife to redraw the forms of the animal. Do not add the definitive details until the end of the process, which is also the time to remove any excess paint, if necessary.

## PALETTE KNIFE TEXTURES

As we have seen in the two exercises devoted to this technique, the use of the palette knife is a wonderful source of creativity for the artist. In this exercise, we are going to paint a waterfall, in which the knife is used to create the effect of cascading water.

▶ *1. After rapidly sketching the structure of the subject, position the main areas of the painting using a brush. Then use the palette knife to apply homogenous impastos to the sky. Using gray tinged with the other colors on the palette, start to paint the rocks. The color mix used here is not uniform, so that the palette knife can create a mottled effect.*

▶ *2. Paint the rocks in green and ocher. The texture of this area should be flat and will provide the base over which to add further impastos. Drawing the edge of the knife gently over the painting paint the cascade, just enough to obtain a broken color. Over this broken background, apply white.*

*3. Paint the cascade by applying the knife over the brushwork. The movement of the palette knife should be drawn out following the forms created by the flowing water. This color tinges the underlying layer of paint. Apply a large amount of white to the upper part of the cascade. Suggest the structure of the rocks by holding the blade flat on the canvas and then lifting it off to create a textured effect.* ▲

# Step by step
# The riverbank

Although it is possible to paint any subject using a palette knife, this tool is best suited to subjects which do not require a great deal of precision. In this exercise, we shall apply the techniques we have learned so far to capture this beautiful river scene. In order to demonstrate all the different lines and marks a palette knife can make, we have chosen a model with highlights and sharp contrasts. Painting with a palette knife is much faster than working with a brush, as more paint can be applied each time.

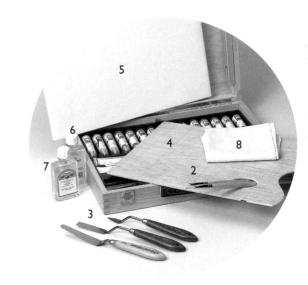

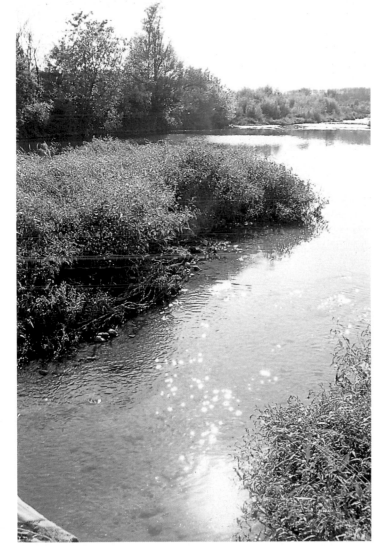

## MATERIALS

*Oil paints (1), brushes (2), palette knives (3), palette (4), canvas-covered cardboard (5), linseed oil (6), turpentine (7), and rag (8).*

1. *Paint the preliminary sketch of the landscape with a brush, without attempting to capture the precise outlines. The brush should contain some turpentine, but at the same time be almost dry, so that the impastos applied with the palette knife will adhere to the dry base. If the background is too damp, subsequent layers of paint will run.*

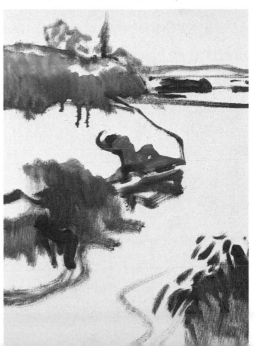

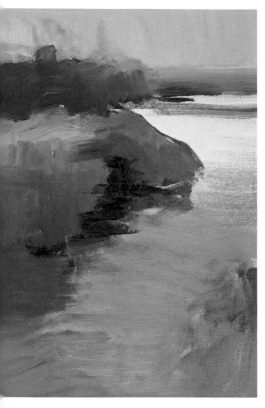

**2.** *Apply the first colors with a brush; this is done to mix the colors, a process which is more difficult to do with a knife. Another reason for using a brush at this stage is to obtain a thin color base which will gradually be thickened as the painting progresses. Your brushwork should be direct and spontaneous, attempting only to situate the main areas of color, without including any details.*

If the paint is too thick in a particular area, it is best to remove it using the edge of the palette knife and start again.

**4.** *Then use the palette knife to add details to the vegetation which completely covers up the color base. The tones should alternate and overlap, mixing the colors without creating too sharp a contrast.*

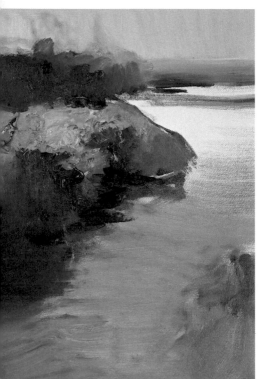

**3.** *Only after you have fully developed the color base using the brush should you start to use the palette knife. First, apply touches of green and yellow to the vegetation on the right. To obtain the right texture, lay the blade flat on the canvas and lift it several times. During this process, it is inevitable that some of the underlying color will be pulled up, mixing the colors directly on the canvas.*

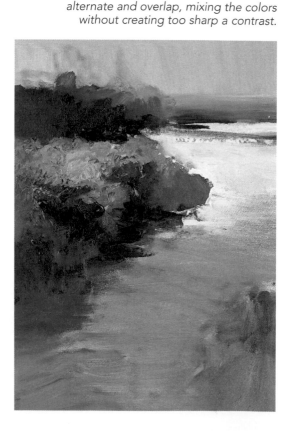

**5.** *Use a small palette knife to paint all the vegetation in the background in dark green, without creating as much texture in the foreground. Paint the area nearest the water by gently spreading out a mixture of blue and green that blends into the background. Apply white to the sky, sliding the palette knife gently and flatly across the canvas. Even pressure should be applied to mix this color with the underlying layer of paint.*

**6.** *Superimpose the colors on the right side of the vegetation and the water. Gently apply many small touches of green to the foreground, without mixing them with the previous colors. To create the texture of the vegetation, use the edge of the blade. Paint the highlights in the water with well-defined notes of pure white.*

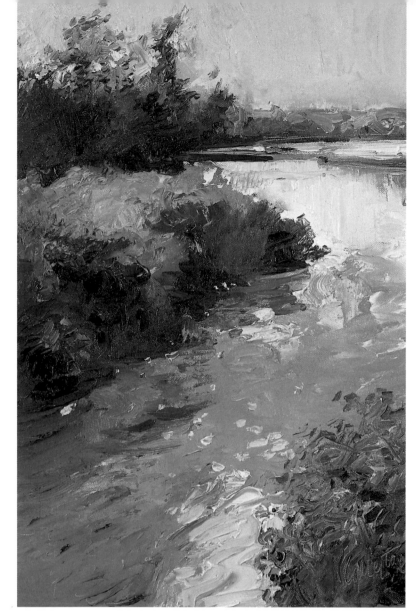

**7.** *Paint the texture of the vegetation in the foreground with earthy colors. Use the tip of the knife in this area to lend shape to the vegetation. To complete this exercise, model the whites on the surface of the water with a flowing, zigzag movement.*

## SUMMARY

**Paint applied with a palette knife** can be pressed over the surface, smoothed out, or laid on directly. The sky was painted with a white that mixed with the underlying color.

Before starting work with the palette knife, it is important to sketch out the main areas with a brush. **The color base** is applied directly with the brush and the darker masses are outlined.

A palette knife can be used to create striking textured colors. Each part of the knife can be used to apply the paint in different ways. The **yellow patches** mixed with some of the previous color, and were created by pressing and lifting the knife on and off the canvas.

The **water** is represented with white notes that are blended into a zigzag shape.

# Combined techniques

## OIL OVER ACRYLIC

Acrylic gel can be used to create textures. Thus, a given volume can be painted and, when it is dry, repainted without modifying the original texture. To practice this effect, we have chosen a landscape with trees to show how to prepare the support with high-density gel. When the gel is applied to the canvas, it is a milky colored paste; after drying out, it becomes transparent.

> **Oil paints can be manipulated by adding materials which alter their texture or by mixing them with other pictorial media such as acrylic. At the beginning of this book we mentioned the possibility of preparing a canvas with acrylic gesso. Anyone who has done this before will know that acrylics dry very quickly, making them a perfect base for painting in oils. Since they are also excellent priming agents, acrylics can be used to obtain a color base and lend texture to a canvas.**

1. *To obtain the dark color of the plywood, simply dilute a little black acrylic paint with a little water and apply it with a flat, wide brush. In just a few minutes the base will have dried out completely. Then apply the high-density gel and form into the shape of the treetops. This can be done with a brush and palette knife to obtain the desired texture. Paint the lower area with gel to which ground marble has been added to lend it texture.*

2. *The background has dried quickly and you can now start to work in oils. This technique allows textured painting to be obtained very quickly and easily as the support is prepared beforehand. Use cerulean blue mixed with white and cobalt blue for the sky. These colors should be mixed directly on the painting. The trees should already have sufficient texture, so little paint is required.*

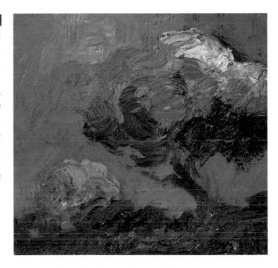

3. *In the lower area of the landscape, add some bright brushstrokes on the land and highlight the textured treatment of the trees.*

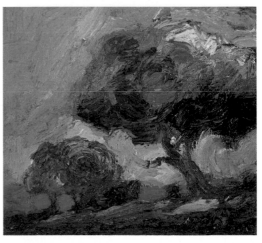

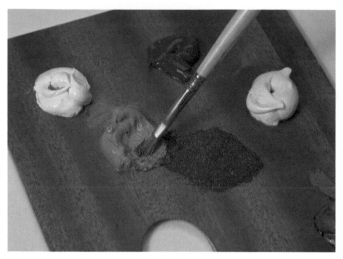

▶ **1.** *Additives should be mixed with the oil on the palette. To obtain a good texture, mix a little additive with the oil using the palette knife or brush until the paint has absorbed it completely. Add the additive gradually, as required. You will be able to work with this mixture after a little practice.*

## TEXTURED PAINTING

Inert matter does not react chemically if mixed with oil. The best way of becoming familiar with the world of textures is to begin with paints that have a medium amount of additive, such as ground marble or hematite in the right proportion. In this section we are going to do an exercise in texture, using a highly abstract motif.

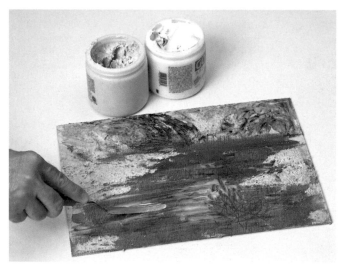

▶ **2.** *As we saw at the beginning of this book, acrylic pastes and gels allow the artists to prepare a textured surface with the added advantage of drying very quickly. There are various types of gel that can create different textures on the support: some are especially suitable for impasto work, others already contain additives such as ground marble. In this exercise we are going to prime a wooden surface with textured gel.*

One of the greatest advantages of priming and preparing surfaces with acrylic gel is that the tools can be cleaned by simply rinsing them under the faucet.

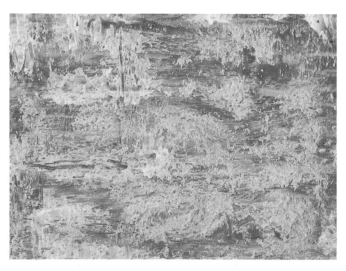

▶ **3.** *It is not necessary to use large amounts of acrylic gel; just enough so that it can be spread out with the palette knife. The shape you give it at this stage is the one it will retain when dry. First lay it on by drawing the knife around in a circular motion. Then spread it out over the painting and shape it. The texture should be even over the entire surface.*

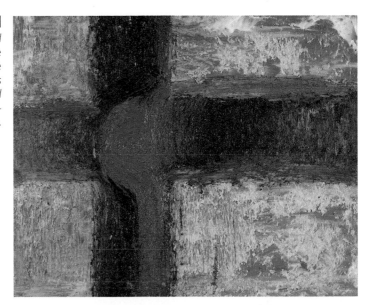

1. *Using a sienna oil mixed with additive, paint a broad stripe in the center of the painting, using both the brush and the palette knife. The mark left by the knife on the surface creates dimension. Over and across this brown-colored stripe, paint another thick, textured stripe in a dark, black color. In the center of the composition, paint a red circle, textured with ground marble.*

## FINISHING THE PAINTING WITH OILS

After applying the textured base, let it dry for a few minutes; a hair-dryer can be used to speed up the process, if necessary. The surface of the painting is now not only well primed but is also permanently textured. The exercise continues using oil paint mixed with hematite; if this is not available, ground marble or even rinsed sand will do.

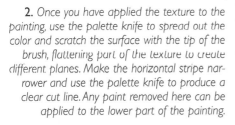

2. *Once you have applied the texture to the painting, use the palette knife to spread out the color and scratch the surface with the tip of the brush, flattening part of the texture to create different planes. Make the horizontal stripe narrower and use the palette knife to produce a clear cut line. Any paint removed here can be applied to the lower part of the painting.*

3. *The thicker the texture, the less precise the painting will be. To finish off this exercise, repaint the stripe on the right and the bluish gray at the bottom. Last, paint a new black patch of color with more texture than the underlying color base.*

## COLOR BASE AND DRYING

In the previous exercise, we created a series of textures based on a preliminary priming with acrylic gel. Another method for creating textured work is oil mixed with ground marble, sand, or any other mineral additive. In this way we can obtain textured paint that is very different than common oil paint.

▶ **1.** *Mix the ocher-colored oil paint and the ground marble on the palette. The best method is to set a little paint aside, adding the powder until the desired texture is obtained. When it is thoroughly mixed, apply it to the painting with the palette knife. The furrows in the ground are obtained by scraping the surface with the knife.*

In textured work, results will not be obtained as quickly as with acrylics, since oils will dry more slowly. However, we do not recommend using cobalt siccative. A specific medium, Dutch varnish, or other mediums specially designed for this purpose should be used instead. The best way to ensure that the painting maintains its color and texture is to let it dry naturally.

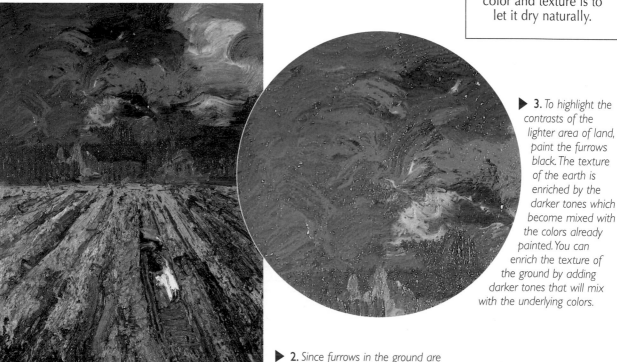

▶ **3.** *To highlight the contrasts of the lighter area of land, paint the furrows black. The texture of the earth is enriched by the darker tones which become mixed with the colors already painted. You can enrich the texture of the ground by adding darker tones that will mix with the underlying colors.*

▶ **2.** *Since furrows in the ground are ill-defined, this texture appears much more realistic and convincing.*

## *Step by step*
# Figure using mixed techniques

Oil paint with additives can create a plastic effect which is completely different than the effect obtained using paint straight from the tube. Especially when a lot of additive is used, textured painting is not as well defined and delicate as ordinary painting: thus, artists should not seek the same degree of detail but concentrate more on achieving a harmonious balance of the elements in the painting.

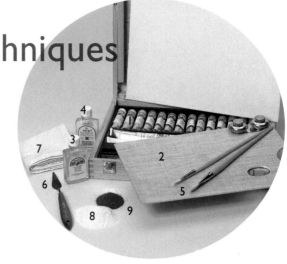

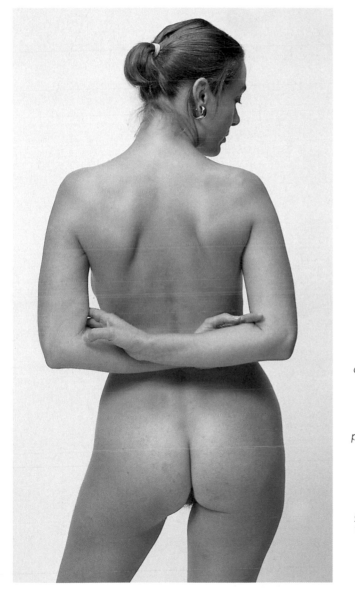

### MATERIALS

*Oil paints (I), palette, (2), linseed oil (3), turpentine (4), brushes (5), palette knife (7), ground marble (8), and hematite or fine sand (9).*

1. *Blocking in the figure is simple in this case, as it does not require a delicate finish. The drawing should act as a model for the successive layers of paint. Prime the painting first with a creamy tone; when this is dry, block in the figure using oils. The paint should be thinned so that this preliminary step can be done quickly and smoothly. Once you have completed the layout of the figure, shade in the background with paint containing a small amount of ground marble.*

*2. Mix an orange colored paint with hematite. The texture of this mineral powder is finer than ground marble and creates a more delicate effect. Use a lighter color on the upper part of the back and then the darkish tone on the right; this situates the main areas of light and shadow. Use the same color with a little bit more white to paint the illuminated area on the back. This whole stage should be completed with the palette knife.*

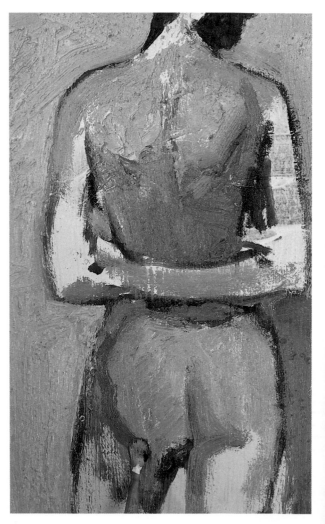

Don't use additives that may deteriorate in oil paint, such as paper, grains of rice, or bread. Other substances to avoid are chalk or plaster, as they absorb the oil.

*3. Once you have completed the upper part of the figure, move on to the lower part. The difference between these two parts as regards treatment and texture is obvious: the colors are much more luminous. First apply the lighter colors to outline the darker areas without mixing colors. Paint the background in a highly luminous blue, first mixed on the palette with ground marble.*

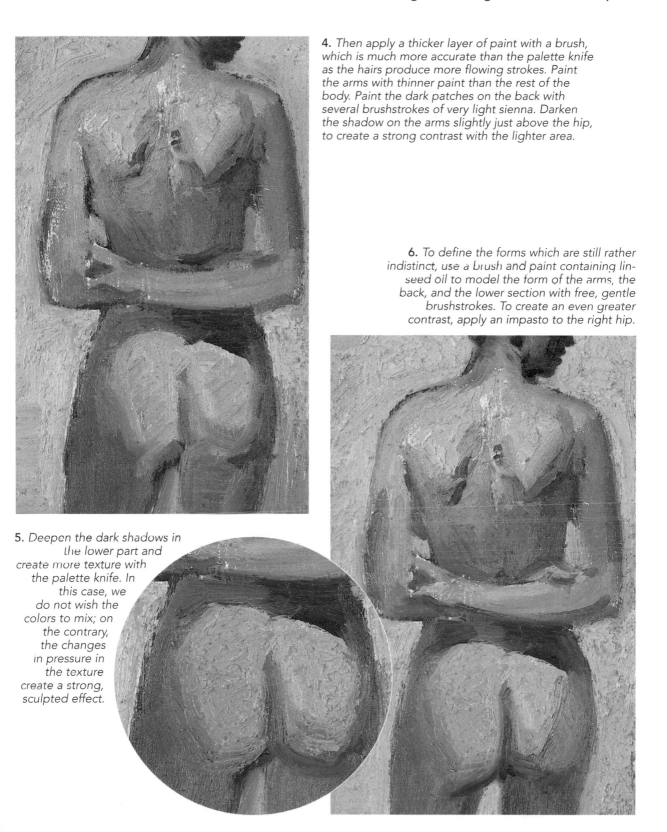

**4.** *Then apply a thicker layer of paint with a brush, which is much more accurate than the palette knife as the hairs produce more flowing strokes. Paint the arms with thinner paint than the rest of the body. Paint the dark patches on the back with several brushstrokes of very light sienna. Darken the shadow on the arms slightly just above the hip, to create a strong contrast with the lighter area.*

**6.** *To define the forms which are still rather indistinct, use a brush and paint containing linseed oil to model the form of the arms, the back, and the lower section with free, gentle brushstrokes. To create an even greater contrast, apply an impasto to the right hip.*

**5.** *Deepen the dark shadows in the lower part and create more texture with the palette knife. In this case, we do not wish the colors to mix; on the contrary, the changes in pressure in the texture create a strong, sculpted effect.*

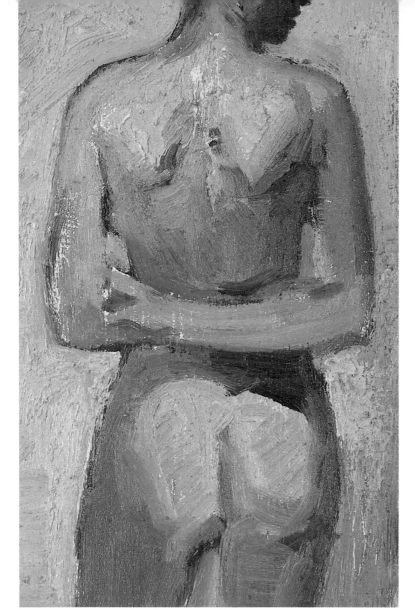

*7. Some further contrasts must still be added to the lower part, add touches of sienna under the arms and model the illuminated areas of the buttocks with a highly luminous tone. There should be a clear difference between the tones that make up the figure. After completing a session, clean all painting materials thoroughly.*

Any remains left on the brushes could ruin them completely. Take good care of them and the palette, which should be scraped with a painter's knife and then thoroughly cleaned with turpentine.

## SUMMARY

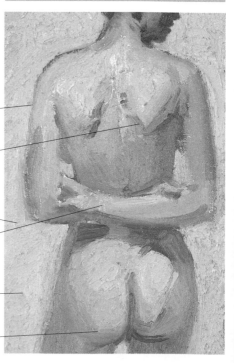

**The drawing** was sketched with very thin oil paint, but not so thin that it drips down the canvas.

After mixing the hematite and the oil paint on the canvas, we applied it to **the figure's back.**

**The background,** of a much rougher texture than the figure, was painted with added ground marble.

**The arms** were painted with very little additive, though a little ground marble or hematite can be added.

**The highly textured background** on the right was reinforced to create a stronger contrast with the figure.

**The contrast of the figure** was also strengthened with free brushwork.

# From blocking in to roughing out

## BLOCKING IN A HUMAN FIGURE

In previous chapters, we learned to block in structures and forms before beginning the painting process. This should always be done before beginning a figure, complicated though it may seem. In this exercise, the blocking in is different in that it has to be very superficial and unconcerned with superfluous details in order to project a better impression of the general structure. Details can be added later.

> The study of a model is one of the most complex works for amateur painters, largely due to the fact that the shapes to be painted are not fully understood. We have already discussed different ways of blocking in a subject. In this section, we will go through two exercises showing the transition from the initial blocking in to the subsequent roughing out and final steps of the painting.

▶ 1. *We have already seen how a complex form can be converted into a set of very simple shapes on the canvas. This process can be used for any subject, whether it is easy or difficult to represent. If the amateur proceeds directly to painting the subject, without stopping to block it in, the final result will most likely look nothing like the original. If you get in the habit of sketching in any form before painting, the results will be much more consistent.*

▶ 2. *After blocking in the basic forms, add the definitive sketch to be used for the painting inside these lines. Blocking in is the first stage in which the final form of the subject is approximated. Allot as much time to this phase as necessary, although the lines drawn will not appear in the final work. When painting human figures, be especially aware of proportion.*

> The sketch should be concise and executed as quickly as possible.

◀

3. *Upon completion of the blocked-in lines and subsequent sketching, the roughing out can be begun. The first paint should be very diluted with turpentine. In these first stages, details should be ignored. The first layers of color will be the basis for an entire series of thicker and direct applications later.*

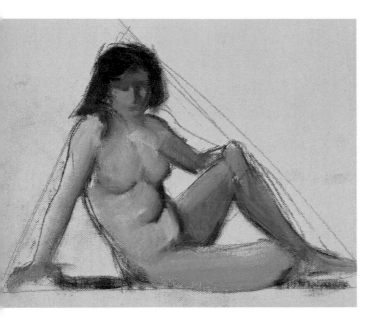

## ROUGHING OUT AND CONSTRUCTION OF THE FIGURE

In order to rough out a blocked-in figure, use a brush that has been dipped first in turpentine and then in a dark color. It is not necessary to stop and correct possible errors. Simply retrace them with a new brushstroke.

▼ 1. *The blocking-in process is finished and the roughing out has begun. The diluted base of color which is applied will serve as a support for later layers of color, as well as providing the initial tones. This first layer is like a rug for the next ones, and blends in and becomes one with the later tones. Denser brushstrokes help to define the contours of forms.*

2. *The addition of these first, darker tones helps define forms and frame the figure within the painting. Contrary to what most amateurs think, dark tones used in the roughing-out procedure should not incorporate black, as it mixes with the rest of the colors. Colors more suitable for this procedure are burnt umber, cobalt blue, sienna, and Van Eyck brown. Dark carmine also enriches dark tones.* ▲

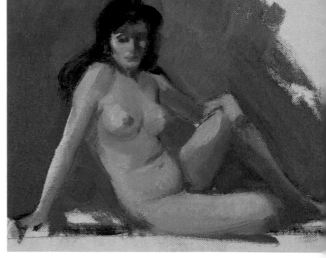

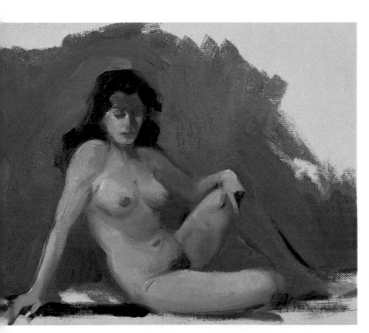

▶ 3. *After darkening the background to make the figure stand out, add the final contrasts. These provide the definitive contours of the figure and unify the different parts.*

## BLOCKING IN AN URBAN LANDSCAPE

After demonstrating how the figure evolves in the blocking-in and roughing-out processes, we will now do a parallel exercise with a subject that may seem quite complex to many people. An urban landscape can be very simple if you understand its elements, or completely chaotic if you do not.

◄ **1.** *Straight, simple lines provide perspective for the wall and the archway. As you can see, the right wall is drawn in a perfectly triangular shape, and the archway projecting from it is sketched in as a rectangle.*

▶ **2.** *With a brush dipped in turpentine, go over the lines of what are to be the wall, the arch and, more importantly, the dark areas defining their forms as well as the main shadows. This completes the initial sketch and the painting of the urban landscape can begin.*

**3.** *Begin to rough out the painting with very flat tones of ocher, starting with the right wall and the archway. As in the previous exercise, this first tone will constitute the base for all later colors. The initial structuring of the painting will allow you to proceed quickly and precisely. In the following steps we will deal with one of the principle problems of on urban landscape: the structure of the painting.*

## DEVELOPMENT OF THE ROUGHING-OUT PROCESS

Although somewhat diluted, the brushstrokes should be direct. Apply the colors very generally at first without many nuances. The surface of the painting should be covered quickly, as the blocking already provides the correct construction of the grounds.

▶ **4.** *If you want to add planes of different tones of a single color, you must use a palette. On the other hand, if you want to add a nuance or contrast to a small area within one plane, you can do this directly on the canvas. Paint the colors making up each area separately, but then add colors in small brushstrokes and mix directly on the canvas. In this roughing out, blue tones come out in the shadows on the left. Rough out the light-filled street area in a broken color made up of ocher, umber, and white, and do the right side in green tones.*

◀ *5. The previous blocking-in process has provided a definitive structure for the painting. Now you can begin to add the nuances appropriate to each area. Contrasts are added in general, whereas shadows are more precisely done.*

▶ *6. Complete the roughing-out process in this exercise with an assessment of the brightest highlights and starkest contrasts in each area.*

# Step by step
# Human figure

During the course of this exercise, it is important to remember the points we have established in this topic, i.e. blocking in based on simplified shapes and the progression of color based on an initial roughing out. Ultimately, specific contrasts and highlights will complete the definition of forms. Note that the technical process in the different sections is the same, and the variation lies in the calculations of proportions and, if necessary, the degree of finish.

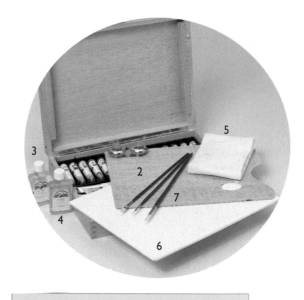

### MATERIALS
Oil paints (1), palette (2), linseed oil (3), turpentine (4), rag (5), canvas-covered cardboard (6), and brushes (7).

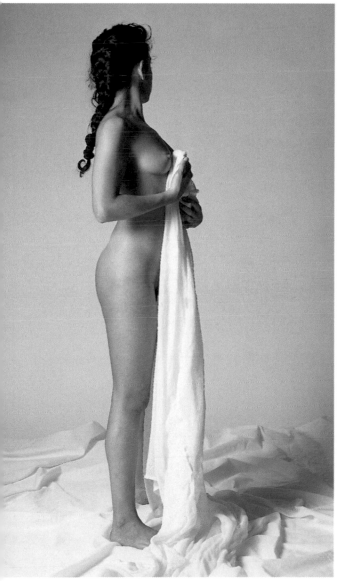

1. In order to rough out the figure, you must first block it in. Here, the previously blocked-in figure has been represented graphically so that you can study it more closely. Based on these elementary forms, complete the outline in a dark-colored oil. For areas requiring a somewhat more definitive line, dip the tip of the brush in turpentine in order to achieve a continuous stroke. Do not attempt to obtain a perfectly constructed sketch.

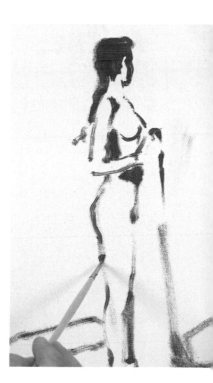

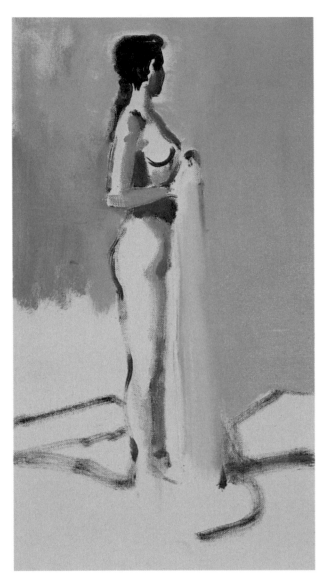

**2.** *Quickly go over the form of the figure with an orange-based color which highlights the contours. This should be done in a brushstroke that outlines the white area yet to be painted. As in previous examples, first paint the background in dark colors so that it makes the unpainted figure stand out.*

Flesh color does not exist as such. But it can be created from a mixture of the following colors: Naples yellow, carmine, sienna, white, and a touch of blue for shadows. Depending on the surrounding colors, orange can be added to highlight specific points.

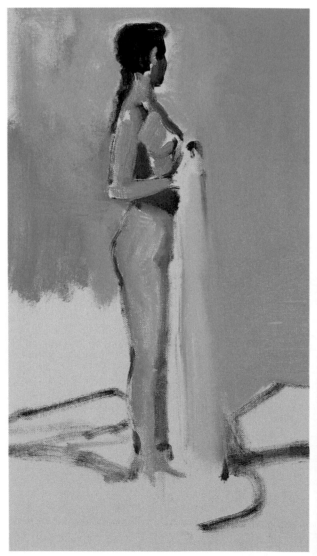

**3.** *Once you have painted the background, rough out the medium toned areas of the figure, for example the left contour of the leg. For the area in the middle of the leg you should use a much brighter color, toned with a bit of white. Along the arm and the breast, apply almost flat colors without attempting any type of modeling. For the moment, the brightest areas should be left unpainted.*

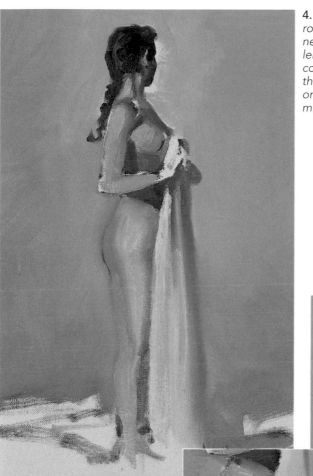

4. *With very concrete brushstrokes in a bright color, rough in the brightest parts of the shoulder, breast, and neck. This will serve as a base for darker tones that will lend volume to the figure. Using a somewhat darker color with a touch of sienna, soften the left contour of the leg and buttock. This color can be mixed directly on the canvas. Paint darker lines of blue and ocher mixed directly onto the sheet held by the model.*

6. *The darker parts should be painted with a mixture of blue, sienna, orange, and carmine. Some brushstrokes will mix the color directly on the canvas and add a note of freshness to the figure. The brighter areas, such as the breast, should be done in flesh color toned with much white.*

5. *Paint the more illuminated part of the leg in a light, bright flesh color, without allowing the brushstrokes to blend together. As you can see in this close-up, the strokes making up the leg are short, horizontal, and very close together.*

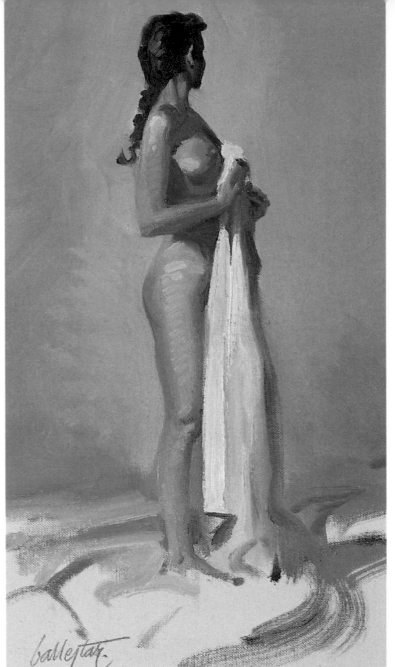

**7.** *To complete the figure, apply color in order to emphasize the depth of the darkest shadows, and add one or two very expressive highlights. So far we have left the entire lower edge of the painting unpainted. These white areas will integrate themselves perfectly into the painting. As a final touch, add a powerful stroke of white to the sheet held by the model.*

## SUMMARY

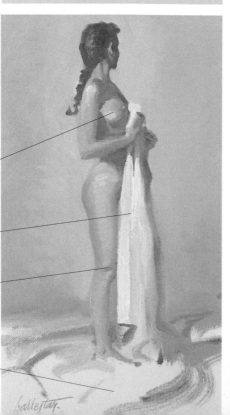

**The highlights of the breast** are painted

**The white of the sheet**

**The knee** was painted with a double brushstroke of carmine, toned with sienna, and white.

**The lower area of the canvas** was left unpainted.

104

# Still life: glazes, highlights, and shadows

## TONAL WORK

The process of obtaining the right tones has been dealt with in earlier topics, but we must return to it, because the process of painting itself is largely based on this principle. It is not only important to learn to represent the highlights in a still life, but also to observe the model closely. This apparently simple exercise demonstrates one of the first mistakes beginners make when faced with a real model.

The still life is one of the most interesting subjects for learning the techniques of oil painting. The main interest lies in the study of highlights, shadows and the main representative methods. Some of the questions dealt with here can be applied to any of the other subjects in this work.

**3.** *The first brushstrokes are applied to the darkest shadow in this still life. When balancing the tones, artists do not usually use black as it reduces the shades of the adjacent colors. Instead of black, you can use burnt or dark umber. A more luminous note is added inside this dark area to underline the contrast.* ▲

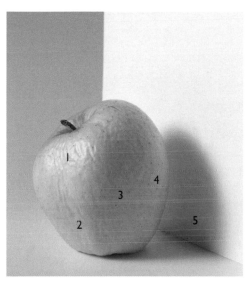

▶ *1. Before starting, study the model to see how the shadows define the different areas. Look closely at this apple and observe different light tones: a point of maximum brightness (1), an area of indirect light (2), a shaded area (3), reflected light (4), and the object's shadow (5).*

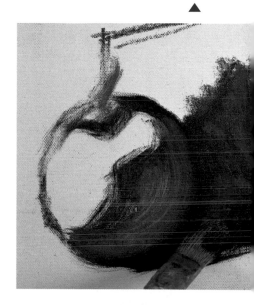

*2. When creating the shadows, it is important to observe the model closely. Make a preliminary sketch in charcoal. After blocking in the form of the apple and the side of the box, draw in the darkest shadow. This is the shadow cast on the wall by the apple.* ▶

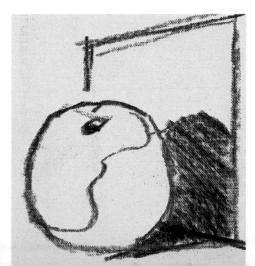

◀ *4. Gently blend the light and dark areas together. The brushwork should shape the shadows depending on the plane in which they lie. These tones will merge delicately.*

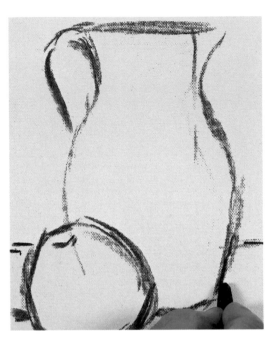

## SHADOWS AND ATMOSPHERE

The range of possibilities offered by shadows allows the artist to create a very rich finish and lend the still life a certain atmosphere. This is done by representing the highlights of the motif in a very limited range of colors. Atmosphere is then created by representing the tones of light and shadow with a certain harmonic range of colors.

▶ *1. Sketch the model using charcoal, which can be easily erased if you need to reposition the main elements. In this preliminary layout define the forms of each element well so as to avoid subsequent mistakes when creating the shadows.*

*3. The highlights are precise lines or spots. The shadows are larger, occupying most of the painting. When painting the areas of light, bear in mind that the point of maximum brightness should be applied last. The colors of the highlights should be mixed on the palette, though they will blend with the intermediate tones when applied to the painting. A perfect sense of atmosphere can be achieved by using colors of the same range.*

▲

*2. Use burnt umber to paint the background against which the main forms of the still life will stand out. Use this tone to sketch the shadows of the two objects as well. Fading brushstrokes are useful for creating intermediate tones.*

▲

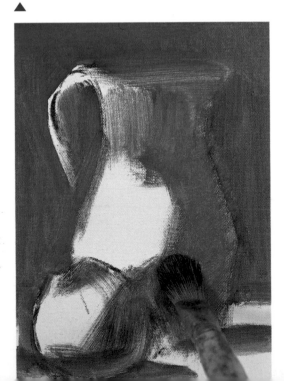

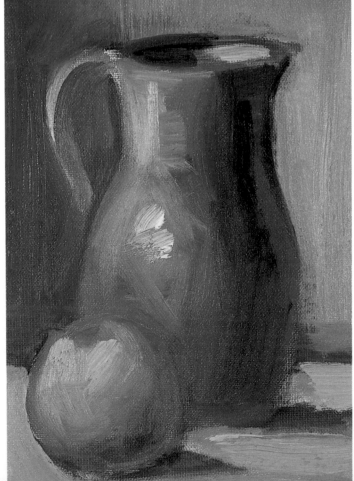

# LIGHT AND SHADOW WITH GLAZES

Aglaze is a layer of oil paint which is so transparent that colors beneath it will still remain visible. So far we have studied how to create shadows using tones that are darkened or gradated, but one of the greatest advantages of oil paint is its potential to be used as a transparent medium. This transparency can be used to create striking light effects.

1. *As in all oil painting techniques, the first colors should be thinned down slightly. Each successive layer should be fatter than the previous one.*

One way to obtain a glaze is to mix linseed oil, a few drops of Dutch varnish, and a tiny amount of oil paint.

2. *Glazes can be used in painting for different reasons: one is their transparency and luminosity, while dark glazes can be used to introduce modifications to the underlying color, without covering it up entirely. Always apply glazes after the first layers of paint making sure, however, that these underlying colors are completely dry, otherwise the two layers will mix instead of being superimposed. Using semi-opaque cobalt blue, fill in part of the background; use the same color to apply a glaze to the shadow of the apple. This glaze should be spread out evenly over the painting with the brush to create a uniform layer.*

## SITUATING GLAZED TONES IN THE PAINTING

Using glazes is a slow process, as the color base of the painting must be totally dry. Nevertheless, it is one of the most interesting complementary techniques for creating subtle shadows. The tones of a glaze do not only affect those of the painting; they can also create a transparent atmosphere, interpreting the light that bathes the still life.

▶ 1. *Use dark glaze to increase the contrast of the tones in shadow. If you apply another glaze over this one, their transparencies will reinforce one another. The resulting effect, however, is not one of greater luminosity, as this is obtained by using luminous colors. An additional glaze will add shades of the tones already present. A completely transparent color painted over a darker one will have no effect. Use a reddish glaze to retouch the shadowy areas on the right and obtain an intermediate tone.*

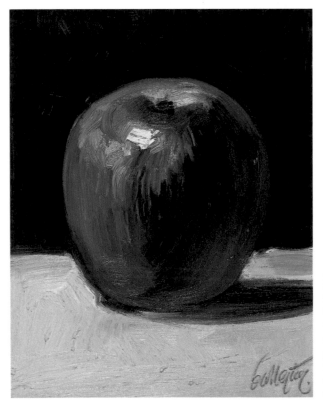

A good alternative for working with glazes is to paint the color base in acrylic since this dries quickly and is then ready for subsequent applications of oil.

▶ 2. *Create the volume by modeling the different tones created by the glazes. Add the highlights with direct touches of white and greenish yellow on the upper part of the apple. When these areas have dried, you can apply a new glaze to adjust the atmospheric illumination; this glaze should be a highly transparent blue. Reglaze the background to darken it and create a greater sensation of depth. Apply another glaze to adjust the shadow of the apple on the table.*

# *Step by step*
# Still life

As we have seen, shadows can be interpreted in different ways. Applying glazes is one alternative, although waiting at different stages throughout the process for the different layers to dry can be rather tedious. On the other hand, glazes are a means of extracting the full potential of oil paints to create shades of color and transparencies. To put this knowledge into practice, we now present an exercise consisting of a still life with glazes. We have chosen a model with an extremely simple composition.

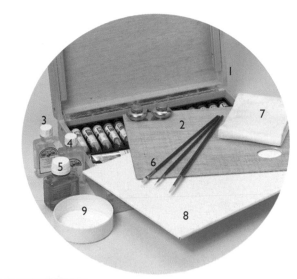

## MATERIALS

*Oil paints (I), palette (2), turpentine (3), linseed oil (4), Dutch varnish (5), brushes (6), rag (7), canvas-covered cardboard (8), and container for mixing the glazes (9).*

**1.** *First, paint the dark area of the background to outline the more luminous forms in the still life. This dark color, a brown mixed with a little black, English red, and cobalt blue, should be slightly diluted with turpentine, but not so much as to make it runny. Leave the lighter areas of the tablecloth unpainted and paint the dark areas with light blue and glaze of highly transparent violet. Do this by first applying the almost transparent cerulean blue. When this has dried, superimpose the violet colored glaze. Paint the shadowy area of the pear green.*

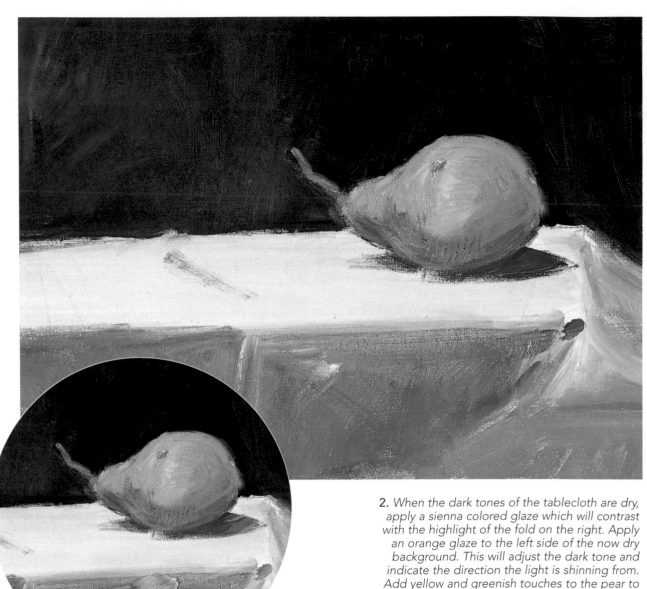

**2.** When the dark tones of the tablecloth are dry, apply a sienna colored glaze which will contrast with the highlight of the fold on the right. Apply an orange glaze to the left side of the now dry background. This will adjust the dark tone and indicate the direction the light is shinning from. Add yellow and greenish touches to the pear to model the form with gentle brushstrokes. The brightest spot on the pear should be a very light yellow. To the right of the main fold, paint a more opaque color that covers the whole of this section. Some of the green of the pear is spread towards the lighted area. When blending colors in this way, very gentle brushwork is necessary. Most of the glaze work will be on the tablecloth. Use a bright blue glaze to modify all the colors already present in the tablecloth.

**3.** Modify the tone of the tablecloth using a luminous, transparent glaze. This effect can only be obtained if the underlying colors are completely dry. Oil paints dry very slowly so we do not recommend using large amounts of color. Paint a very bright ocher glaze over the white. This glaze will also alter the original tone of the darker colors.

**4.** *Wait a whole day before resuming work. Paint the whole of the illuminated area of the table-cloth using sweeping, horizontal brushstrokes in white, yellow, and ocher. A further, reddish, glaze can then be applied to modify the almost black tones: this color suggests a warm light that creates the atmosphere.*

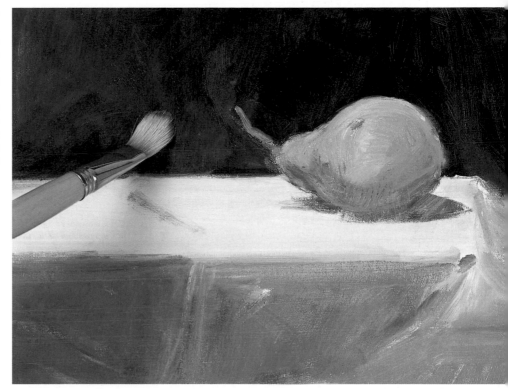

Because glaze work on shadows can be so time consuming, you may want to work on two paintings at the same time. This means less time is spent waiting and more time is spent acquiring a greater understanding of shadows.

**5.** *When the previous stage is completely dry, paint over it again, without blending the colors already on the painting. Paint the dark shadows on the pear with a blue glaze on the right and a cadmium red glaze on the left. Then adjust the color of the tablecloth with glazes over the areas in shadow. Blend these glazes with opaque brushstrokes of a more luminous color. Paint the table top bright white on the right and white tinged with Naples yellow on the left.*

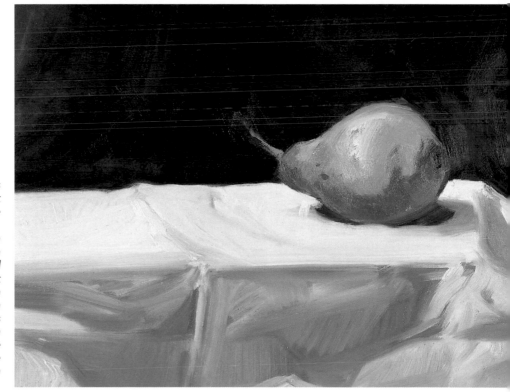

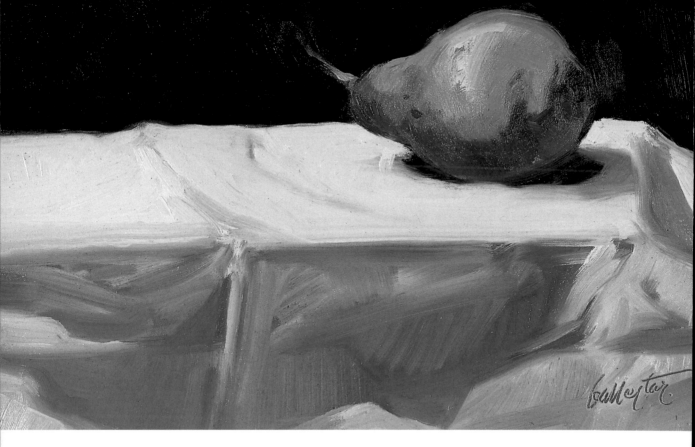

**6.** *Use luminous colors almost verging on white to paint the brightest highlights in the folds of the left side of the tablecloth. This is the final glaze in this exercise. As mentioned earlier, this type of work does not require great effort, but it does demand patience. Nevertheless, this may actually be an incentive for learning to paint in oils.*

## SUMMARY

The **first colors** are the darkest, outlining the form of the fruit and the table.

**All colors should be perfectly dry** before applying any glazes.

**The first layers of color** should be slightly diluted; thick layers of paint should never be used to shorten the drying time.

The **glaze used to darken the shadow of the pear** is blue and red; the modeling of the form should be done gently and gradually.

Different glazes were applied to the **tablecloth**. Their high transparency allows all the underlying tones to remain visible.

**The brightest highlights** were painted using opaque tones when the painting was almost finished.

# Modeling with oils

## MODELING A STILL LIFE

We recommend reviewing the concepts of tonal values, which will make this topic far easier to follow. We have chosen a still life in order to bring out the tonal values of a subject and then model its forms. It is important to study the lights, as well as the gesture of the brushstroke for painting shadows. This exercise is a fitting prelude for modeling a human figure, which will be demonstrated in the next exercise.

The modeling of any subject begins with the tonal values. This is discussed in several topics in this book, and certain basic concepts are provided, such as tonal evaluation, the study of light and shadow, and blending tones. This topic will put this theory into practice using motifs that are well suited to this technique, the still life and the figure.

▶ 1. *Many amateurs do not pay enough attention to the drawing of the model, and often end in failure before ever reaching the painting stage. The drawing is the foundation of the painting. With a good drawing, the application of shadows becomes almost intuitive. An incorrect drawing, on the other hand, will almost certainly lead to incorrectly placed shadows as well.*

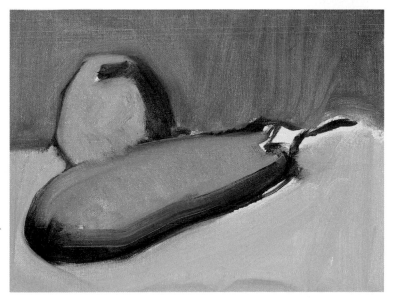

3. *First concentrate on the contrasts between light and shadows. Do not attempt to define anything. Apply the shadows gradually, looking for the form of the light. The first luminous tones will compete with the shadows and cause the emergence of simultaneous contrasts (a dark color placed directly next to a light one causes a mutual enhancement of the two), so you must constantly compensate for this effect by brightening or darkening tones.*

▼
2. *Using paint thinned with abundant turpentine, set out the subject. The advantages of starting with very diluted paint is that the shadows can be situated from the outset and errors are easy to correct. The best way to rectify an error is to run your finger or a rag over the painted area in order to open up a white or remove the undesired stroke.*

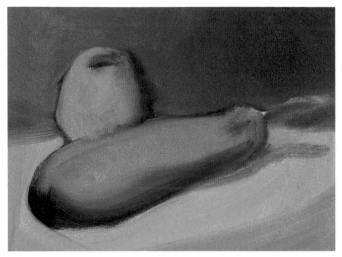

▶ 1. *Dark tones can be blended with light ones by running the brush over the two of them various times. Consider carefully which brush is most appropriate for each one of these blendings. While any type of brush can be used to rough out the canvas, blending techniques demand a particular type of brush, preferably the soft hair type. A wide brush made of synthetic hair can be used to blend tones together; several strokes painted with this brush are enough to blend two colors perfectly.*

## THE USE OF THE BRUSH AND COLOR

The tones demonstrated earlier provide a guide to the light areas of the model. This will allow you to obtain the shadows by blending and modeling. At this early stage of the work, the movement of the brush is important, as shadows cannot be painted solely by gradating tones. The stroke must also be adapted to the object's plane.

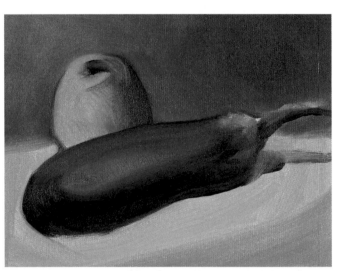

▶

2. *When blending tones, it is necessary to study the plane in which the shadow is located. Because the objects in this still life have curved and spherical surfaces, the brushstroke must follow the form of each plane and distribute the dark tone around the area in light. The idea is to increase the presence of dark tones so that the contrast to the light tones becomes ever more evident.*

> Modeling begins with the application of tonal values and ends with the blending of colors and tones to create the effects of light.

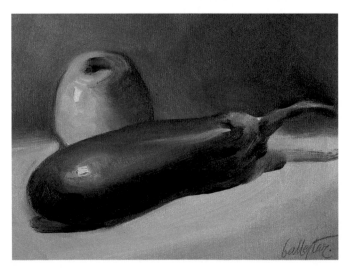

▶ 3. *Only after the modeling is complete can you add the highlights, which indicate the direction of the light and the quality and texture of the object.*

# MODELING A HUMAN FIGURE

The reason we chose a simple still life as the subject of the previous exercise is to demonstrate that regardless of how complex a shape may appear, it can always be reduced to far more elementary forms. The shape of the apple painted in the last exercise can then later be compared to the round shape of a shoulder. Once you have studied how a still life can be modeled using a single color, you can apply the same concepts to model a human figure by means of tonal values. To simplify this question which may seen rather complicated, we have chosen a detail of the human body as the subject of the next exercise. This is an excellent model for studying the way in which light and shadows adapt themselves to different forms.

◀

*1. Having sketched the shoulder with sienna, apply a dark background of the same color. In this way, the drawing fits better within the context of the painting. With a brush dipped in turpentine but still quite dry, add the first dark features of the anatomy. This procedure makes it easy to sketch the shadows and make subsequent elaborations.*

*2. Fill in the interior of the figure using ocher with a hint of orange. This subject will help you see how different curved planes can already be represented with brush-strokes according to the incidence of the light. For the moment the color will be very flat even though there is already a clear differentiation between the planes of light. Accentuate the difference in the light by applying a reddish tone between the chest and the collar bone. In order to highlight the contrast between the background and the figure, add some blue to the background.*

*3. The color base should now be complete. Over this color use tones that contain less turpentine, but are still somewhat transparent. Thus, add some linseed oil or Dutch varnish to the paint, just enough to superimpose a glaze over the background. This first glaze of almost pure white cannot be applied, however, until the background is completely dry.*

▲                                                                                    ▲

## THE COLOR OF LIGHT

When modeling the shapes of a human figure, do not limit yourself to a fixed set of flesh tones. The color of a person's skin is dictated by the color of the light that envelops it. This is a crucial question to bear in mind when the shape of your figure is based on tones and colors reflected off the skin. Another point to remember is that highlights, colors, and shadows also depend exclusively on the light that creates them.

▶ 1. *When painting the color of the light that envelops the figure, begin with the shadow tones, reflected on the skin. Paint the darkest shadows, located between the chest and the arm, with a very dark combination of burnt umber and a touch of red. Allow certain areas to merge, while leaving others fresh with perfectly visible strokes. Blend the highlight on the neck until the brushworks disappear.*

**2.** *Model the figure by gradating light and dark tones. At this stage, intensify the contrasts in the neck and the arm with increasingly delicate brushstrokes that create volume, lending form to the musculature of the shoulder. Here you will notice similarities in the way the volume of the apple in the previous exercise and the shoulder have been obtained.*

▲

Delicate brushwork is required to model the forms of a human figure. A wide brush with a synthetic hair tip is good enough for this purpose.

**3.** *To finish modeling, apply the final contrasts with increasingly dark glazes. Intensify the highlights on the skin by subtly blending them with a brush.*

▲

# Step by step
# Female nude

Modeling in oils is one of the most traditional techniques of this medium. In addition to this, the application of glazes creates transparent layers that modify underlying colors. The subject of the last exercise in this topic is a female nude which will allow you to observe the use of gradations, blends, and glazes to model the motif. To make this exercise complete, we have illuminated the model with great care so as to obtain a good distribution of shadows.

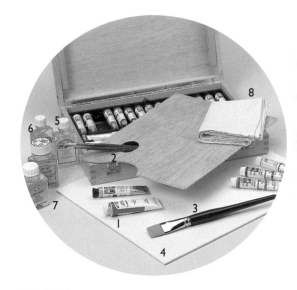

**1.** *Sketch the main forms with a fine brushstroke, and go over each part of the anatomy until you have obtained the right proportions. Paint in the most basic tones of the figure over the perfectly drawn form using two colors toned with white.*

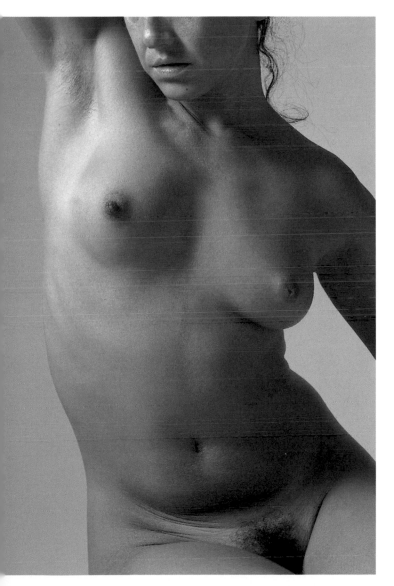

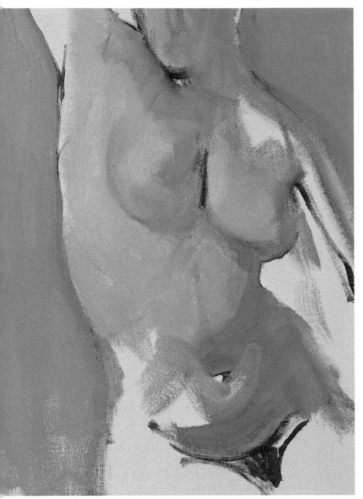

2. *Once you have developed the figure and defined the main areas of light with flesh colors, paint the background in order to outline the shape of the figure. In separating the form from the background, gradate the various areas of light by considering the illumination as a whole. The most luminous colors can now be applied. Without blending the tones, conform the brushwork to the direction of the plane being painted. The modeling and blending of the color should be done in the same direction as the brushstrokes.*

The first layers of oil paint must be very diluted so that the modeling process can be carried out on a lean surface, which allows blending. This process is very important so that the glazes can be added at the very end.

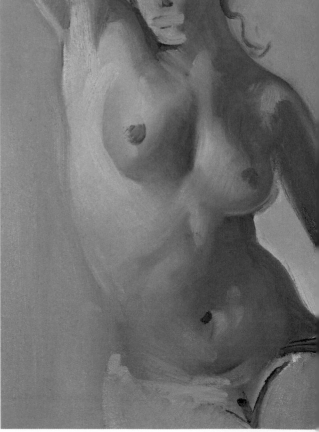

3. *Begin to paint the shadows of the figure and, at the same time, blend the dark tones with the much lighter underlying ones. The brushstrokes used in this blend should follow the direction of the form in its plane. Begin to paint the more luminous tones on the left in the same way that you painted the darker areas on the right of the figure. This procedure will allow you to model the breast and muscles of the raised arm. One important aspect concerning glazes: the stroke must be so delicate that it does not leave a mark on the surface of the canvas.*

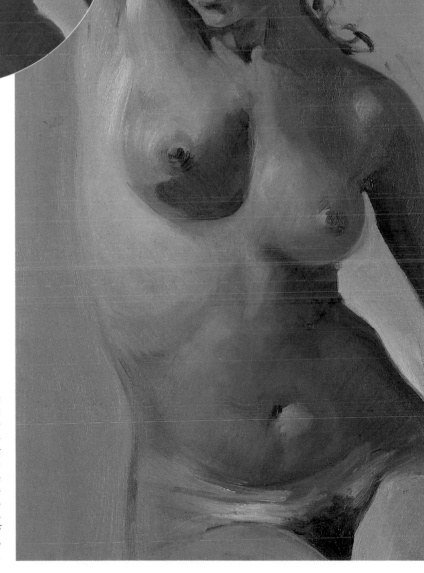

**4.** *Once the painting has dried completely, paint the very transparent glazes with Dutch varnish and medium yellow. Paint the right side of the raised arm and model the top part of the breast with various tones mixed on the palette.*

Yellow light can help the artist to create colors from a specific color range on the palette. The choice of the color of light is very important for obtaining a well-modeled figure.

**5.** *The glazes will blend with the colors that are not glazed. It is essential to allow the first glaze to dry completely before starting the next one in the darkest area of the painting. Prepare a sienna glaze and paint the shadows on the right side of the hips below the breast and the arm. Paint the area around the stomach with a new glaze of orange, which will modify the light in this area.*

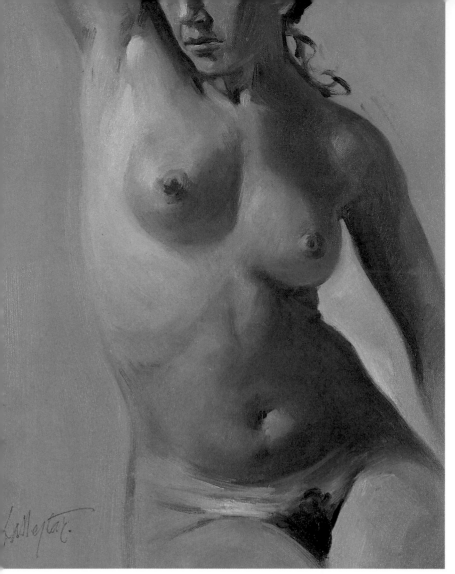

**6.** Deepen the contrasts in the darkest parts of the shadow with a very dark color. Then, make this color transparent and finish the modeling by increasing the shadows of the right breast, the stomach, and the pubis. This completes this exercise in modeling and painting with tonal values.

## SUMMARY

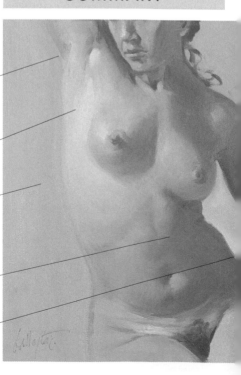

**The preliminary drawing** was sketched with a brush. It is important to use paint diluted with ample turpentine in case corrections need to be made.

The areas of light and shadow were established **with the first layers of color.**

The figure was outlined **with a dark color.**

**The shadows** were created with glazes of sienna and carmine and the use of mode line tonal values.

**A dark tone** lends form to the hips.

# 14

# Flowers

## DABS OF COLOR AND GLAZES

The direct application of pure colors can be combined with superimposed layers which modify those beneath. As we have already discussed in the corresponding chapter, glazes affect lighter colors much more than darker ones. Here we will demonstrate a simple exercise involving the application of glazes.

Flowers could be considered a separate category within the still life genre. Painting flowers requires special techniques which are not normally used in other types of still lifes, such as fruit or vase still lives. If you learn the techniques described in these pages, flowers can become one of the easiest subjects to paint, since in most cases they are not painted in an excessively realistic way, but rather with very loose, direct brushstrokes. In this topic, we will present several interesting examples.

1. The subject of this exercise is a white flower which is very easy to sketch. Few colors are needed and the flower can be painted with direct applications of paint which follow the contours perfectly. The flower ▲ should be painted in bright colors, even though these will isolate it from the background.

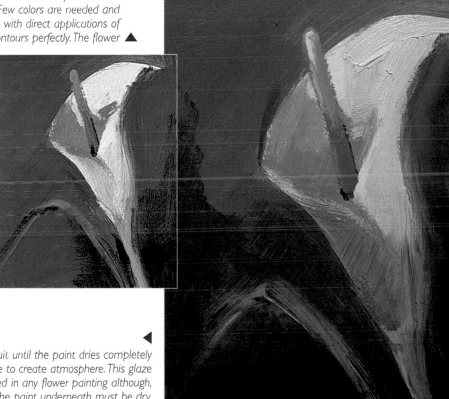

◄

2. You must wait until the paint dries completely before adding a glaze to create atmosphere. This glaze technique can be used in any flower painting although, as already stated, the paint underneath must be dry. Thus, several days may elapse before the final glaze can be applied. Apply a very bright ocher as a glaze on the right side of the flower. A highly transparent blue layer can be added to part of the flower, the darkest areas, and to part of the background. Glazes modify dark colors differently than light ones.

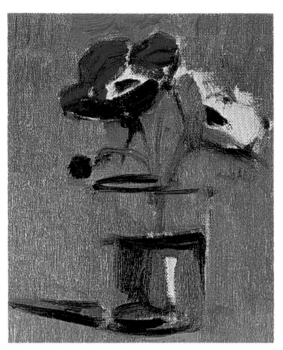

## FROM ROUGHING OUT TO HIGHLIGHTING

In the previous exercise, we applied glazes over bright colors in order to change the luminosity of the flower. This is only one of many options artists have when painting the subject of flowers. Impasto is another technique often used for painting still lifes with flowers, which can be effected with direct applications of color. Flowers usually appear in vases or, as in this example, in a glass of water. Here it is very important to represent the highlights in a clean way, so that the colors nearby don't appear soiled.

▶ **1.** *After blocking in the form, mix the colors you will be using on the palette and apply them to the painting. In this still life, use predominately short, vertical brushstrokes. Fill in the background with numerous brushstrokes in various tones of violet. Leave the most luminous colors, corresponding to highlights on the glass and the right flower, unpainted. The left flower should be roughed out with direct dabs of color.*

**2.** *In order to harmonize the dark colors with the bright ones, the highlights were left unpainted in the previous step. When you add white to the unpainted canvas, the color will not be dirtied by previous layers and will be all the more brilliant. Apply a strong highlight in white to the illuminated part of the glass.*
▲

**3.** *Strong contrasts and brilliant highlights add the finishing touches to the various forms of the flowers and the glass. All highlights will not have the same intensity. Apply the smallest ones, on the rim of the glass, with a direct brushstroke over the darker colors.* ▲

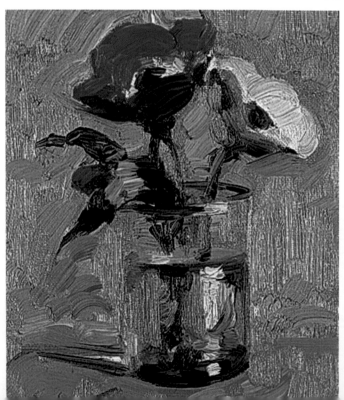

# THE BACKGROUND IN A STILL LIFE WITH FLOWERS

Depending on how brushstrokes are applied within the composition, different planes can be created. Throughout this book, we have stressed the importance of the roughing-out process. Thanks to this process, the flower can be placed in a focal position, without ignoring the background, which plays a key role in the brightness of the whole.

*In these examples we can appreciate how the brightness of the background is crucial in creating a contrast with the main element. Here, the change from one color background to another either heightens the contrast or even almost envelopes the flower completely.*

1. *Points of light especially in areas of great contrast have a great influence on dark areas. They should thus be applied with care. The relationship of the central figure to the background is of great importance, especially in flower paintings, in which the different colors often present great contrasts among themselves. In the initial roughing out it is important to decide which colors will be applied to each plane. At this stage, any changes can be made easily.*

2. *Dark areas do not require as much precision as brighter areas. Brighter areas also have more contrasts and details. The relationship between the tones of the flower and the background can be created by adding darker tones to the flower.*

▲

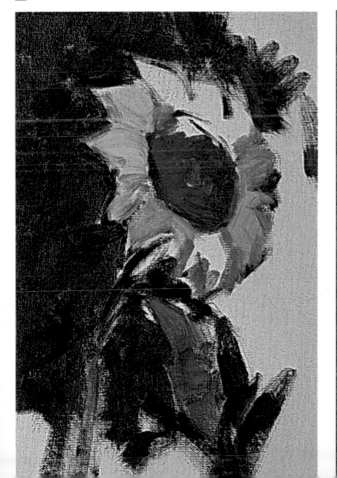

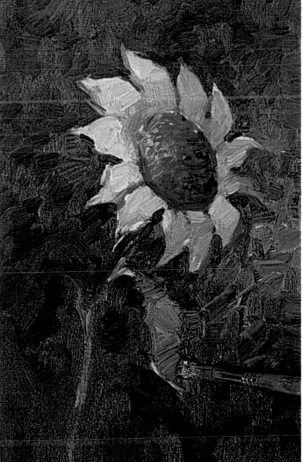

▶ **1.** *Paint the drawing in acrylics after a previous pencil sketch. The strokes should be very similar to those done in oil paint. Acrylics can be thinned with water in order to obtain different brushstrokes and color effects.*

## A VERY PRACTICAL TECHNIQUE

In the following exercise, we will create a flower using two different pictorial techniques. This is referred to as combined techniques. We will use acrylics and oil paints. First we will apply the acrylics, which are soluble in water and dry very quickly. To prevent the paint from drying while you paint, simply dip your brush in a jar of water. Once we have applied acrylics, we will then continue with oil paints to finish off the painting. The great advantage of this technique is the quickness with which you can work and the ease of cleaning the brushes.

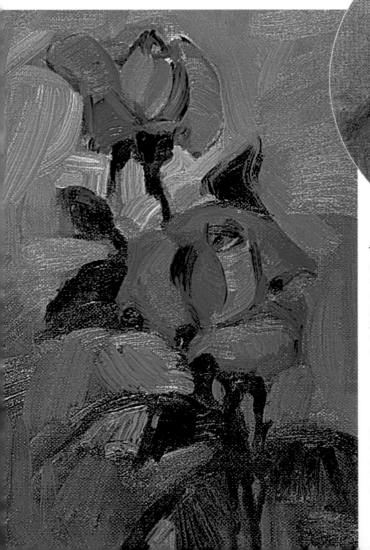

▼ **2.** *Roughing out in acrylic paint provides a good base for oils, which can be applied once the acrylic layer has dried. First paint the background in a very diluted and transparent umber. This paint should dry in several minutes, after which you can paint the flowers in a very bright magenta. The green of the leaves should be added last. Once you have completed the acrylic roughing out clean the brushes thoroughly with water and soap to eliminate any traces of paint.*

▶ **3.** *Once you have completed the entire background in acrylics, you can continue in oil paints just as if the previous layer had been done in oils as well, with the great advantage that it will have dried much more quickly. The final results will be no different from a painting done completely in oil paints.*

## *Step by step*
# Flowers with dabs of color

Often, amateurs find themselves in a dilemma, especially when they don't have a clear image of what they want to paint. This should not pose a problem, as the still life is one of the most exciting subjects that can be captured in oil painting. A simple bouquet of flowers can provide as much satisfaction as the most complex of models. This exercise should be extremely interesting and will allow you to experiment with subtle colors and textures which cannot be used in other oil painting exercises.

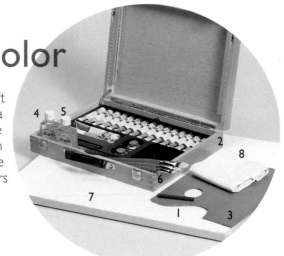

### MATERIALS

*Charcoal (1), oil paints (2), palette (3), linseed oil (4), turpentine (5), paintbrushes (6), canvas-covered cardboard (7), and a rag (8).*

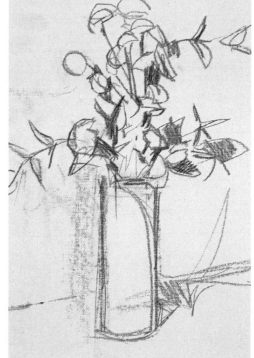

1. *The flower vase has not been placed in the exact center, but slightly displaced to the right, adding interest to the composition. With respect to the drawing of the flowers, notice the total absence of detail. Only the main forms should be drawn in as simple shapes. It is important to draw in the stems and leaves correctly, as they will serve as a framework for the flowers.*

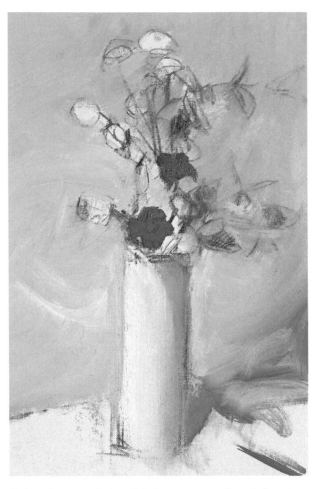

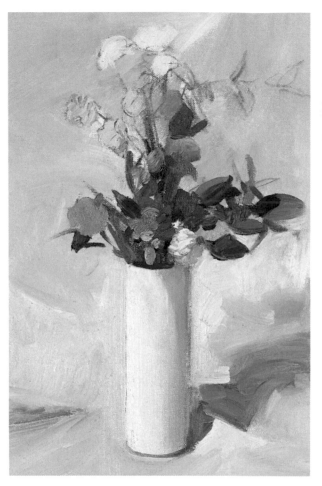

**2.** In a flower painting, it is important to first define the background on which the flowers, stems, and leaves are to be drawn. This is because it is much easier to paint a fine stem on a painted area than to paint a background around such a fine line. As in any other oil painting, the first layers should be more diluted. With this in mind, apply the background in a well-thinned cerulean tone. Mix some white brushstrokes directly on the canvas, with several touches of cobalt blue. Paint the carnations directly in reddish tones without too much definition. Rough out the shaded side in green, which will blend into the white of the illuminated side.

**3.** Emphasize the contrast of the shadow of the vase on the background with cobalt blue toned down with white. The base can be precisely outlined in this color as well. So far, the colors used to rough out the flowers, although executed in direct strokes, have been muted. This allows you to apply much brighter colors now. The previous colors now become the darker areas of the flowers. The brushstrokes on the petals should be added as small touches of light, implying the form of the petals without defining them.

Although you may want to use fresh, spontaneous brushstrokes, avoid doing this in works where you want total control of the forms. Excessively thick applications of paint will prevent details.

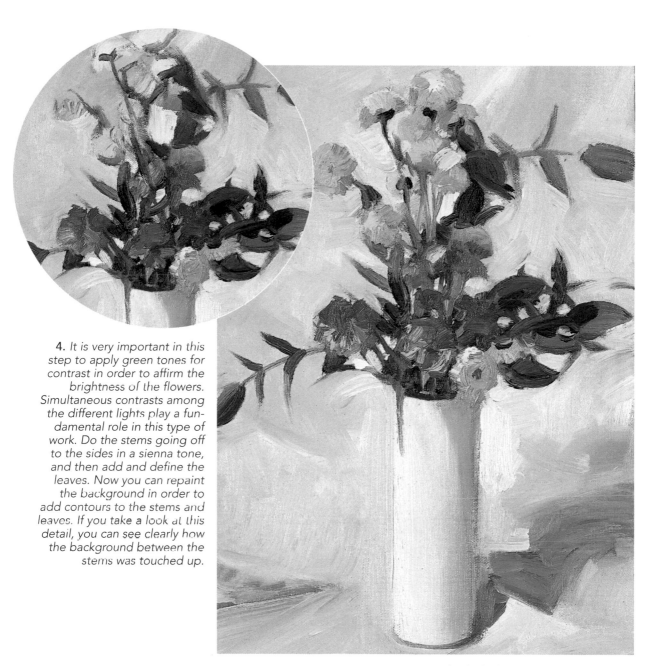

**4.** *It is very important in this step to apply green tones for contrast in order to affirm the brightness of the flowers. Simultaneous contrasts among the different lights play a fundamental role in this type of work. Do the stems going off to the sides in a sienna tone, and then add and define the leaves. Now you can repaint the background in order to add contours to the stems and leaves. If you take a look at this detail, you can see clearly how the background between the stems was touched up.*

**5.** *Paint both the background as well as the flowers in a very defined interchange of color. Then you can begin to paint the stems to finish off the bouquet. Paint these remaining details onto the blue background. As the brush moves along, it will mix some of the green with the background, which is an important factor in transmitting the brightness of the atmosphere. You can enhance the flowers with direct and luminous applications of color, keeping in mind, at this stage, the direction from which the light is coming.*

It may seem that the background is of little importance and does not deserve special attention, but this is not quite true. The emphasis, relief, and color of the central motif depends to a large extent on whether the background is done well.

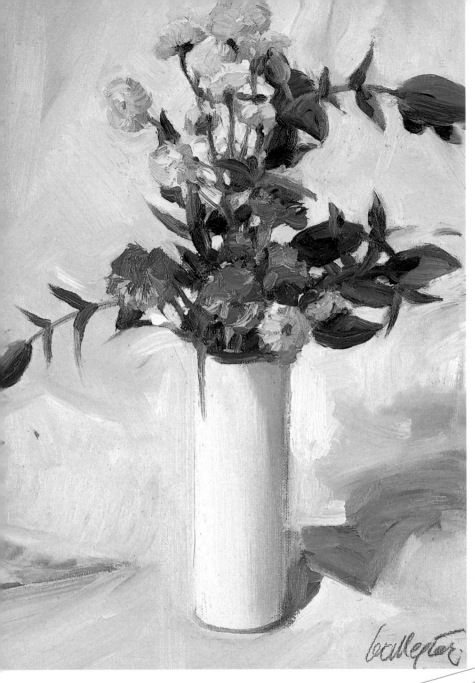

**6.** *The finish of this still life should be very fresh, thus be careful with your brush work so that the colors do not mix too much. The finishing touches will be the addition of the most powerful and direct highlights. In yellow flowers, cadmium yellow can be used for the strongest and most brilliant colors, and Naples yellow for the highlights. In carnations, the color used for highlights is white, which creates pink tones when it mixes with the carmine of the flower.*

## SUMMARY

**The background** was roughed out first, since the stems and flowers must be painted in over it.

**The flowers** were roughed out without a very defined form. Yellow flowers should be done in a grayish tone at this stage.

**The stems,** added at the end, mix in with some of the background color.

**The highlights in the flowers** should be done at the end, with very direct and contrasting strokes.

# Depth in the landscape

## BUILDING UP A LANDSCAPE

Artists build up a landscape by creating the planes where the elements they want to include are situated. For instance, in this landscape, we could have chosen not to include the water situated between the trees and the spectator, but we have opted for the composition reproduced here in order to lend depth to the subject by means of this extra plane.

The landscape is the best link there is between the painter and nature. Some of the questions included in this subject might appear complicated if they are not tackled with the right techniques. This topic will expound on some of these problems, such as depth and how to achieve each one of the planes by means of color, brushwork, and roughing out. You will find answers to any questions or doubts by following the exercises carefully.

▼ 1. The sketch is paramount since it allows you to study the composition and carry out any corrections that may be necessary. Even though it is done with a brush, the sketch for a painting is still considered a drawing. With a brush dipped in turpentine, that is damp but not wet, you can sketch with a texture that facilitates the execution of the basic forms.

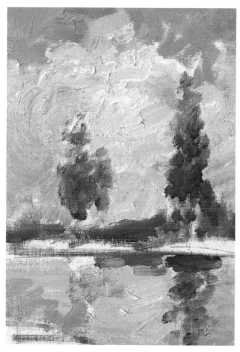

▼ 2. Using the outline drawn with a brush and very little color, begin to paint with luminous tones. In this type of work, abundant paint is normally applied to the canvas, so it is necessary to define each area of color well beforehand. The brushstrokes must have a constructive character according to the plane being painted. The colors of the sky are definitive, although the dark color of the trees and that of the reflections on the water are not.

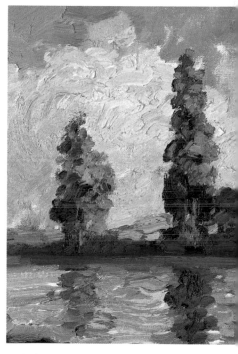

▼ 3. Once you have the brightest colors, apply the dark ones. In this exercise, the short brushwork and impastos should not drag up the underlying colors of the picture. Be careful to use just the right amount of pressure when applying the paint to the canvas. In this manner, paint the trees with many tiny brushstrokes, alternating the light colors in the brightest area with dark tones in the shadow.

## PATCHES OF COLOR

The depth of a landscape can be interpreted by means of a series of patches that define each one of the forms and objects. The painting of a landscape using patches is a highly effective way of achieving the various planes required to create depth. The next exercise in this topic is designed to demonstrate how a landscape can be given depth by painting the trees with patches of color.

▼ 1. *Each stroke applied will directly define the plane of the object being painted. Build up the sky with tiny brushstrokes applied in no particular direction, so that an ambiguous texture is created in the background. For the trees, apply the brushstrokes in the direction of the plane; paint the brightest greens first. Paint a dark green tone in the area in shadow, this patch of color is not as constructive as that painted in the brightest area.*

A filbert brush is the best type of brush to use for this exercise. It produces brushstrokes without a pronounced cutoff which facilitates quick blending. The use of a medium-sized one will help you to avoid unnecessary details.

3. *As the painting process comes to a close, the brushstrokes should become more precise in an attempt to lend form to the plane. The foreground is always the most detailed plane, while the receding ones become gradually less defined.* ▲

▼ 2. *Paint new direct tones in the treetops, without allowing the dark and the light tones to blend together. Each stroke should represent a plane that lends the crowns of the trees shape. Some strokes will superimpose others, permitting the different tones to alternate in the borders between light and shadow. Vary the brush treatment according to the distance of the tree from the spectator. Paint the ground with burnt umber, sienna, carmine, yellow, green, and white; the stroke in this area should be slanted and each application should drag some of the adjacent color with it.*

## VARIOUS TEXTURES

In this painting, the texture of the brushstroke takes on a prominent role since, as you will see shortly, several simple patches of paint can represent a dense clump of flowers or the crowns of a group of trees seen from a distance. Textures in the foreground must be treated differently than those in the background.

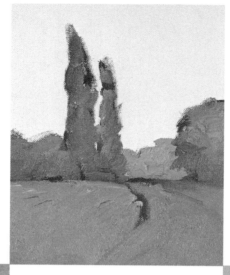

▶ 1. *In the preliminary application of colors, the tones that separate planes according to distance provide the greatest contrast. In the first part of the painting, during the roughing out, avoid superfluous work. In the landscape genre, the roughing out of color provides a base on which subsequent brushwork and, toward the end, textures can be applied.*

◀

3. *The tiny hints of color differentiate the painting's planes and bring out the textures, volume, and brightness. Paint the clouds white and the sky that outlines them light blue. Paint the dark areas of the vegetation directly over the underlying colors.*

▼ 2. *Paint dark colors around the areas reserved for the lightest tones. By painting blue the part reserved for the sky, the clouds will be perfectly outlined. In order to guarantee that these white areas remain clean and untouched by the adjacent blue, apply the white to the clouds from the center outward, and do not go over it a second time once the brush has come into contact with the adjacent color.*

▶ 4. *With direct applications of yellow painted over the previously applied green, add the main areas of light. The final details should include tiny dabs of red to define the poppies. The texture in the foreground is more evident and contrasted, while the texture in the more distant planes is far more general in terms of area rather than detail.*

## DEPTH AND COLOR

There are so many ways to paint a landscape that it is impossible to mention them all. Landscapes can be executed with all kinds of color patches and strokes, planes painted with direct applications of color, and a wide range of techniques used to convey the sensation of depth. Color can also be employed to heighten the effect of depth. If artists wish to paint a colorful landscape, the receding planes of the land and sky can be defined by color.

▶ 1. *In this landscape at dusk, paint the sky orange, going around the areas reserved for the clouds. Paint the dark areas with patches of violet. The two colors used from the start of the painting are complementary colors, therefore, by including violet, an interplay of contrasts is established, thus making the clouds appear much brighter.*

▶ 2. *Tone down the colors that are too bright according to the effect of distance. Harsh contrasts must be compensated for by adding several grayish tones. Paint the white of the clouds in this way (since clouds are never pure white). In order to avoid a too striking contrast, begin the areas of light in the brightest part and drag some of these tones in with your brush as you move on to the darker colors.*

▶ 3. *Paint the lower part of the landscape with two tones of green. In the foreground, the brushstrokes should be dark and vertical. In the background they should be a yellowish color and long and horizontal. The last application should consist of several small and quick strokes of dabs of red, which contrast with the green fields.*

# Step by step
# Landscape

The oil medium allows the artist to paint a landscape in numerous ways. The subject that we will demonstrate next requires the painter to develop each one of the different forms of depth contained in the model. If you scrutinize the picture carefully, you will see that there is a stream and a tree in the foreground on the right. The most distant planes possess much less detail and at the same time contain abundant vegetation. This landscape is not difficult to paint, although it is important to build each area correctly.

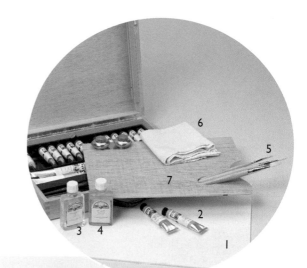

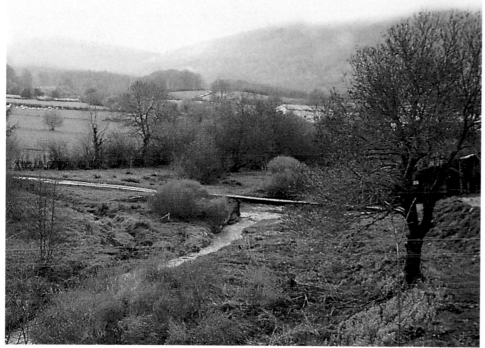

## MATERIALS

*Canvas-covered cardboard (1), oil paints (2), linseed oil (3), turpentine (4), brushes, (5), palette (6), and a rag (7).*

**1.** *Sketch the planes of the landscape directly using paint thinned with a high amount of turpentine and relatively dry brushstrokes. Represent the main forms of the trees in the background with thick applications of dark color. In earlier topics, the sketch was used to obtain as much of the model's forms as possible. In this exercise, only the main lines of each plane should be painted in.*

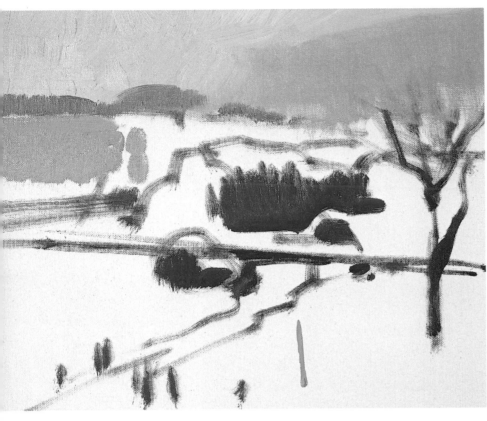

**2.** *Once the sketch is done, paint the sky with a color containing a greater proportion of white, cerulean blue, and a hint of carmine. To finish the first phase of this painting, apply long brushstrokes that are blended together. It is important to keep the different color treatment for each one of the landscape's planes in mind. The farthermost planes should be painted first with untextured brushwork, then the nearer planes with finer applications of thick paint. The effect of these strokes helps to construct each of the planes in depth. After roughing the sky, paint the violet tones (mixed with white) of the mountains and the first mass of green in the background.*

To paint each one of the planes correctly, the main dark areas must be defined. Corrections on a roughed-out canvas can be made with a rag soaked in turpentine or, if there is too much paint, with the help of a palette knife.

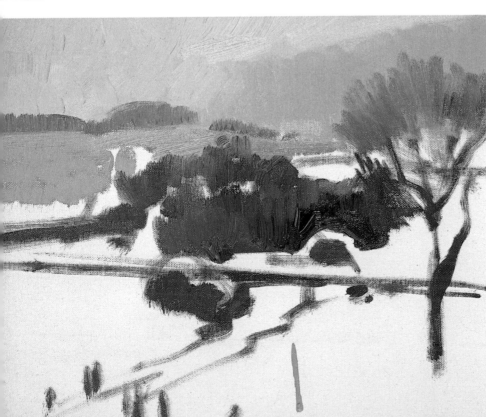

**3.** *Paint the tones of the nearest planes with a color containing much less white than the farthest ones, and apply it to the canvas in a pure state. This way, the contrast with respect to the planes in the background can be increased. The brushstrokes should be much smaller and thicker for the trees in the center of the landscape. In this area, use light, tiny brushstrokes that do not drag any of the underlying color with them.*

**4.** In the middle ground, apply a white tone above the trees in order to outline them. Starting at the top, paint blue vertical dabs over the whitish green of the background, mixing them but without allowing the two colors to mix. In the surrounding area the strokes should be shorter and abrupt; paint a variety of green tones in the middle ground and on left-hand side of the stream.

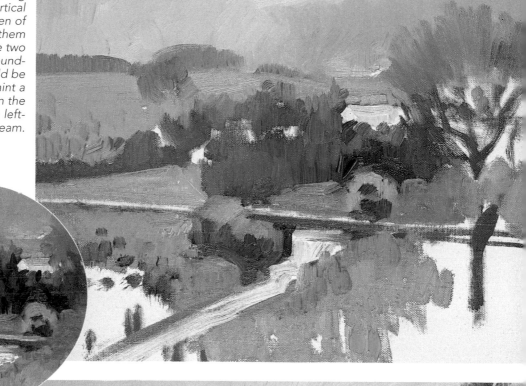

**5.** Paint the trees in the middle ground with a great variety of short strokes in tones of violet, blue, and dark carmine.

**6.** Paint the darkest contrasts in the center of the wooded area. The most luminous brushstrokes in this area can be made with very clear tones of violet. Paint the darkest areas with dark green and blue. On the left bank of the stream, use closer together, more contrasted strokes than those on the right. Give the tree in the foreground greater detail. Starting at the crown, use short brushstrokes that drag part of the underlying color with them. Then, paint the trunk with a very dark brown.

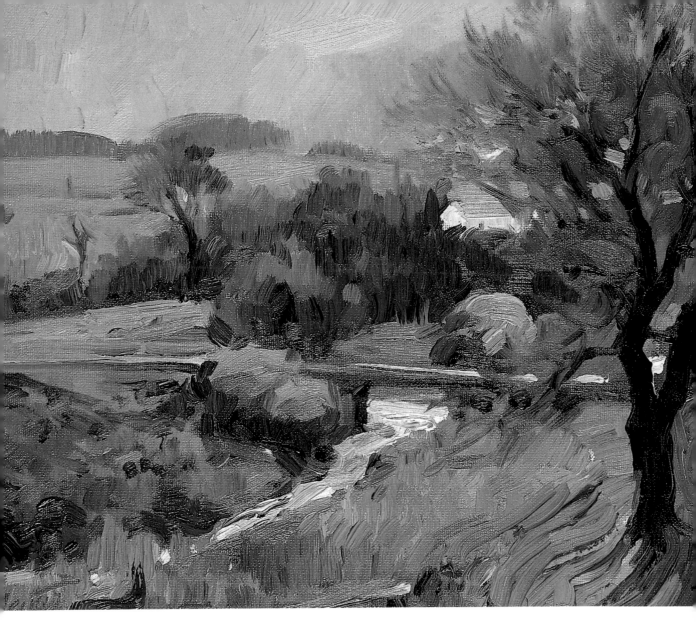

7. All that remains is to gradually increase the contrasts with tiny strokes that heighten the tone, while defining the forms of the landscape's nearest planes. Paint new dark tones on the left bank of the stream, thus increasing the contrast with the brightness of the water. Emphasize the contrasts on the right side in the area nearest to the foreground.

## SUMMARY

Long brushstrokes were applied **to the sky.**

**The colors of the background** contain white to increase the sensation of depth.

**The darkest colors** in the center of the landscape were painted with tiny vertical strokes.

**The treetop of the nearest tree** was built up gradually, superimposing short, contrasted strokes over the tones blended with the background.

**The brushwork in the foreground** should become increasingly smaller and contrasted.

# 16

# The sky

## THE STRUCTURE OF CLOUDS

When painting in oils, it is essential to follow certain steps. This is true for any subject, even one as abstract as a cloud. One of the most important steps is the preliminary rough sketch of the shape, which should precede the painting of the subject as such.

The sky is one of the aspects of landscape painting that gives artists more opportunities for expression. Although a landscape may remain virtually unchanged for long periods of time, the sky is constantly changing, and these changes in the sky affect both the color of the landscape and its feeling or atmosphere. The effects produced by the sky have so many possible variations that every time we deal with a given landscape it can produce a different painting. Every cloud we paint will be different; its unique shape will never be repeated.

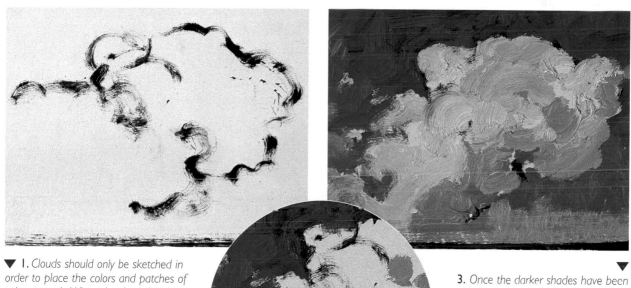

▼ **1.** Clouds should only be sketched in order to place the colors and patches of color correctly. When sketching the shape of a cloud, you must use a heavily diluted brush and very little color. The traces left by the brush will be more than enough to suggest the main shape of the cloud.

**3.** Once the darker shades have been filled in, we paint the main white areas. Naples yellow can be used instead of pure white to break up the excessive brightness. Dabs of white are added to the areas painted in blue, mixing the colors with the strokes of the brush.

**2.** Mix cerulean blue with Prussian blue and white on the palette. Use this mixture to paint the sky around the clouds until their shape stands out against it. The clouds will be outlined by the surrounding sky; the white in the background is the unpainted canvas. Use grayish shades with a touch of blue to paint the clouds, leaving the luminous areas blank.

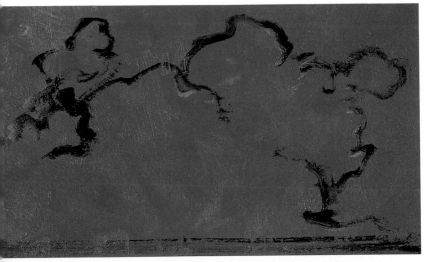

▶ **1.** *The first layers of paint should be fairly diluted so that it flows across the canvas. This will also act as a foundation for later layers, which will require much thicker paint. First sketch the basic shape of the clouds directly with oil paint. The sketch does not need to be very precise, although it should contain the most important forms so that the colors can be accurately placed.*

## THE USE OF WHITE

In this exercise we will study the effects produced by using a base color instead of the white of the canvas. This will help you to understand the treatment of white in the painting of clouds. This is a simple exercise, although it requires knowledge of different color ranges. Before starting, the canvas-covered cardboard should be primed with acrylic. This dries very quickly, so painting can begin almost at once.

▶ **2.** *The shape of the clouds is framed by the blue of the sky, which undergoes a gradation towards the horizon. Use a very pure blue to paint the uppermost area of the sky, which will frame the shape of the clouds and blend into white in the lower sections. When using oil paints, colors can be painted one on top of each other, regardless of how bright they are. The lighter colors, such as white or Naples yellow, are easy to apply, so it is essential to clearly establish the limits of each area before starting to paint the highlights of the clouds.*

▶ **3.** *Start painting the clouds in their darkest parts. Add the whites and the direct highlights last. It is important to avoid stark contrasts between light and dark areas. Blend them softly at some points, taking care not to create sharp angles. Leave the white for last, painting in the highlights that have been left blank. Finally, fill in the most luminous areas with applications of pure white paint. Pay special attention to the direction of the brushstrokes in each of the areas of the clouds.*

**1.** *First rough out the sky scene. Afterward paint in the blue tones that define the shape of the clouds by contrast. Your brushwork should be free without blending the different shades of blue. The inside of the clouds should also be painted freely, starting with the grays that enclose the highlights and ending with the whites of the brightest points.*

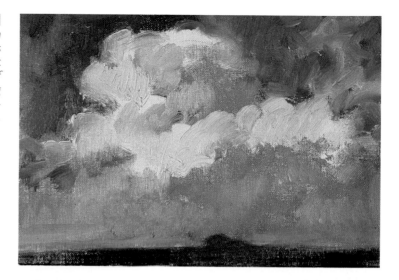

## COLOR IN THE HORIZON

When painting clouds, different areas of the sky must be represented with different shades of color. Depending on the time of day, the weather, and the vantage point, the appearance of the sky can vary considerably. In order to practice this subtle effect, we have suggested painting the sky with a spontaneous finish. On top of the first sketch, we will continue the painting, blending the shades until the brushstrokes are completely eliminated. Note the treatment of the colors in the area of the horizon.

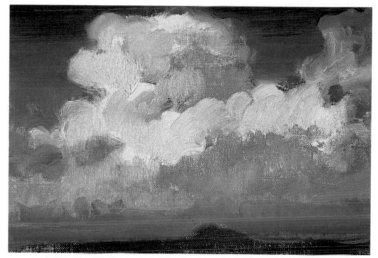

**2.** *Up to this point, the colors have been painted in a direct spontaneous style, and as a result the differences in color with respect to the horizon are clearly visible. The painting could be left as it is, but this exercise will go one step further, blending the colors until they create a completely different impression. Start by softening the blues with a filbert brush, continuing until the brushstrokes are completely blended.*

**3.** *While softening the blue shades of the sky, add new tones to enrich the colors of the painting. Apply tones of violet in the upper regions of the sky and reddish tones near the horizon. The brushstrokes should be fluid and very soft. Brush over the new colors repeatedly until they blend with the underlying colors, taking care not to leave visible brushstrokes on the painting. In this final step, add a few drops of linseed oil to the mix on the palette, as well as another few drops of Dutch varnish, to produce very fluid paint.*

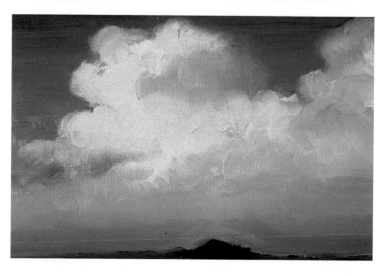

▶ 1. *Impastos of color are extremely simple to paint. When we are not dealing with sharp, direct contrasts, a range of luminous tones can serve as a base. After painting the cloud with the appropriate half tones, surround it with a dense atmosphere of Naples yellow. This method produces an effect of great luminosity. As you can see, the sky does not always have to be painted blue.*

## SKETCHES

Sketches permit a quick, spontaneous representation of clouds. An exercise like this one can serve as a basis for other paintings or simply as practice. Colors can be applied in a variety of ways with expressive brushwork or blending. Both of these methods are perfectly applicable to sketching. The atmosphere, combined with impastos, can produce interesting effects. This idea will be developed in the following exercise.

▶ 2. *Once the more luminous tones have been painted, use darker shades to give shape to the clouds. Burnt umber, brown, or any dark tone of blue should be used, rather than black. Paint the necessary gray areas inside the cloud and then add the brightest whites on top of this.*

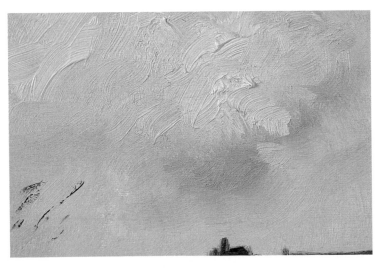

▶ 3. *Finally, blend some areas of the cloud with the yellowish sky, merging these areas into the atmosphere. This produces the effect of a dense, slightly misty atmosphere.*

## Step by step
# Sky with clouds

As a subject, the sky is simpler than a still life or a portrait and has the additional advantage of allowing artists a great deal of freedom of expression. Painting a sky is a pleasant exercise for an artist, since it offers gratifying results without overly complex procedures. In this exercise we will paint a cloudy sky. Although generally absent from the picture, a thin strip of land is included that ads as a reference point and brings out the immensity of the sky.

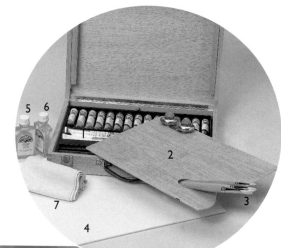

## MATERIALS

*Oil paints (I), a palette (2), paintbrushes (3), canvas-covered cardboard (4), linseed oil (5), turpentine (6), and a rag (7).*

**1.** *First, sketch out the shape of the clouds. These first lines immediately establish the main forms of the clouds and their distribution in the sky. Use diluted cobalt blue so that the brush slides easily across the canvas. The clouds take up most of the surface of the painting, as the sky is very overcast. In fact, there is only a small amount of blue visible. The sketch should only outline the most important forms without going into any detail.*

# STEP BY STEP: Sky with clouds

**2.** *Once the shape of the clouds has been sketched, fill in the small areas of blue in the sky, using Prussian blue mixed with cerulean blue. As you paint the lower areas of the sky, increase the proportion of cerulean blue, which gives a soft gradation creating the impression of a low sky seen in perspective. The previously sketched clouds should now be perfectly framed against the blue in the background.*

**3.** *Paint the strip of the horizon with brownish paint mixed with a touch of blue. Once the background has been painted, rough out the clouds that are framed against it. The clouds will be painted with leaden tones. These grayish tones can be obtained by mixing the original color with white. Paint the big cloud on the left with a mixture of Prussian blue and white, increasing the amount of blue in the white and not vice-versa. Use Naples yellow for the brightest part of the cloud. In the lower section of the painting, the areas near the horizon should be painted in very light shades of violet.*

**4.** *Paint the brightest highlights of the big cloud on the left with cerulean blue mixed with abundant white. The colors in the cloud on the right are grayer and stormy. These grayish colors can be obtained by adding Van Eyck brown to the gray mixture.*

It is a good idea to keep a file of photographs organized by themes. You can use your own photographs or cut them out of magazines.

**5.** *The tones of gray in the lower area of the picture should become progressively darker. These tones, produced by mixing Van Eyck brown, Prussian blue, and white, should be painted on top of the lighter shades used in the first part of the exercise. Paint in blue areas between the clouds on the left, creating a contrast with the lower area of the cloud.*

When creating different tones of gray, it is always preferable to use brown or umber rather than black. When black is used to darken tones, the resulting ranges of color are poor and rather dirty. Moreover, if yellow is used in the mix, the gray derived from black becomes a dirty greenish color.

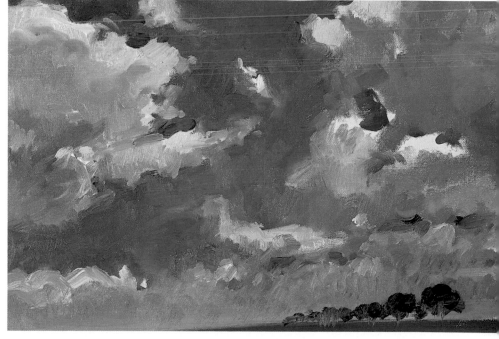

**6.** *Paint the lighter areas of the clouds with white mixed with the colors on the palette. Mix the white with quite a bit of color, especially in the lower areas near the horizon. In this area, apply short strokes that drag part of the underlying tones with them. Then sketch the profile of the trees on the horizon using dark, thick paint. The nearest trees should be larger and well contrasted, whereas the farthest ones should be smaller and merely suggested with tones that are a little darker than the sky.*

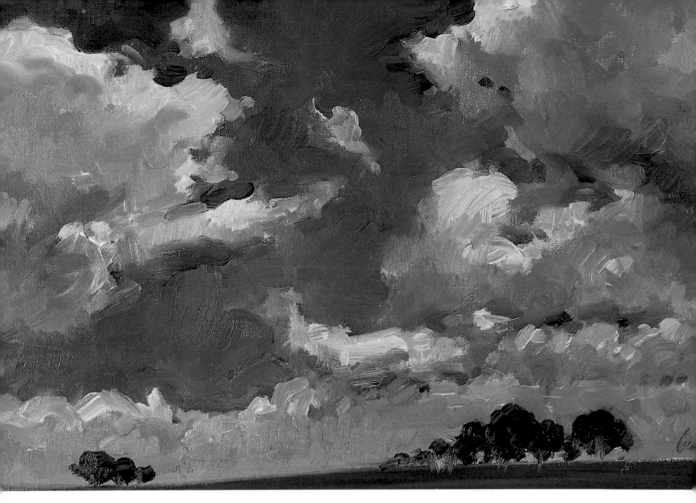

**7.** *Paint some trees on the left-hand side of the horizon to help define the lower area of the landscape. Paint the brightest highlights of the clouds last with nearly pure shades of white, filling in all of the parts that were left blank. At this stage, the brushwork should be much more precise. This can be seen in the cloud on the right, which requires most of the work.*

## SUMMARY

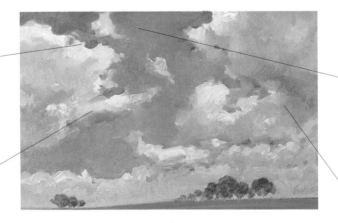

**The sketch of the clouds** was painted using slightly diluted blue paint. In terms of technique, the initial stage of this subject is no different from any other oil painting.

**The lightest shades** were painted last. The details should be painted with dabs of pure color.

**The blue in the background** outlines the shape of the clouds, even though the clouds take up most of the landscape. Tones of gray were used to darken the shaded areas of the clouds. It is important to avoid using black to obtain grays, since this produces excessively dirty tones.

**The darkest shades of gray** were obtained with Van Eyck brown. These gray tones model the clouds, giving them their final shape.

# Trees and plants

## SKETCHING A TREE

No matter how simple a tree may appear to be, it is never just a stick with a few branches attached to it. It has a sinuous shape, often with small variations that develop into knots or grains. Apart from this, the initial sketch of a tree should follow the same geometrical patterns as the other subjects we have dealt with in this book. Even a complicated tree can initially be regarded as a series of simple geometrical forms. The following exercise shows how a tree can be developed from simple lines and forms.

The tree is an element of the landscape that requires a close study of nature. Painting a tree depends essentially on sketching its shape. In this section we will look at the structure of the trunk and branches and also deal with the painting of other kinds of plants. The focus will be mainly on the use of color and the appropriate brushwork for each area. The following exercises will provide a wide variety of methods and techniques that can be used in landscape painting.

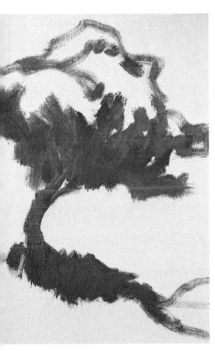

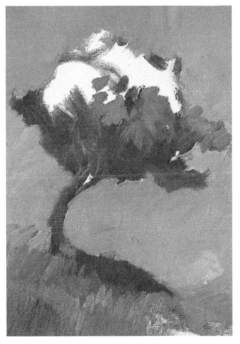

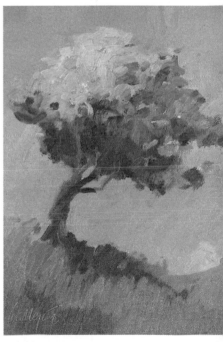

▼ 1. After the preliminary sketch, fill in the dark areas of the crown and the trunk, using dense brushstrokes of a dark color. Paint these areas as definitively as possible, paying special attention to the direction of the brushstrokes, which will give the tree its texture. In the first stages, it is important to avoid varying the tones so that the distinction between light and shadow is clear.

▼ 2. So far, the shaded areas that outline the highlights have been painted. Now fill in the background so that the whole shape of the tree is clearly outlined and the highlights are isolated. By filling in the rest of the painting and leaving the crown blank, the color of the background becomes evident. This color can be obtained by mixing blue, white, and red along with some of the other colors left on the palette.

▼ 3. After positioning the highlights and filling in the shaded areas, paint the most luminous areas to bring out their full brightness. This area should have been left blank to prevent the lightest shades from being stained by other colors. It is essential to be especially careful with the texture created by the brushstrokes, which should be short and close together. As you can see, some of the yellow lines should be mixed directly on the canvas.

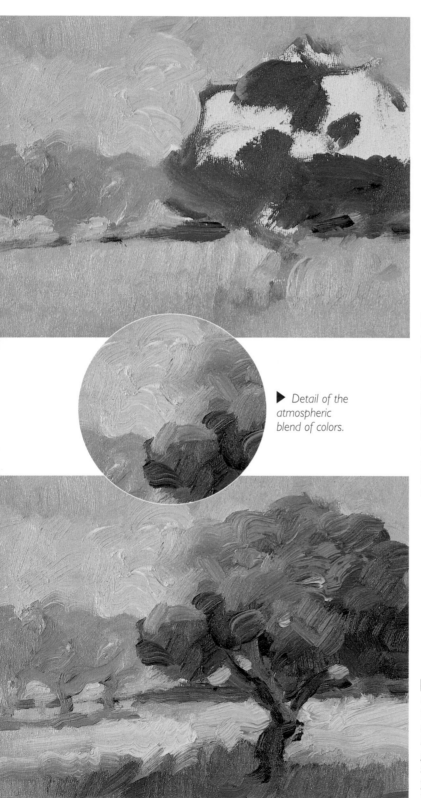

▶ Detail of the atmospheric blend of colors.

# THE CROWN OF THE TREES AND THE ATMOSPHERE

The previous exercise involved painting one tree in isolation. The atmosphere allows us to position the trees in the landscape. As we will see, this is not an overly complicated process: it simply involves taking the background color into consideration as a contrast to the color of the tree.

▶ 1. *This exercise involves positioning some of the trees in the background and others in the foreground closer to the vantage point of the observer. The trees in the background should be painted with patches of colors that blend in with the color of the atmosphere. In this case, use a very whitish shade of green with some Naples yellow added to keep it from becoming too much like a pastel. As in the first exercise, frame the preliminary sketch of the tree with the background. There should be a marked difference in contrast between the foreground and the background: the former has sharp contrasts, while the latter has almost none.*

▶ 2. *Paint the tree in the foreground without using white in the mixture, heightening the contrast through the use of dark tones of green, burnt umber, and blue. This will create a sharp difference between the trees in the background and the foreground. The terrain should be dealt with in the same way: the foreground should be full of reds, yellows, and earth colors without any white, while the background should be painted in pastel colors.*

## BRANCHES

The structure of branches can be very complex if the model is not carefully examined. The first step in any exercise dealing with branches must always be a detailed study of their structure. This structure starts with the foundations, which are the first boughs that branch out from the trunk. This topic includes two exercises which, with sufficient practice, will provide the techniques necessary for the confident and accurate painting of trees.

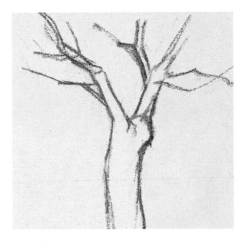

▼ 1. One of the most common media to sketch with is charcoal. In this case, two thick boughs branch off from the trunk. Separate lines extending from these represent the smaller branches.

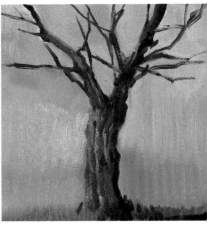

▼ 2. A charcoal sketch allows us to paint in colors confidently. Paint the dark areas of the trunk with lines that extend all the way to the smaller branches. Apply the background color on top of the preliminary sketch. Then sketch in the branches once again, this time with the paintbrush.

1. This second exercise starts with a sketch drawn diluted with oil paint and a fairly dry brush. After the main lines have been sketched, paint the inside with various intensities of color; some brushstrokes should be completely transparent, and others more opaque. Sketch the branches in with resolute strokes.

▲

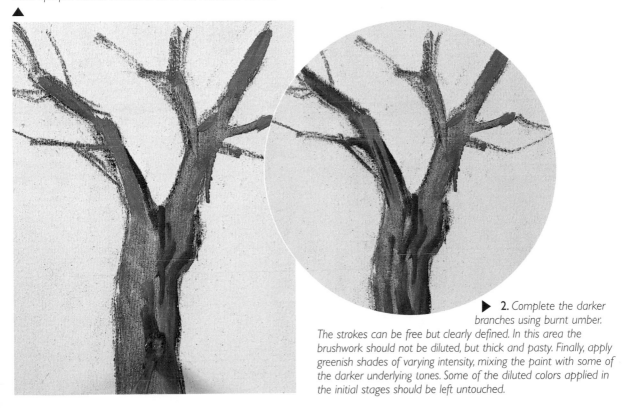

▶ 2. Complete the darker branches using burnt umber. The strokes can be free but clearly defined. In this area the brushwork should not be diluted, but thick and pasty. Finally, apply greenish shades of varying intensity, mixing the paint with some of the darker underlying tones. Some of the diluted colors applied in the initial stages should be left untouched.

147

## GROUPS OF TREES

Having painted the trunk of a tree, we will now move on to an exercise that practices painting a small grove of trees. The subject chosen for this exercise is part of a wood, which is not excessively dense and features a few trees in the foreground. After the exercise in the previous section, this subject should not prove too difficult.

▶ 1. *As in the previous exercise, the first step is to sketch in the main shapes of the trunks and branches. First, sketch the general forms with charcoal, and then fill in the outlines with a very dark shade of violet painting over the charcoal, but taking care to follow the sketch closely and precisely. This technique is used to sketch in both the trees and the main features of the landscape.*

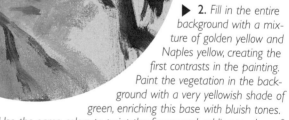

▶ 2. *Fill in the entire background with a mixture of golden yellow and Naples yellow, creating the first contrasts in the painting. Paint the vegetation in the background with a very yellowish shade of green, enriching this base with bluish tones. Use the same colors to paint the foreground, adding touches of orange. Apply carmine to the shadow of the tree.*

▶ 3. *The most illuminated areas of the terrain should be painted in bright orange. This shade will complement the violet tones. Apply dense, reddish brushstrokes to the trunks of the trees.*

## Step by step
# Trees in the distance

An atmospheric effect is produced when particles of dust or humidity accumulate in the air under certain lighting conditions. Because of the distance, the density of the atmosphere whitens the colors in the background. This phenomenon provides interesting possibilities for oil painting. The atmospheric effect can be created by progressively adding white to the colors as they reach farther and farther into the distance.

## MATERIALS

*Oil paints (1), a palette (2), paintbrushes (3), canvas-covered cardboard (4), linseed oil (5), turpentine (6), and a rag (7).*

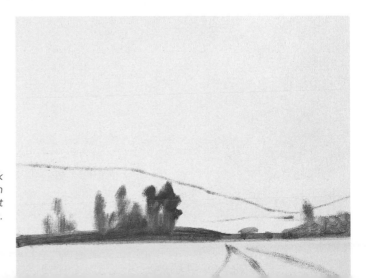

**1.** *When seen from a distance, trees lack detail. However, it is still important to sketch the shape of the trees with distinct lines that contrast clearly with the rest of the painting.*

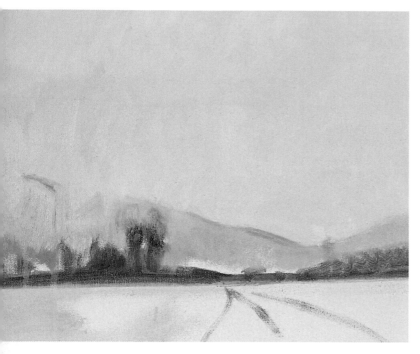

**2.** *The first applications of color should be in the most distant plane: the mountains in the background. Sketch this area with a mix containing a great deal of white with just a drop of cobalt blue and another of violet. Very little color is needed to give it the required tone. It is also essential to paint the lightest tones first. Use a luminous shade of white mixed with Naples yellow to fill in the area of the sky.*

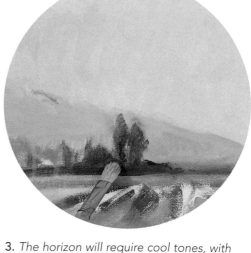

**3.** *The horizon will require cool tones, with colors that become increasingly pastel-like as they recede into the distance. The colors should blend in with the background both on the horizon and in the grove of trees in the distance. The drag of the brush should create slightly marbled shades at the point where two colors meet. This narrow, blurred area will act as a link between the background and the outlines of the trees.*

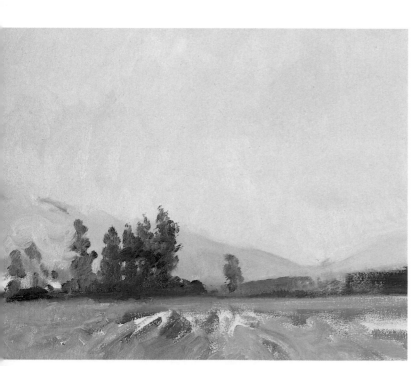

**4.** *After these steps, the landscape should be completely filled in with color. On top of these pastel shades, begin to paint a series of restrained contrasts that will profile the most important areas of the painting. Paint the trees with small, precise brushstrokes in green, adding white in some areas to suggest the atmosphere. Use a darker tone of green for the closer trees, contrasting them with those in the background.*

**5.** *The tone of violet in the background should act as a base for painting the trees on the horizon. Even though they are in the distance, these trees should be painted in dark green; this time mixed with white to represent the mist that intervenes between this plane and the closer ones. The brushwork in the lower area should be more detailed and precise, using concise, vertical strokes in dark shades.*

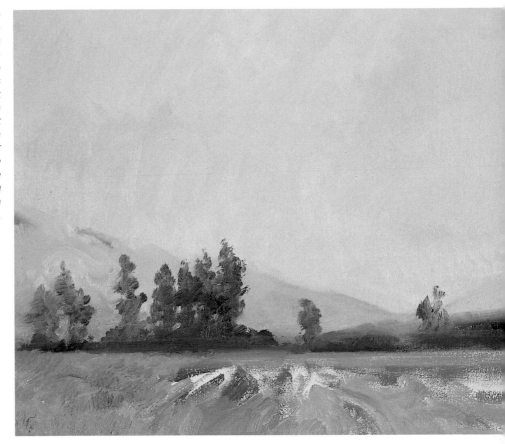

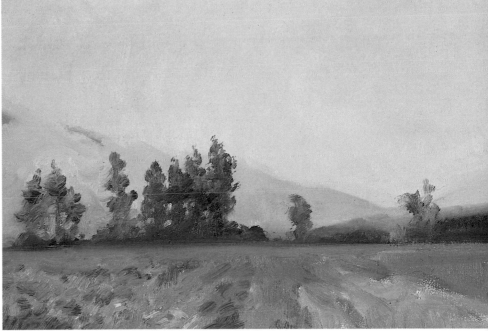

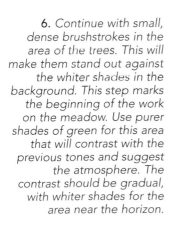

**6.** *Continue with small, dense brushstrokes in the area of the trees. This will make them stand out against the whiter shades in the background. This step marks the beginning of the work on the meadow. Use purer shades of green for this area that will contrast with the previous tones and suggest the atmosphere. The contrast should be gradual, with whiter shades for the area near the horizon.*

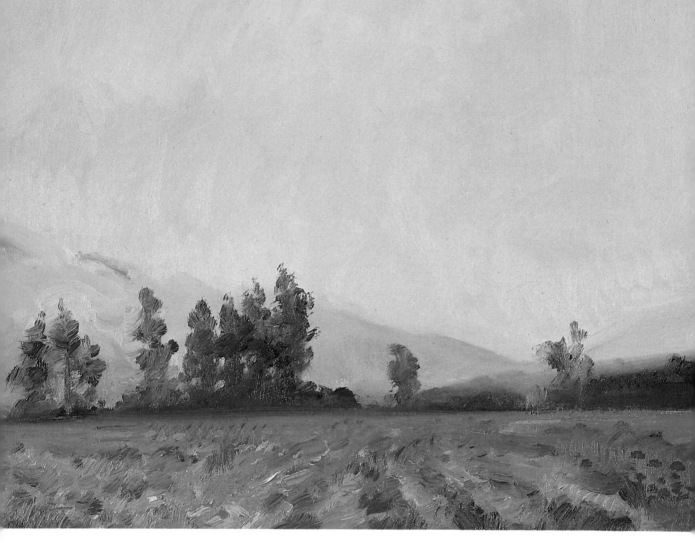

**7.** *The grove of trees can be suggested in the background by using small dabs of color. These shades should be dark and blend with the pastel shades in the background. The depth of the atmospheric effect can be enhanced by adding various contrasts in the foreground. These pure, contrasted colors accentuate the depth of the background, which was painted in pastel shades. The trees should now be perfectly integrated into the background.*

## SUMMARY

**The first colors** were light and mixed with white to suggest the atmosphere.

**The trees in the distance** were painted as flat patches of color, with no individually defined shapes.

**The contrasts** that make the trees stand out were combined with different shades of green.

**The terrain** incorporates less white as it nears the vantage point of the observer.

# The way they painted:

## Claude Monet

(Paris 1840-Giverny 1926)

# Water lilies

Monet was one of the most prolific artists of his time. The father of Impressionism, he developed the theories that allowed the movement to break with previous academic tradition. In fact, all of today's pictorial movements stem to some degree from Impressionism or the movements immediately following. Monet's work, like that of many other artists, is particularly useful for studying the different pictorial possibilities permitted by oil paints, since it does not involve complicated procedures.

In his works, Monet invested a great deal of time and interest in the study of light, one of the bastions of Impressionism. For the subject of this painting, Monet had a large basin built with the sole purpose of growing water lilies in it in order to paint them from nature. He created an entire large format series on this subject, which he placed in a circular room to give the spectator the sensation of being enveloped.

## MATERIALS

*Oil paints (1), palette (2), paintbrushes (3), canvascovered cardboard (4), turpentine (5), and linseed oil (6).*

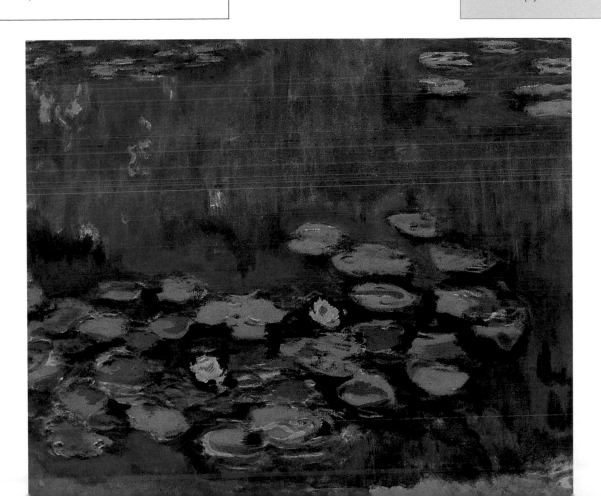

# STEP BY STEP: *Water lilies* by Claude Monet

1. Monet's paintings are often very fresh and direct. In this work, we see an immediate impression of the subject, which makes a detailed drawing of the forms unnecessary. The work began with a very general and thinned roughing-out, with which the entire background of still water was done. The oil paint should be thinned with quite a lot of turpentine, but not enough to allow the colors to mix on the canvas. The original was quite large. Here we have reduced the format, but retained the principal techniques, such as the slight blending of the greens and blues in the background. This painting must be done on an upright canvas, so that the force of gravity carries the paint downwards.

2. The colors should be applied in nearly vertical brushstrokes, leaving the areas blank where the water lilies are to be. Strokes of very bright blue can be used to sketch in the shapes of the water lilies while providing dividing lines among them. Just as in any reproduction, it is important to note the main lines of the composition. If you observe the original attentively, you will notice that the water lilies are placed on the canvas in an S-shape.

**3.** *The initial roughing out should be very diluted. The white background should still show through the first layers of paint. Once you have selected the colors that will cover this background (all of which should be in very cool tones, including the yellows), you can begin to paint with much more concrete strokes that situate the most distant floating lily pads in the upper left-hand corner. In this area, the brushstrokes should not define distinct forms.*

It is important to see the original works in museums or galleries. When you come into direct contact with the work, you can see the different techniques used by the artist much more clearly.

**4.** *The shapes of the lily pads are defined by color areas that are reflected in the surface of the water. If you look closely at this detail, you will see that each individual brushstroke appears as a simple spot and its effect is meaningless. If, on the other hand, you observe the whole from a distance, you can see the points of light of the different areas of this landscape. This roughing out requires colors that are previously mixed on the palette. The color is not pure green, but approximates a bluish gray.*

# STEP BY STEP: *Water lilies* by Claude Monet

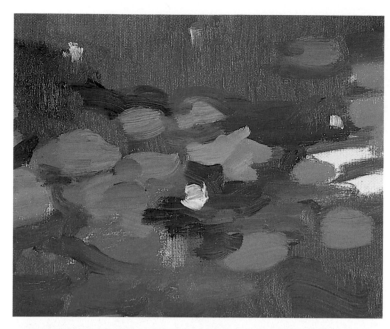

**5.** *Continue filling in the lily pads and their reflections on the left side of the painting. Mix cobalt blue with some ultramarine to contrast with the blue of the water. As you can see in this image, the water lilies appear much brighter due to the contrast, as the background becomes darker. With very short, precise brushstrokes, but without any definition, paint some flowers on the pond water.*

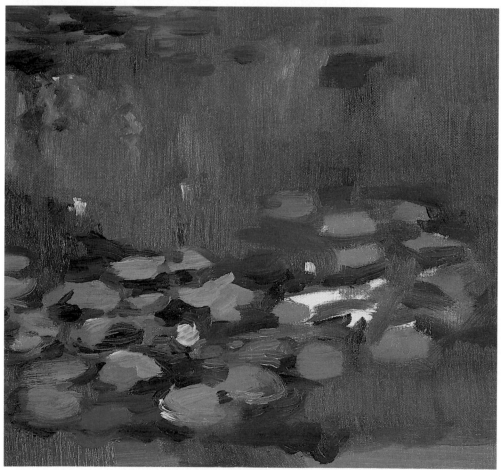

**6.** *Apply the colors making up the entire lower part of the painting with much more contrast. Your brushstrokes should continue to become thicker as you apply the paint directly, without blending the colors and tones in the layers beneath. Paint the blues around the leaves in the same manner. Also add some touches of yellow to the flower in the middle, using a very faded carmine to emphasize the contrast with the cold tones of the landscape.*

**7.** Add reflections to the upper area in soft, undulating brushstrokes that descend vertically. It is inevitable that some of the paint from previous layers will mix into these brushstrokes. After painting the central flower in the same way as the first yellow flower, develop the upper area. Here, with a few more patches of color, you can finish covering the entire surface of the water lily pads.

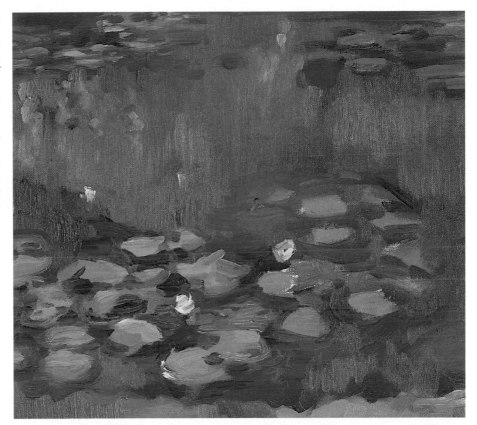

**8.** In the upper area, you can see how just a few very bright brushstrokes can perfectly define the floating lily pads. This time, the color contrasts well with the blues surrounding it. To heighten the contrast, add a dark blue. In the lower area of the painting, the contrast between the alternating light colors of the leaves and the darker background will complete the whole. Finish off the contours of the leaves in carmine and grayish green tones.

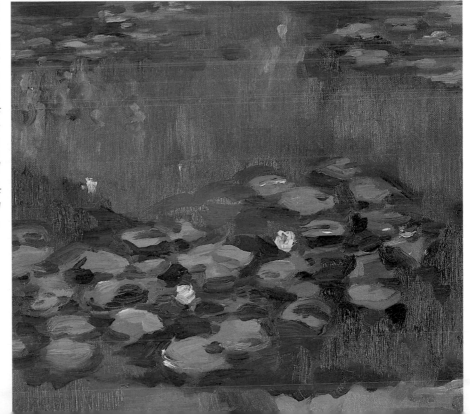

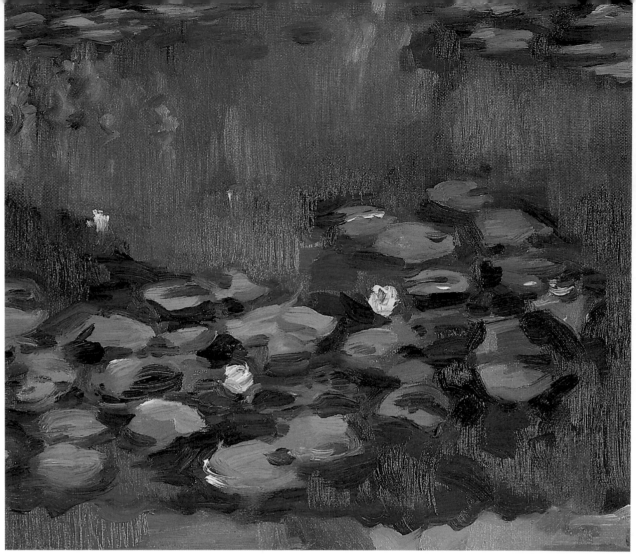

**9.** *Only the darkest and thickest contrasts have yet to be added to finish this painting. These final tones will help to emphasize some of the areas of medium luminosity. The dark greens applied in this final phase should not clearly define forms either, but will help to contrast the contours of the leaves against the surface*

## SUMMARY

**The first colors added** were thinned with turpentine. Since the paint was very liquid, it ran down the canvas, allowing the background to come through.

**Bright blue** outlines the shapes of the leaves, as well as establishing their separation.

**The leaves** were painted in a somewhat grayish tone, making them stand out from the dark colors of the water.

**The flowers were** painted with direct strokes of yellow.

# The way they painted:

## Vincent van Gogh
(Groot Zundert 1853-Auvers 1890)

# Pink peach tree in bloom

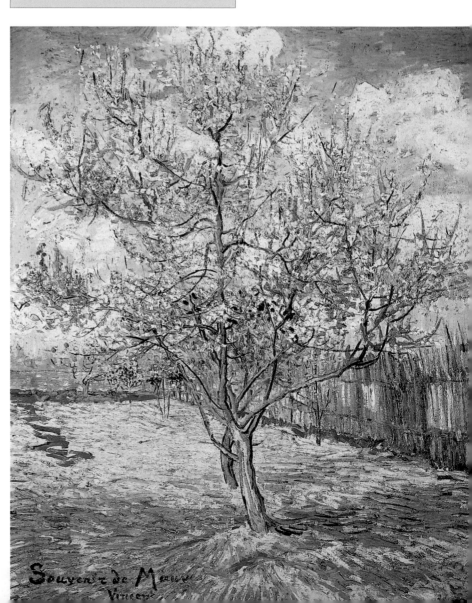

Van Gogh is one of the most controversial painters in history. This artist's work went unnoticed during his lifetime, and mental illness left him on the brink of madness. Despite this, many of today's artistic movements would not exist without Van Gogh. His invaluable contribution to art is the way he used color and the brushstroke, which provided the first step toward Expressionism.

Van Gogh's paintings are energetic and full of feeling. Rather than being a virtuoso of the drawing, Van Gogh's real mastery lies in the impressive force he was able to convey through his use of color and brushwork. Likewise, his motifs, which were always very close to home, reflected his own particular view of reality. His twisted and expressive style is one of the characteristics that best define the artist's work. This is one of the landscapes that the master painted. As you can see in the model, he didn't search for a complex or grandiose motif. A simple garden containing a peach tree was enough.

**1.** *Sometimes an apparently simple sketch requires even greater attention to detail. The composition of this painting can deceive the spectator, since the tree is slightly off center; its mass takes on a somewhat more precise form that could easily go unnoticed if its main lines are not studied with utmost care. A charcoal sketch will help you to understand these forms, as well as the general lines of the fence that encloses the garden.*

The brushstroke played a very crucial role in Van Gogh's painting. When attempting to reproduce this effect, it is important to study how the thick layer of color merges with the others on the canvas.

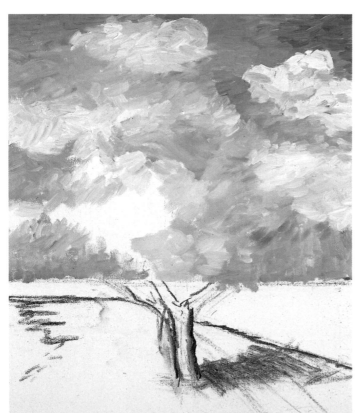

**2.** *The first step is to paint the sky. In this way, you can rough out the entire area against which the florid branches of the peach tree will be situated. Do not define all of the clouds in the same way. Slightly contrast the uppermost ones against the blue sky, but, as you move towards the lower clouds, add a hint of cerulean blue to your mixture. Pure white is not very useful in this case, as it can clash with the Naples yellow. Van Gogh always began his paintings with a simple structure which he enriched with successive layers of color.*

**3.** *Once you have roughed out the sky, paint in the ground and the fence. Just as Van Gogh did in the original, elaborate the ground with an interesting rhythm of tones and colors. The background color should be very bright, paint it with a base color of Naples yellow with a touch of yellow ocher and bright green. As you work towards the earth in the foreground, apply more leaden and slightly dark tones, always within the cool range. The colors used in the foreground should be earth tones. Paint this area with long directional strokes that lead toward the main tree. Paint the fence with vertical strokes, except the part in the background, where the brushwork tends to be somewhat more blended.*

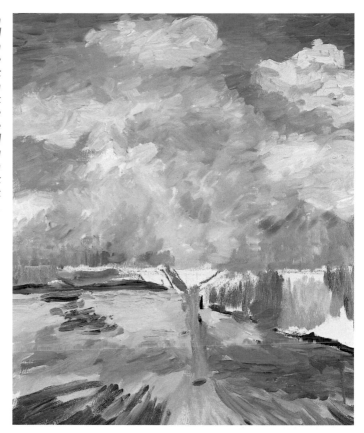

**4.** *Now that you have roughed out the background completely, it is time to define each one of the areas, studying the brushstroke and color that must be applied within each one of them. Bear in mind that on most occasions, the new brushstrokes will drag up part of the underlying ones. In order to compensate for the tones in the foreground, Van Gogh applied short strokes in a variety of very bright green tones in the middle ground. Apply blue to the shadows cast on the ground, and paint the parts in direct sunlight with ocher tones.*

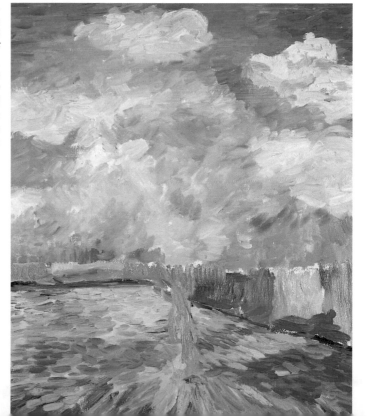

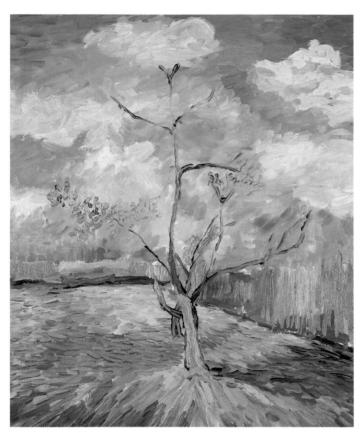

**5.** With a fine brush, trace over the outline of the main tree, applying various colors; on the one hand, black, and on the other hand a sienna tone that will blend in some parts with the background and with the black of the original drawing. Just as the great painter did himself, apply color to the main branch, from which the others are then extended. Continue to paint the ground with strokes that alternate colors and tones that correspond to the luminosity of each part.

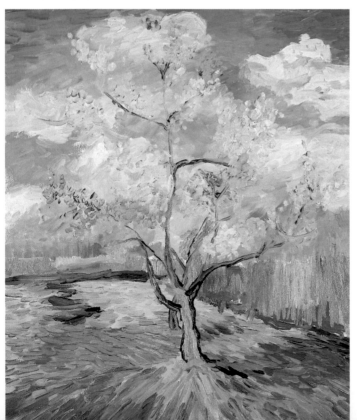

**6.** Once you have painted the most significant branches move on to the leaves. This stage is especially complex, as there is a risk of applying too much paint to the treetop. Therefore, it is important to paint this picture energetically but with sufficient restraint. The colors used in the pink branches should be a combination of carmine, orange, ocher, Naples yellow, and white. As you can see, several greenish tones were also included.

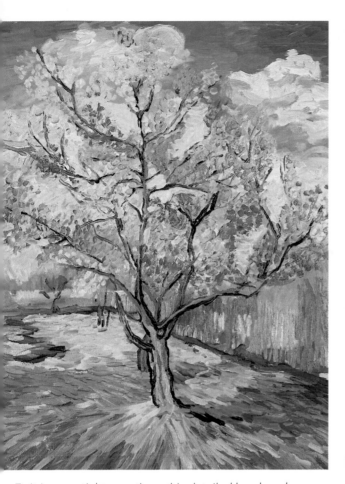

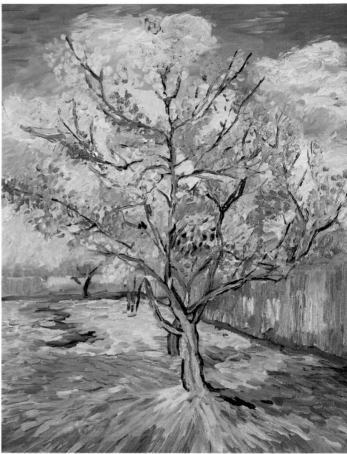

7. It is essential to continue this detailed brushwork in each of the areas of the treetop. The brushstrokes must be short, but not so short as to be dots. Each one of these areas must be painted with a complete range of tones, applying different shades of color with each stroke. Paint the middle of the treetop with several orange tones, while red toned with Naples yellow should predominate on the right. As you gradually paint the crown of the tree, correct and add in the shape of certain branches, which should be represented as fine strokes interrupted by the pinkish foliage. Paint the trunk with bluish tones and a pumpkin color, without letting them superimpose the black lines that define it.

8. Continue with the tiny applications that give form to the crown of the peach tree. In certain areas apply small strokes of black, producing a stark contrast with the rest of the pastel-like tones that surround them. Draw the thinnest branches with your finest brush, without affecting the bright colors of the background.

> In works that contain color impastos, it is necessary to consider the mixture directly on the canvas, as well as on the palette. On occasion, a tone can be corrected by adding direct color.

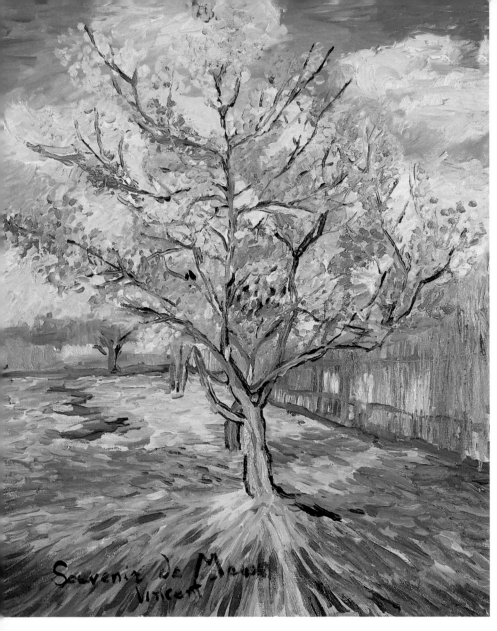

**9.** *The final and numerous brushstrokes applied to the treetop should gradually become purer in terms of color, you can even add pure tones of red and carmine that will produce a stark contrast with the whitish colors of what is now the background. The color work on the ground is meticulous, and should be painted with a much smaller brush than the one used so far. The work on the fence is also intense. The different degrees of light in each of its areas will help you to finish it.*

## SUMMARY

**The sky was painted with cerulean blue.** The clouds were painted with a diverse range of very whitish tones.

**The tone of the ground** corresponds to the different qualities of light it reflects.

**The outline of the main tree** was drawn and outlined with a contour that perfectly defines it.

**The leaves were painted with pastel-like tones,** mixed to a greater degree with white and Naples yellow.

As the painting advanced, **the strokes and colors of the ground** were applied more precisely.

# The way they painted:
## André Derain
(Chatou 1880-Garches 1954)

# The Algerian

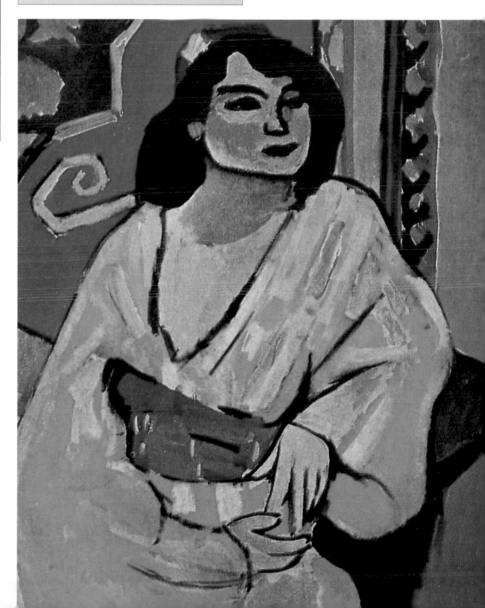

**MATERIALS**

*Charcoal (1), oil paints (2), canvas mounted on a stretcher (3), palette (4), brushes (5), turpentine (6), linseed oil (7), and a rag (8).*

Derain, who inherited the theories that Gauguin unintentionally bequeathed, was one of the painters who lead the post-Impressionist movement known as the Fauves. Fauvism was characterized by the violent use of color, which required absolute knowledge of color theory. Despite the excessive academic zeal that emanates from Derain's work, it is impossible to negate the tremendous force of his paintings.

Fauve painting, as well as that of the Nabis, is characterized by, among other things, the use of complementary colors and the use of lines to define the forms of the objects being painted. The painting shown here is a good example of this pictorial style. It is a complex work that is also fun to paint. The process required is within the grasp of all amateur painters. Nonetheless, as you can see in the original, the result has an outstanding visual impact.

# STEP BY STEP: *The Algerian* by André Derain

**1.** *If in other paintings, the sketch is fundamental, in this work it is indispensable, since the colors that will later be applied are completely flat and lack any type of modeling or tonal blending. The outline of the drawing must be exact in order to enable the artist to develop both the color of the line and the blocks of color that fill in each area. On the other hand, when drawing with charcoal, many of the most confusing lines can be erased cleanly with a rag. Derain drew a drawing similar to this one in order to closely study each one of the later painting stages.*

> The preliminary drawing or sketch must be executed in a medium that can be easily rectified, such as charcoal or even oil paint itself. One technique that is common among painters is to sketch the model in acrylic, which can be corrected while it is still wet. Furthermore, acrylic dries quickly and is compatible with oil paint.

**2.** *Once you have sketched out the figure, the most important lines of the drawing must be checked. In this exercise, it is very important that the drawing be perfectly defined before paint is applied, because this outline will mediate between each area of the figure and the background. The lines must be painted relatively thick, because they will serve as a boundary that will separate the various areas of color.*

**3.** *After completing this preliminary drawing with thick lines perfectly marked out, you can begin painting the areas. Derain always started with the complementary colors. He painted the hollow on the right of the door with a very luminous violet; next to that a frame with a pinkish tone; the lower part is painted with an intermediate tone oscillating between the two. The background on the left of the figure should be painted with a reddish color, which later on will be made more intense. Just as in the original, the colors should be flat; that is to say, they should lack gradations or any type of tonal values. Apply a very light pink color to the face and use a dark violet tone for the shadow of the neck.*

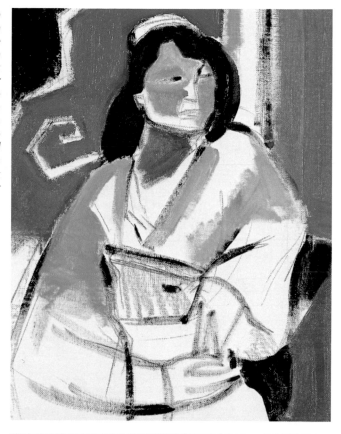

When working with pure colors, it is important to avoid mixing them as much as possible, especially with black. If a color has been dirtied excessively, don't continue; remove it with the palette knife and paint over the area again.

**4.** *Continue to work on the dress that began with green toned with a touch of white without attempting to express any volume, although other colors should be applied in the area of the sleeve, to increase the chromatic depth of the work. Paint the background definitively with entirely flat tones. The visual effect between cool and warm colors is marked by intense tonal complementary contrasts. Paint the face by area, applying new colors over the previously painted one. Each new area should form a different plane, even though there is no line of division.*

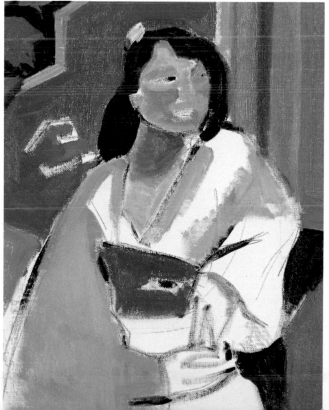

**5.** *Each area, even those that were left unpainted must be painted with a flat color which will in turn serve as a dividing line. Notice how on the left of the painting, in the background, the strokes of green create dividing lines. The volute that has been left unpainted should now be painted bright green. Paint a reddish stroke in the form of arches over the green door frame. Using a fine brush, begin to paint the face once again; this time the lines must be thin and precise.*

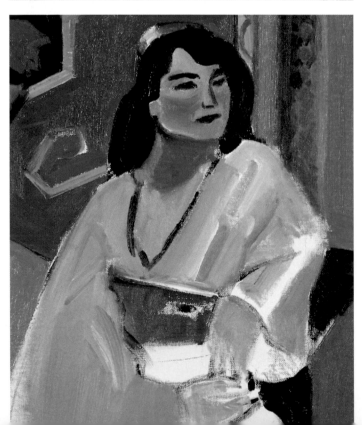

**6.** *Now the main features of the face have been outlined. With a fine brush dipped in black and violet, paint in the nose. Paint the lips with dark carmine. Use different colors for the dress, taking advantage of this to create new areas of flat color. On the left side apply sky blue tinged with white. In the unpainted areas on the right, apply a flesh tone. Paint the hands with a barely yellowish tone, which will provide a base for the next step.*

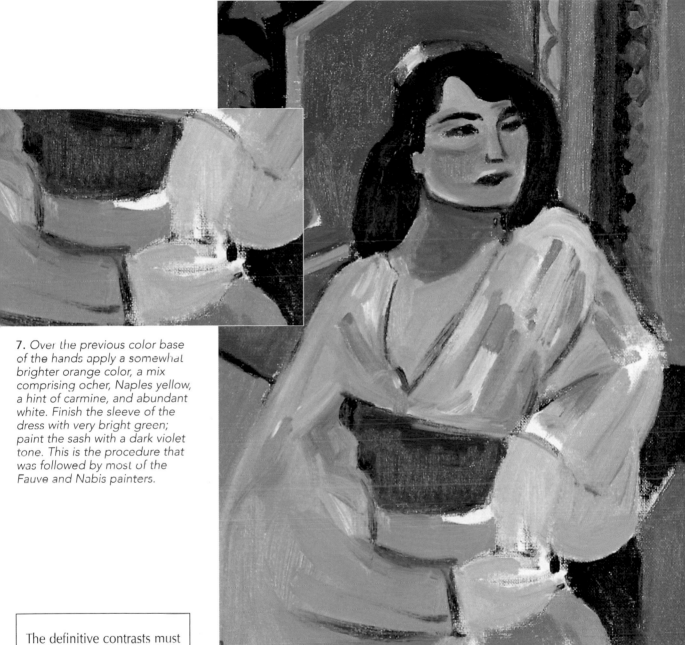

**7.** *Over the previous color base of the hands apply a somewhat brighter orange color, a mix comprising ocher, Naples yellow, a hint of carmine, and abundant white. Finish the sleeve of the dress with very bright green; paint the sash with a dark violet tone. This is the procedure that was followed by most of the Fauve and Nabis painters.*

The definitive contrasts must be left for last. In this way it is possible to add hues that enrich the overall color of the work, yet are not too conclusive. The outline of the forms must be precise and clearly indicate the different planes.

**8.** *With a fine stroke, finish the woman's profile, which should now be perfectly defined and separated from the colors of the neck. Apply a brushstroke to the cheek to highlight and separate the areas of light around the eye. Paint the white of the eye with the same bright green used to darken the eyebrows and the eyelids. With burnt umber draw and outline the decoration on the frame on the right.*

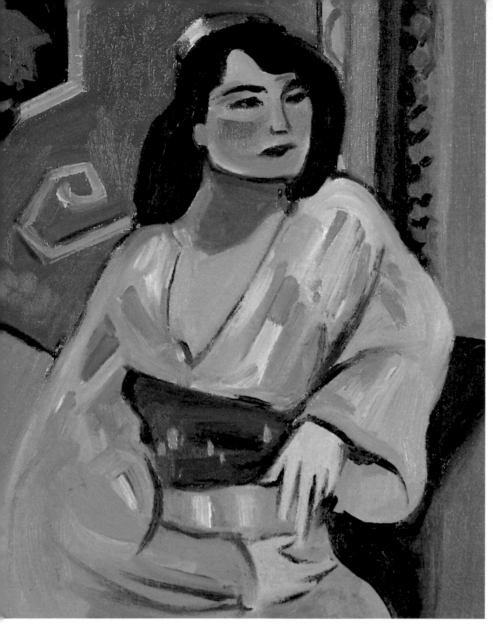

9. Once the canvas is completely filled with the flat colors that have been used so far, all that remains is to fill in those areas that are still blank and go over the most important lines. With that, the interpretation of this painting by Derain is concluded.

When painting the final strokes, artists must consider the colors of the picture; that is, if they want to reduce the brightness of certain areas, the outline of the last brushstrokes must allow the underlying colors to remain visible.

## SUMMARY

**The preliminary drawing** was executed in charcoal, so that any incorrect lines can be rectified easily.

The intense red **in the background** produces a sharp contrast with the bright tones of green, as well as the violet tones. This is one of the characteristics of this style of painting.

Each one of the colors painted **on the face** is a plane: the sketched lines allow new features to be defined.

**All the areas** were outlined at the end with the same color they were painted with or with a black stroke.

**The color treatment** of the hands was achieved after the roughing out.

# The way they painted:
## Paul Cézanne
(Aix-en-Provence 1839-Aix-en-Provence 1906)

# Still life

Cézanne was, along with Gauguin and Van Gogh, one of the principal precursors of the post-Impressionism movement. Admired by his contemporaries to the point of being called the genius, Cézanne is key to contemporary painting. His contributions to technique and theory gave way to the logic with which Picasso developed Cubism.

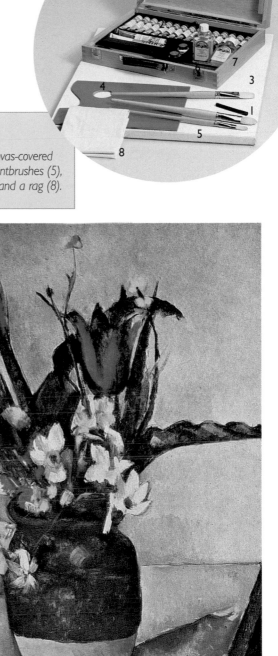

## MATERIALS
*Charcoal (1), oil paints (2), canvas-covered cardboard (3), palette (4), paintbrushes (5), turpentine (6), linseed oil (7), and a rag (8).*

Cézanne's works strive towards the synthesis of planes, i.e. showing all the possible views of an object in one painting. In this still life, the theories of this ingenious painter were not yet fully developed, although we can already appreciate a few details that approximate such notions. Observe the plane of the table with respect to the rest of the objects in the still life, as well as the way in which the short brushstrokes construct forms through small planes.

# STEP BY STEP: *Still life* by Paul Cézanne

1. *Cézanne always placed a special emphasis on the study of composition in all of his paintings. Nonetheless, Cézanne's compositional technique was based on a progressive construction of forms. Cézanne probably didn't sketch the still life before painting it, but it will be easier to interpret his work if you block in its essential lines in charcoal. Make straight lines with the flat side of the charcoal, holding the stick lengthwise. In any case, do not aim for a finished sketch, but simply an idea of the principal planes through the lines that define them.*

If you want to preserve the initial blocking in as the basic structure of the painting, you can spray it with fixative. Although you paint over it or touch it up, the sketch will remain unchanged.

2. *Add the first color to the background, applying it very thinly, so that the lines of the blocking in beneath show through. The color should be applied irregularly, and not necessarily pure. Blue should be mixed with white and some touches of ocher. In this detail, you can see how the brushstroke penetrates into the sketched forms. Subsequently, more diluted layers will be able to cover these first transparent background layers perfectly.*

**3.** *Finish the background in different intensities of blue and a great variety of brushstrokes in different directions forming different planes. The color should be mixed on the palette as well as on the canvas itself, allowing the paintbrush to drag up some of the paint from the underlying layers. As Cézanne did, paint the vase in a great variety of planes, without modeling shapes. In this example, you can see how the wide brushstrokes do not blend with one another, but overlap. To prevent the colors from blending completely, it is important to avoid going over each brushstroke excessively.*

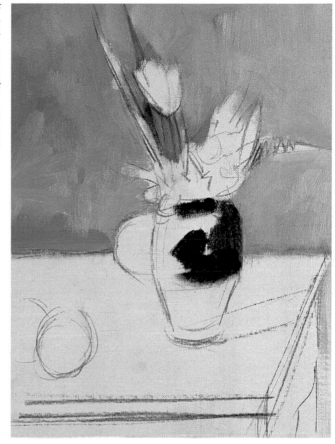

> The entire work should be roughed out as a whole, so that all of the areas will be finished at the same time and it will be easier to correct any mistakes.

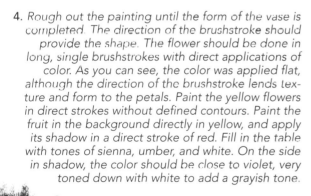

**4.** *Rough out the painting until the form of the vase is completed. The direction of the brushstroke should provide the shape. The flower should be done in long, single brushstrokes with direct applications of color. As you can see, the color was applied flat, although the direction of the brushstroke lends texture and form to the petals. Paint the yellow flowers in direct strokes without defined contours. Paint the fruit in the background directly in yellow, and apply its shadow in a direct stroke of red. Fill in the table with tones of sienna, umber, and white. On the side in shadow, the color should be close to violet, very toned down with white to add a grayish tone.*

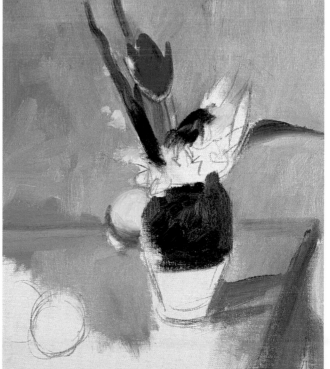

**5.** *In this detail, you can see the technique Cézanne used to construct the different planes of the table with brushstrokes. Some strokes are slightly bluish, some blue mixed with white, others reddish and orange. The different brushstrokes combine to form criss-crossing planes which let the background colors show through. Quickly rough out the orange on the left with slightly grayish colors that have been mixed with white. The presence of white in the color mixtures produces impure colors.*

**6.** *Apply new tones over the previous ones of the table, including carmine and various blue hues. When mixed on the palette with white, slightly violet pink tones can be produced. The shadow cast on the table can be reproduced with a carmine toned down with some white and umber. Finish off the shape of the vase with some strokes of whitish paint along the base. Naples yellow, sienna, and white can be used to make the mix for this part. The upper part of the vase should include some small areas of ocher. Paint the right flower in very light tones, which will contrast with later additions of pure colors.*

**7.** *Apply large areas of dark colors to the right side of the vase. Black, however, should not be used at all in this exercise. The dark tones are highlighted instead by the effects of simultaneous contrasts. Cézanne respected the theories of Impressionism, which rejected the use of black in the study of light. Given that very bright colors are used in the rest of the painting, you can simply use a darker tone in this area to intensify the extremes: the lighter areas will appear even more luminous and the darker tones will appear more dense. Use dark brushstrokes to finish shaping the leaves. In the lighter area of the vase, shadows can also be suggested with loose brushstrokes which do not blend into the background colors.*

One of Cézanne's theories was that all objects can be reduced to simple geometrical shapes. Each plane of an object can correspond to a color independent from the rest of the planes.

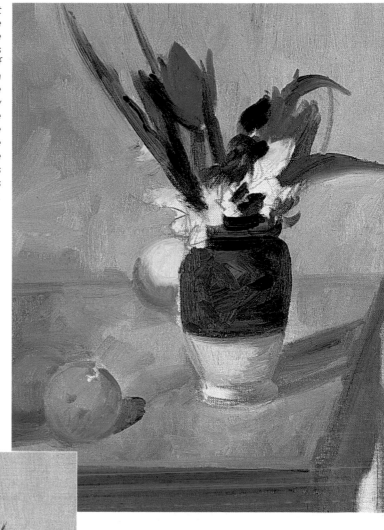

**8.** *The entire flower work should be done in pure colors and flat brushstrokes. The differences between each of the areas can be established through the application of completely different and very direct tones that are not blended together. Paint the smallest flowers in very direct, specific brushstrokes with no attempt at detailed contours.*

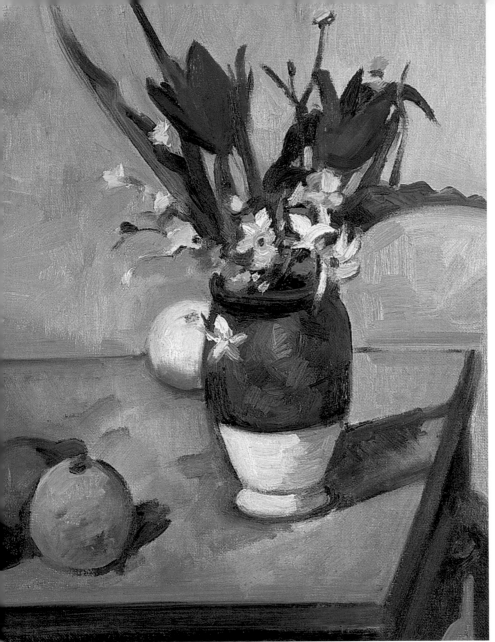

**9.** *To finish off the painting, the forms of each plane must be given more definition. Finish the contour of the vase by darkening the blue tones around it on the table. Lighten the fruit in the background with white to obtain tonalities closer to the original. Define the orange tones in the right by notably darkening the surrounding area with bluish tones. Give the different planes of the table the finishing touch by repeatedly darkening the dark areas.*

If necessary, allow the painting to dry overnight between each session to avoid undesired impastos. This allows for a much cleaner finish.

## SUMMARY

**The original sketch** was based on simple geometrical elements which allow you to approximate the forms to those in the original and study the composition in depth.

**The background** was painted in blues toned down with abundant white. The brushstrokes are direct and the tones do not blend, but rather form independent planes.

**The progression of colors in the flowers** began with a flat tone applied in different areas.

**The small flowers** were painted in very direct touches of yellow and white.

**In the vase**, each change in tone was carried out directly, blending together without the colors.